D1387726

Celebrity & Performance

RotoVision

A RotoVision Book

Published and distributed by RotoVision SA
Route Suisse 9
CH-1295 Mies
Switzerland

RotoVision SA
Sales and Editorial Office
Sheridan House, 114 Western Road
Hove BN3 1DD, UK

Tel: +44 (0)1273 72 72 68
Fax: +44 (0)1273 72 72 69
www.rotovision.com

10 9 8 7 6 5 4 3 2 1

ISBN: 978-2-940378-40-1

Art Director for RotoVision: Jane Waterhouse
Design: JCLanaway
Cover design: Jane Waterhouse
Lighting diagrams: Rob Brandt

Typeset in Univers and Sabon

Reprographics in Singapore by ProVision Pte.
Tel: +65 6334 7720
Fax: +65 6334 7721

Printed in Singapore by Star Standard (Pte) Ltd.

The World's Top
Photographers'
WORKSHOPS

Celebrity &
Performance

Andy Steel

Contents

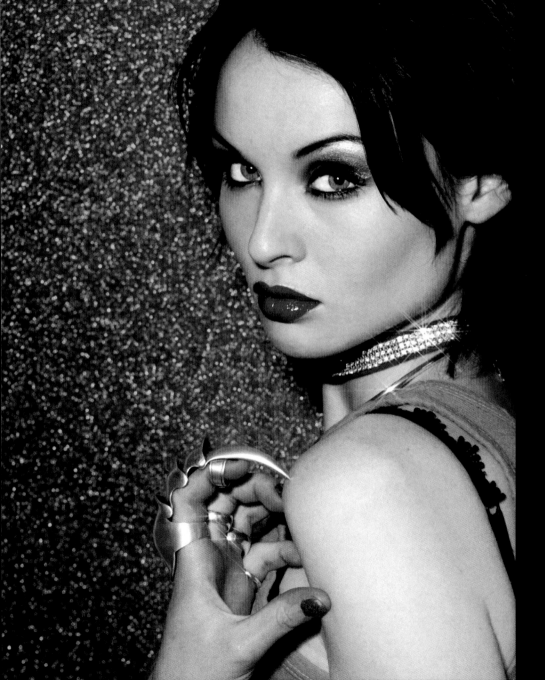

The evolving world of celebrity and performance photography continues to feed the insatiable appetite of the world's public. At the heart of this is just a handful of specialists who spend each working day recording the lives of A-list stars and public performers. Each is unique, offering their own distinctive take on the world's most-seen faces and leading personalities.

Browsing through the eye-catching pages of this book reminds me of some things that sparked my interest in the world of celebrity to begin with. The first is that we—and I speak on behalf of most of Western culture—live in a world that has become intrigued with image, fashion, and fame. And then there's the sheer scale and power of celebrity, and the insidious manner in which the genre is able to influence our daily lives. These circumstances would never have been possible without the camera, and those who practice their trade behind the lens.

I'm not sure anyone could have imagined how the growth of modern technology—in particular the digital camera—would help unearth some of the magic and mystery of the world's leading stars, bringing each closer to our ears and eyes.

Whether it's the glittering turquoise of the latest supermodel dress, or the smile of a Hollywood star looking out from your computer screen, none of this would be possible without the real stars of celebrity—the photographers.

Andy Steel

Left:
Sophie Ellis-Bextor, *Ministry*
Soulla Petrou

Right:
Samuel L. Jackson
James Cheadle

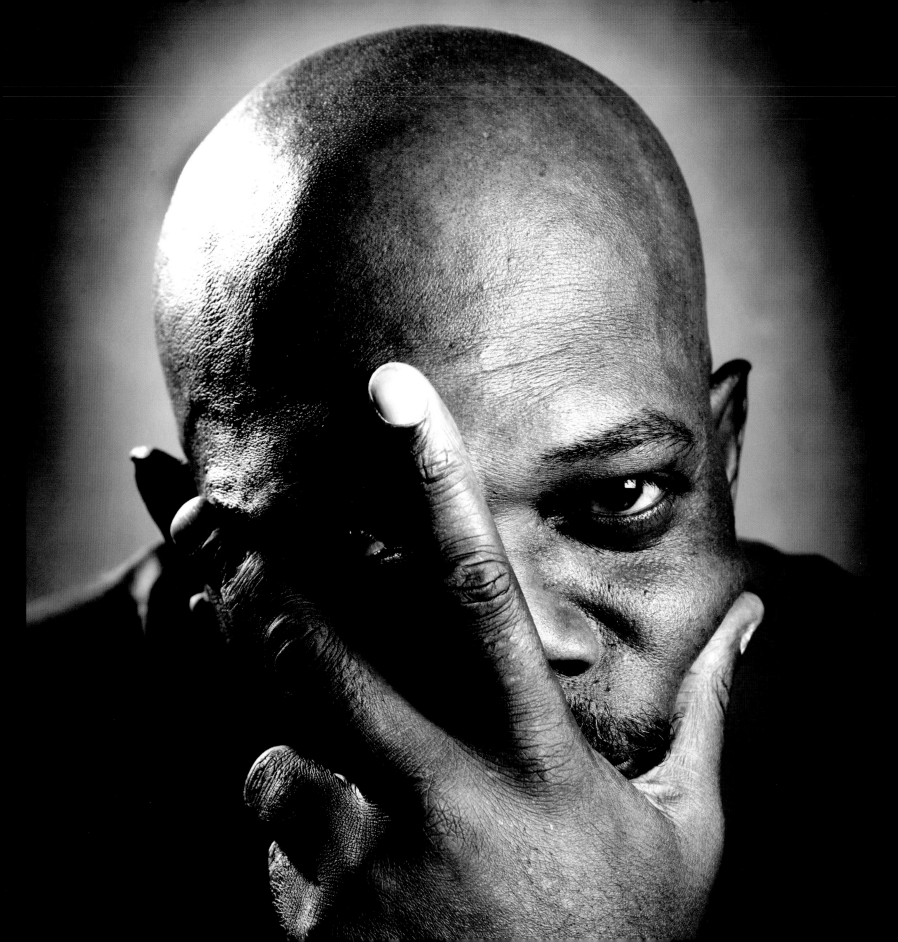

Offbeat reportage

Polly Borland's photography is, quite simply, unique. She earned her reputation for specializing in stylized portraiture and offbeat reportage in her home town of Melbourne, before moving to the UK in the late 1980s. In 1994 she was awarded the prestigious John Kobal Photographic Portrait Award, a world-wide showcase for new talent in portrait photography, organized by London's National Portrait Gallery. The gallery has since acquired a number of Polly's photographs for its permanent collection and, in 2000, exhibited a solo show of her work in the UK and Australia. powerHouse Books published her first book, *The Babies*, in 2001, and that same year Polly was one of eight photographers invited to shoot Queen Elizabeth II to celebrate her Golden Jubilee. In 2006 Polly spent three months in the outback of Queensland, Australia, creating an exquisite and haunting set of images of the entire cast of *The Proposition*. The movie was directed by her husband, John Hillcoat, and written by her close friend, Nick Cave. She says of her work, "I'm fascinated by people. I love meeting them, photographing them, finding out about them. The best portraiture is when you get beneath the skin of someone; it's psychologically revealing. You penetrate the surface."

Guy Pearce
I went off-set with Guy Pearce (one of Australia's biggest actors and one of the stars of *The Proposition*) and his make-up artist to take a portrait of him in full character dress. This shot reminds me of an old-fashioned portrait, with low depth of field, which makes the background look like a painting.

CAMERA: Mamiya 7
LENS: 80mm
FILM: Fujifilm Pro color negative 160
APERTURE: f/8
SHUTTER SPEED: 1/250 sec
LIGHT CONDITIONS: Natural, sunny

Polly Borland: Offbeat reportage

Interview

AS: What was your first ever camera?

PB: A Nikon SLR with fixed 50mm lens, followed by a 35mm lens. It was my father's. I remember using it during my final school year, so I would have been 17.

AS: Where do your ideas for innovative pictures come from?

PB: My imagination, and life experiences. I like to be aware of the things that surround me: art, paintings, movies. I've been inspired by Technicolor movies, such as *The Wizard of Oz*, and the photographers Larry Clarke, Diane Arbus, and Weegee, whose real name is Arthur Fellig.

AS: Why did you decide not to do other types of photography, such as sports or nature work, for example?

PB: People are my main interest and I'm quite figurative in my approach to life. Although I've photographed landscapes, sport is not an interest of mine. For me, photography is not a straightforward recording, but a tool for expressing individual ideas.

AS: Is it fair to say, like many successful photographers, that you had a "lucky break" at some stage?

PB: No. I've done things through sheer hard work. I left Australia in 1989 and when I came to London it took me about three years to earn a break. I knocked on doors; tried to get appointments to meet people, sent out my portfolio. I was waitressing to make ends meet. I hated it. The first commission that really set me off was offered by the then picture editor of *The Independent on Sunday* magazine, Victoria Lukens. I photographed a couple who were married in the Chelsea Register Office, and, because I tried to be visually innovative, my work became identifiable with the magazine.

AS: Do you shoot what you want or do others generally define what's required of you?

PB: I've always done what I wanted and this hasn't changed. I'm employed for my creative approach to image-making. If I'm doing an advertising shoot, it's a bit more organized, with a brief, but I've only ever done one advertising job, for More 4 in Iraq, called *Iraq: The Bloody Circus*. Advertising is not something I want to evolve into.

AS: Where are you mostly based, and where are your most popular locations?

PB: I am living temporarily in Pittsburgh, USA, though my home is in Brighton, UK. I work where I find subjects that matter to me. My photography is becoming more personal, rather than commissioned. I also base myself where I can produce work for gallery exhibitions.

AS: Which types of places do you like to photograph in the most, and why?

PB: Places don't matter, people do. Generally, I like to shoot in places that are quite plain, usually interiors, although these photos for *The Proposition* were done outside. I prefer an environment in which I have control, and it's easier inside because it's more difficult to control light outdoors. I would rather use flash, or artificial light, than natural light.

AS: What things do you enjoy most about your job?

PB: Meeting people, the process of shooting, seeing the final product.

Ray Winstone and Emily Watson
I photographed Ray Winstone and Emily Watson between takes, bouncing artificial light and using available, natural light. I asked them to pose in a formal way, even though Ray had just been tortured and Emily assaulted in the last take! I thought it would make an interesting picture. I rated and exposed the film normally, but pushed it three stops.

CAMERA: Mamiya 7
LENS: 65mm
FILM: Fujifilm Pro color negative 400
APERTURE: f/8
SHUTTER SPEED: 1/60 sec
LIGHT CONDITIONS: Natural, artificial

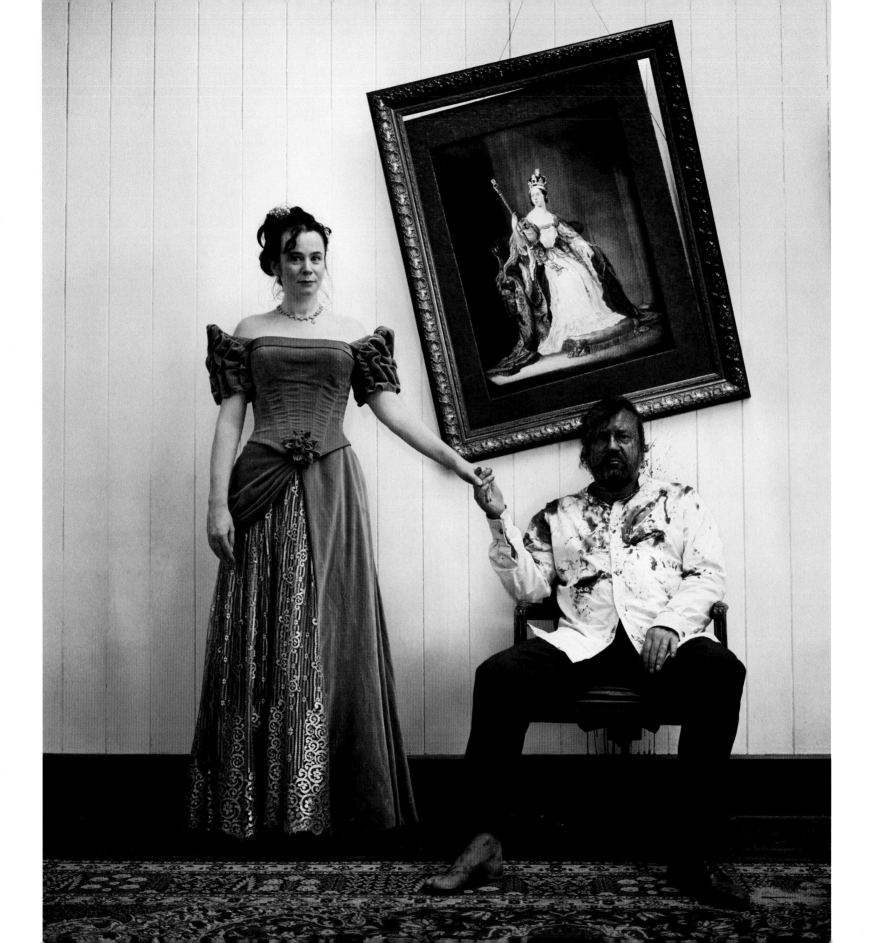

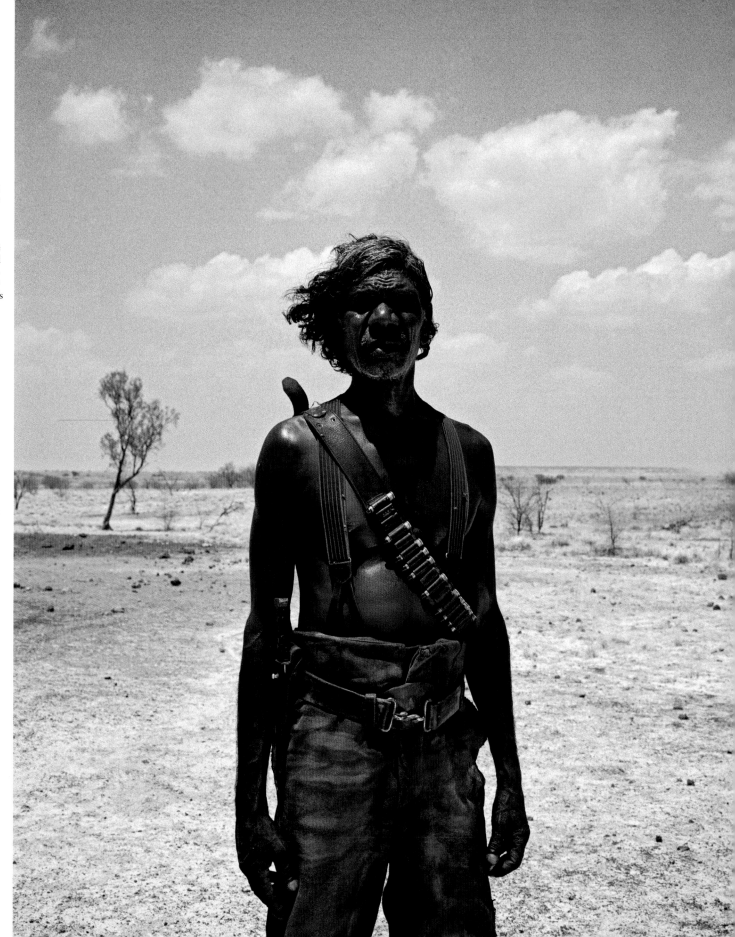

Right: **David Gulpilil**
This series of photographs was shot in Queensland's outback, in and around a town called Winton. I was working on the movie *The Proposition*, and this shot is of one of Australia's most famous actors, David Gulpilil. Because of the heat—it was 40–50°C—I exposed the film as normal and then pushed it three stops, to enhance the sun-baked feel of the harsh climate. I used a 65mm lens, which has a slightly wider angle, to capture the clouds and create a sense of scale.

CAMERA: Mamiya 7
LENS: 65mm
FILM: Fujifilm Pro color negative 160
APERTURE: f/22
SHUTTER SPEED: 1/500 sec
LIGHT CONDITIONS: Natural, sunny

Far right: **Richard Wilson**
It was at the end of a long day and light was fading, so I decided to use a fast film—400—to capture enough light and bring out the detail of blood on actor Richard Wilson's body. I actually shot the picture handheld with a 1/15 sec shutter speed, pushing it three stops, and I wasn't sure if it would be sharp enough. But it turned out just how I had envisaged.

CAMERA: Mamiya 7
LENS: 65mm
FILM: Fujifilm Pro color negative 400
APERTURE: f/5.6
SHUTTER SPEED: 1/15 sec
LIGHT CONDITIONS: Natural, fading daylight

AS: From a technical aspect, what are the most difficult things about your photography?

PB: I'm neurotic about sharpness. I wear glasses and sometimes it's difficult for me to test the sharpness of an image with my eyes. When I work in low light I use a tripod, but I prefer to shoot without one.

AS: How would you describe your personal style or technique?

PB: Bold, graphic, and colorful. Quirky. It's a little bit offbeat.

AS: What's in your kit bag? Which camera system do you use and why?

PB: A Pentax 6 × 7 film camera—it's about eight years old— with 75mm "prime" lens and 105mm "macro" lens. With this system I use two Bowens 500kW studio light heads, with softbox. I sometimes hire extra lights when I go abroad, or if I need higher power. I've also got a Mamiya 7 with 65 and 80mm lenses. For 35mm photography I use a Nikon FM2, with Nikkor 35, 50, and 55mm lenses, and a Vivitar flash, which I attach to the hotshoe. The type of film I use is vital and I always rely on Fujifilm Pro for 35mm and 120-roll film photography. Speed is either 400 or 160. I also own a Manfrotto tripod and a Leica Minilux zoom compact camera.

AS: Do you try to make sure your work appeals to the widest possible audience?

PB: No. I only think about what I like. It's just from my eye. I've always worked this way. When I'm looking through the camera I know what looks good and what doesn't. It's instinctive, you know.

AS: When are the busiest times of the year for you?

PB: There aren't any. I used to be busy all the time, but I've taken myself out of the editorial game. I only do special projects that interest me.

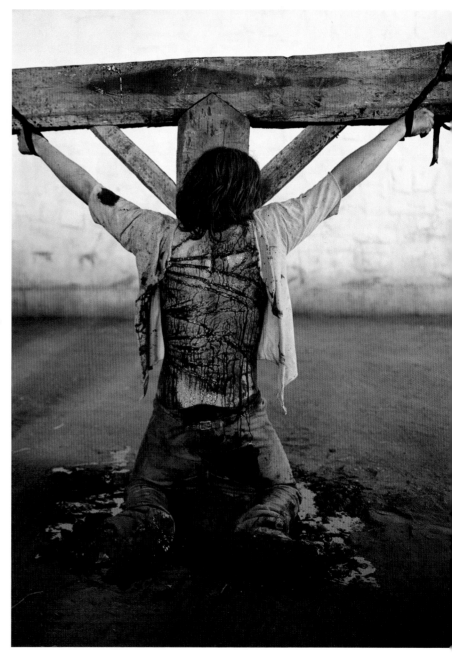

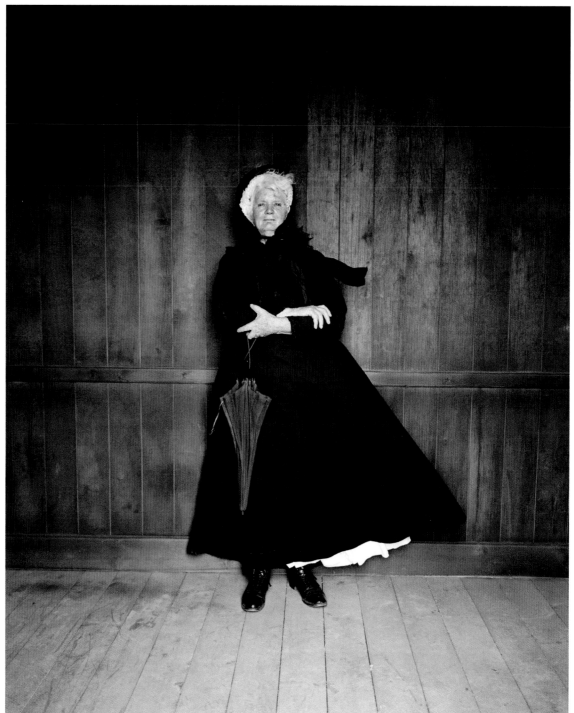

Proposition extra
The lady in this picture was an extra found living in the town of Winton. I used my 65mm lens and exposed at 1/60 sec to capture the area of natural light surrounding her. It was very windy outside, blowing into the room, which enhanced the picture by blowing her skirt to one side. Again I pushed the film—this time rated at 400—about three stops, to keep the feel of the photo in line with the others in *The Proposition* series.

CAMERA: Mamiya 7
LENS: 65mm
FILM: Fujifilm Pro color negative 400
APERTURE: f/16
SHUTTER SPEED: 1/60 sec
LIGHT CONDITIONS: Natural, sunny

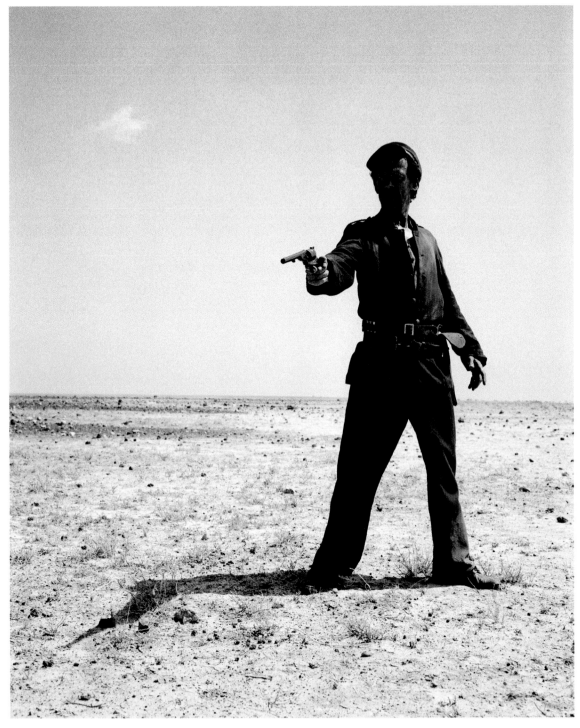

Iain Gardiner
This was shot using midday light. It's not my favorite light as it's very, very harsh and top-heavy, but it lends itself to the harsh reality of the environment, keeping with the style of the movie set.

CAMERA: Mamiya 7
LENS: 80mm
FILM: Fujifilm Pro color negative 160
APERTURE: f/22
SHUTTER SPEED: 1/500 sec
LIGHT CONDITIONS: Natural, sunny

AS: Which places or things do you dislike photographing the most?

PB: Business people—those who live to make money. People in gray suits who like big cars don't interest me aesthetically, ideologically, or financially. My motivation has never been money. I did once photograph Donald Trump, but there was more going on than straight business. People are my motivation. I've photographed more everyday than famous people. But I'm interested in fame and power, and how they affect people.

AS: What types of pictures do you find most difficult to take?

PB: Bright sunshine poses the most difficulty, because I can't control the light. Tuning yourself to treat each and every person the same can also be difficult: the photographer's skill lies in concentrating on any given person they're photographing, at any given time. It shouldn't matter whether they're famous or not.

AS: Which do you prefer, digital or film, and why?

PB: I don't own a digital camera, and I don't see the need for digital. I'm not a commercial photographer who needs to work fast. I like the organic and physical nature of film. I like the results, too, because they're less sterile.

AS: How much of your work do you manipulate using imaging software?

PB: I don't use imaging software, although I work closely with my lab. Sometimes there is retouching to be done, such as softening someone's facial lines, but it's not usual practice. Photography should record what's in front of the lens and not be created by a computer.

AS: What do you consider your greatest photographic achievements to date?

PB: My series *The Babies*, which took me about seven years to complete. My 2000 exhibition of 56 portraits of significant Australians who have made a contribution to British life. Being invited to photograph the Queen in 2001 at Buckingham Palace.

AS: What does the future hold for you?

PB: I have a young child who takes up a lot of my time at the moment. Photographically, I want to continue with exhibitions of my personal projects, and to work on children's books, with photos and illustrations.

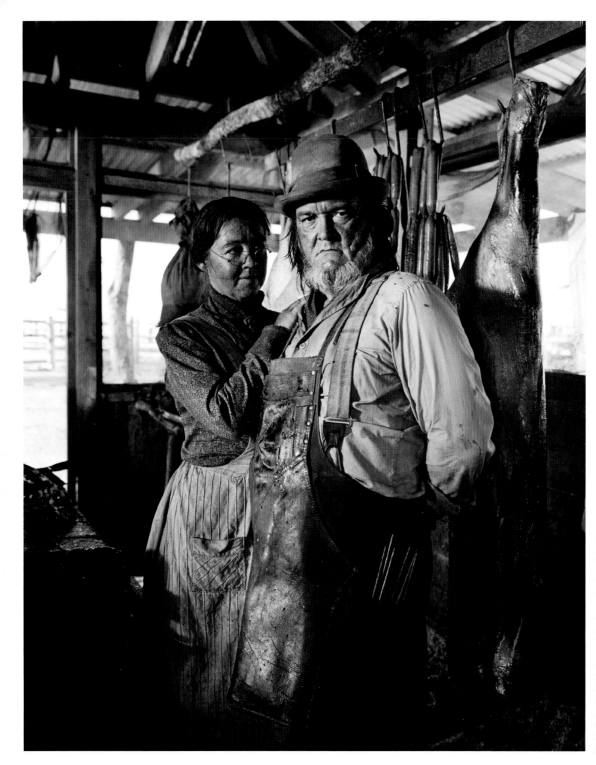

Winton's butcher and his wife
I took this shot of Winton's butcher and his wife by pushing the film slightly to maintain the consistency across the portraits. Shooting on 160 color negative film, with a reciprocation of f/16 at 1/60 sec, enabled me to do this.

CAMERA: Mamiya 7
LENS: 65mm
FILM: Fujifilm Pro color negative 160
APERTURE: f/16
SHUTTER SPEED: 1/60 sec
LIGHT CONDITIONS: Natural, sunny

Tips for Success

1. Research your subject

Before embarking on your shoot, find out as much about the person you are going to be photographing as possible. This will help you to bring out their personality when the time comes.

2. Get the basics right first

Always shoot what you know is going to work before experimenting with different angles, lighting, and film.

3. Use your personality

Be friendly when photographing people; make them feel relaxed. This will help you gain their trust and draw out their true characteristics.

4. Keep it simple

Try not to get too complicated with setups and lighting. Simplicity—which is very important for portraiture—enables you to concentrate on your subject.

5. Build a good relationship with a lab

For good results, it's vital that your processing lab understands what you need from them. Most of what I've learnt has been from printers, and they can usually make my mistakes look good—if they themselves are good at what they do.

6. Be persistent

If you love photography you'll never give up. It took me three years in England to get my first proper break, and I only managed it through sheer diligence.

7. Develop your own style

People employ photographers, especially in the portrait field, because of their individuality and style. Work out what you do best aesthetically—follow your instincts.

8. Be creative

For some, approaching a shoot in a formulaic manner works. Not for me, however, as nearly all of my best results come from a spontaneous approach. I like to create and feel my way through a shoot.

9. Experiment with film

It may be a dying industry, but I recommend you to try film—it's more textural and has an organic feel that digital cannot match.

10. Don't use cluttered backgrounds

It's the person you're concentrating on, not the background. Less clutter and distraction will draw out your subject's features and personality.

Danny Huston
The light here is absolutely beautiful, taken shortly after dawn. I asked Italian-born actor Danny Huston to stand on this rock, in full character dress. I decided to "push" the 400 film and shoot with an aperture of f/22, to capture as much sharpness as possible.

Essential Equipment

- Mamiya 7 medium format camera body

- Mamiya lenses ranging from 65 to 80mm

- Pentax 67 medium format camera body

- Pentax lenses ranging from 75mm to 105mm

- Nikon FM2 35mm camera body

- Nikkor lenses ranging from 35 to 55mm

- Fujifilm Pro 35mm and 120-roll film

- Bowens 500kW studio lights

- Softbox

- Vivitar flashgun

- Manfrotto tripod

Specification

CAMERA: Mamiya 7

LENS: 80mm

FILM: Fujifilm Pro color negative 400

APERTURE: f/22

SHUTTER SPEED: 1/60 sec

LIGHT CONDITIONS: Natural, sunny

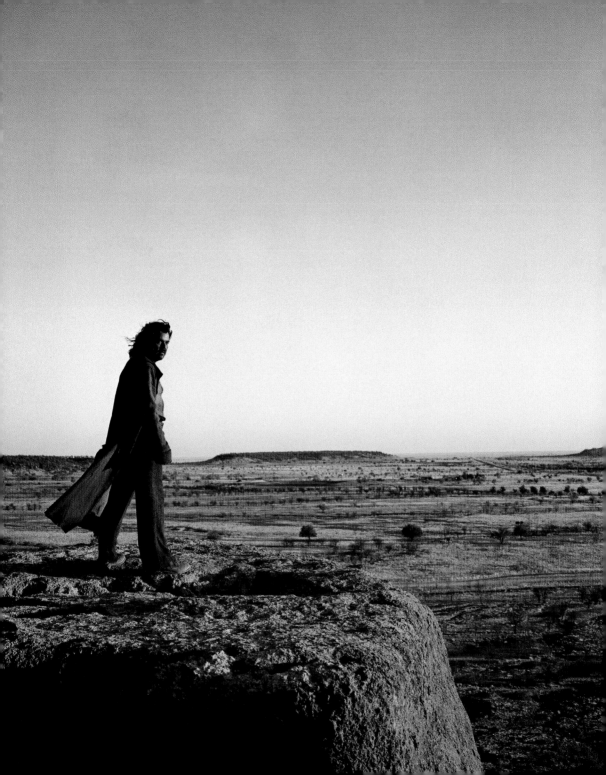

Immediacy is key

Sheila Burnett's taste in classical music is almost as eclectic as her taste in photography. "I like Bill Brandt and Jacques Henri Lartigue," she says enthusiastically. "And Cartier-Bresson. I completely respond to this type of photography." Birmingham-born Burnett came to London for "adventure and excitement" in the late 1960s after finishing art school, and soon after landed a job as an illustrator with Fleet Street giant *The Sun*. She worked at the newspaper for four years before joining the Pip Simmons Theatre Group as a stage performer, in 1974, and it was here that her interest in theater photography emerged. Her commissions have reached the very highest echelons of stage photography and include the prestigious Shakespeare's Globe and National Theatre in London, and the Birmingham Repertory Theatre. Over the years she has also taken portraits of many household names, including Ewan McGregor, Joan Collins, and Ike Turner.

Madame Butterfly, **Royal Albert Hall, London**
The Royal Albert Hall is a huge building with many excellent viewing opportunities. I took this shot right at the front of the hall, as many of my others were taken above the massive organ, or from seating boxes. I had to work quickly to capture the entire event from all angles and this particular shot seemed to stand out.

CAMERA: Canon EOS 5D
LENS: 135mm
ISO: 800
APERTURE: f/5.6
SHUTTER SPEED: 1/60 sec
LIGHT CONDITIONS: Artificial

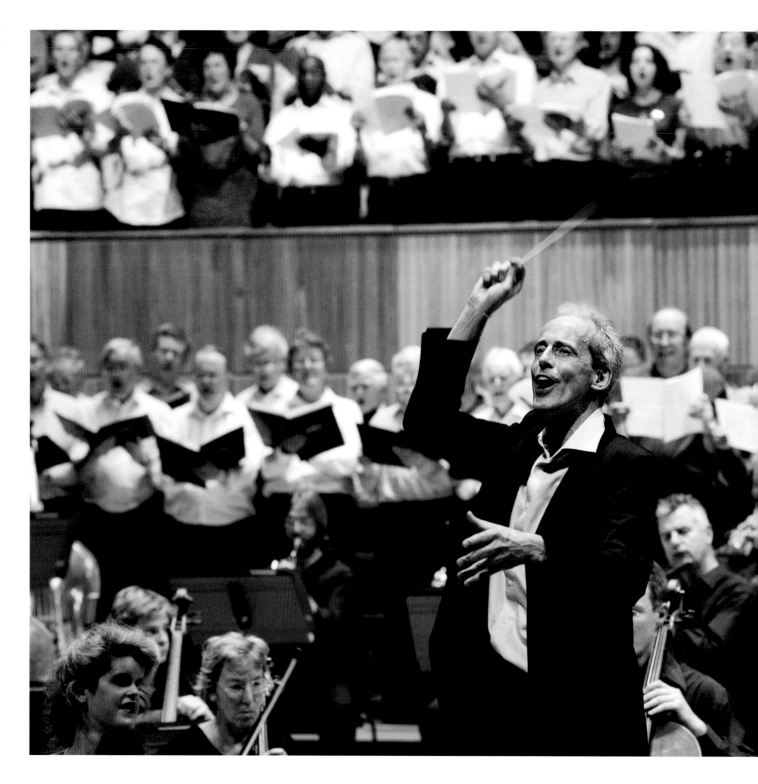

Paul Daniel, Royal Festival Hall, London
Beethoven's Symphony No. 9, conducted by Paul Daniel, was the first piece of music played in the new auditorium at the Royal Festival Hall, following a two-year refurbishment. It was packed. I wanted a full view of the musicians, choirs, and performers. I needed to get front-of-stage pictures, too, and I took this shot with my 135mm lens. It wasn't the ideal focal length—I was aching to have a lens that could get in closer, but the shot turned out fine.

CAMERA: Canon EOS 5D
LENS: 135mm
ISO: 800
APERTURE: f/5.6
SHUTTER SPEED: 1/60 sec
LIGHT CONDITIONS: Artificial

AS: What was your first ever camera?

SB: A Konica 35mm film SLR.

AS: Where do your ideas for innovative pictures come from?

SB: On a good day inspiration is provided from everywhere. If the light is good—outside as well as inside—the photographs have a better chance of success.

AS: Why did you decide not to do other types of photography, such as sports or nature work, for example?

SB: I studied at art school, not photography school. Art and theater are very closely connected. I became a stage performer for eight years, which led to becoming a theatrical photographer. You might say it was an automatic transition. I've never had the desire to take photographs of nature or sport.

AS: Is it fair to say, like many successful photographers, that you had a "lucky break" at some stage?

SB: I've worked hard to establish myself in a competitive environment. I did, however, finish second in a photography competition a few years ago, and doing so introduced me to the big establishments on London's South Bank, such as the Royal Festival Hall, and the Queen Elizabeth Hall. I got involved with the region and I have been offered many theatrical commissions since.

AS: Do you shoot what you want or do others generally define what's required of you?

SB: It depends on the job. Some theater commissions are very directed and when I turn up everything is ready to shoot. But other jobs are more innovative and less directed; the Tate Modern performances, for example, are very conceptual and I never know what's going to happen. As a photographer, this situation raises my awareness and puts me in a highly tuned state of mind. I adapt to the circumstances.

AS: Where are you mostly based, and where are your most popular locations?

SB: Mostly in London, both at my home—where I have a portrait studio—and in performance spaces which, in addition to the ones already mentioned, include the Hayward Gallery, Royal Albert Hall, and Shakespeare's Globe. I have also worked at the Theatre Royal, in Newcastle; the Royal Exchange Theatre, in Manchester; and the Birmingham Hippodrome, among others.

AS: Which types of places do you like to photograph in the most? Why?

SB: I've worked on many projects at the Royal Albert Hall. It feels good to be surrounded by art and history. Recently I was given the keys to the Royal Box, to photograph a fashion show. I was sitting where Queen Victoria once sat and I felt very privileged to be there. It was, and still is, a very special feeling.

AS: What things do you enjoy most about your job?

SB: I wake most mornings knowing I will be doing something that pleases me.

AS: From a technical aspect, what are the most difficult things about your photography?

SB: I'm innumerate, which for a photographer is not great! Anything that involves calculation I find very difficult, and it's one of the reasons why I often use my camera in shutter priority mode, set to a shutter speed of around 1/120 sec. Light is difficult. I'm used to stage lighting, but my cameras respond to red or orange light with difficultly—no matter how good it looks to the naked eye.

AS: How would you describe your personal style or technique?

SB: Reportage—recording the things I see. I prefer immediacy, rather than having a more technical, considered approach.

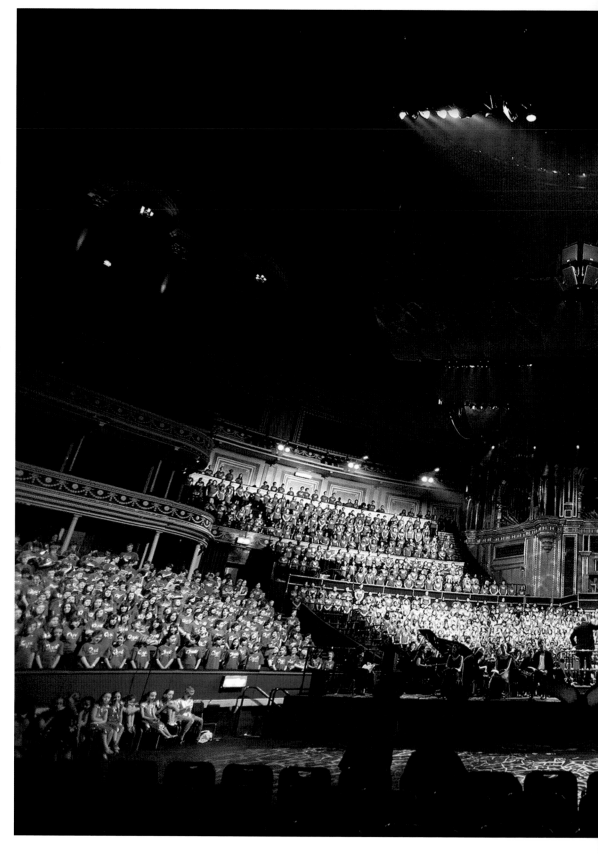

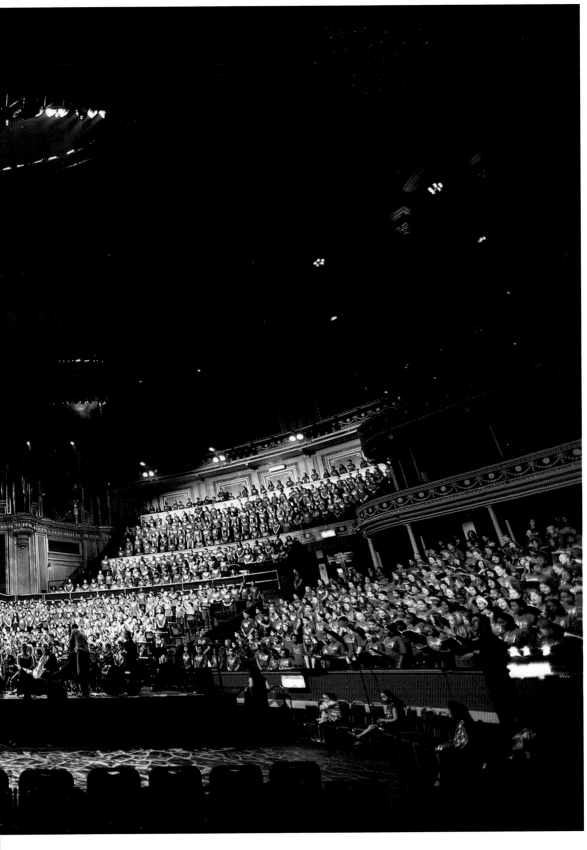

Ocean World, Royal Albert Hall, London

This photo is of 1,500 children performing with the English Chamber Orchestra, and students from the Royal College of Music. It was quite an easy shot to take because I had the sturdiness of the chairs to give support. Importantly, I had time to set the bracketing function on my camera, and I also had time to try different lenses. I was able to position myself at the back of the auditorium, to record the full sweep of the stage. The image was slightly sharpened later in Photoshop.

CAMERA: Canon EOS 5D
LENS: 24–70mm
ISO: 800
APERTURE: f/5.6
SHUTTER SPEED: 1/60 sec
LIGHT CONDITIONS: Artificial

AS: What's in your kit bag? Which camera system do you use and why?

SB: I have small hands, so I prefer smaller camera bodies such as the Canon EOS 5D. I own two. I have three favorite lenses, including a 135mm f/2, because it can cover just about any auditorium. I also use it for all portraiture—it's my "desert island lens." I also have a 16–35mm f/2.8, because it's fast, small, and accurate, and a 24–70mm f/2.8, which is good for theater work, because its focal range is wide and it can get close to the action. I always take four 2GB CF cards, so that I have enough space, and I occasionally carry a Canon 430EX flashgun. Before I switched to digital capture I used a Canon EOS analogue camera, and I still use most of the lenses I purchased with that system.

AS: Do you try to make sure your work appeals to the widest possible audience?

SB: I try to please my clients, but I also have to be happy with the results. I have to be aware not just of the aesthetics of an image, but also its requirements for press, marketing, and archiving.

Henry IV, **Original Theatre Company, London**
The audience moved with the action, in what is known as a "promenade," during this performance of *Henry IV*. The light was low, but good, enabling plenty of picture detail. I rarely see a run-through of any play and this was no exception. The idea was for me to follow the action and keep out of everyone's way. It wasn't the easiest performance to capture because of the difficulty cameras have recording red light, and having to predict where the actors would go. I didn't use a tripod, but relied on light on walls, doors, and chairs to make slow shutter speeds possible.

CAMERA: Canon EOS 5D
LENS: 16–35mm
ISO: 800
APERTURE: f/2.8
SHUTTER SPEED: 1/60 sec
LIGHT CONDITIONS: Artificial

Children of Hercules,
The Scoop, London
Theatrical performances
outdoors can be tricky, but
if you have good lighting, as
with this performance, you can
get away with it. I was able to
get in close with a 24–70mm
lens. I stayed for the whole play
to get shots of the audience under
the night sky, with Tower Bridge
in the background.

CAMERA: Canon EOS 5D
LENS: 24–70mm
ISO: 800
APERTURE: f/5.6
SHUTTER SPEED: 1/60 sec
LIGHT CONDITIONS: Artificial,
night

AS: When are the busiest times of the year for you?

SB: There's a book called *Spotlight* which all leading performers and actors appear in. Because I take portraits of many actors, and because the deadline for publication is April and November for women and men, respectively, I am often busy at these times.

AS: Which places or things do you dislike photographing the most?

SB: I don't like being in a place which forces me to use flash. Dark auditoriums or dull rooms with fluorescent lights make good photography almost impossible.

AS: What types of pictures do you find the most difficult to take?

SB: Organized group shots.

AS: Which do you prefer, digital or film, and why?

SB: Having made the move to digital, it's like a blindfold has been taken off. I had always developed my photos in my own darkroom, so for me editing digitally means it's an altogether easier process.

Daisy Lewis, home studio, London
With all routine photo sessions in my home, I like to think it works both ways—it's not up to photographer or sitter, it's a joint effort to get the right results. I always suggest a 10-minute warm-up, however, so I can establish who is camera-shy. Daisy was completely relaxed in front of the camera.

CAMERA: Canon EOS 3
LENS: 135mm
ISO: 400 (set to 200)
APERTURE: f/8
SHUTTER SPEED: 1/125 sec
LIGHT CONDITIONS: Tungsten and daylight

Ewan McGregor, Hampstead Theatre, London
When an actor of Ewan McGregor's caliber is the subject, you can expect a full press turnout, and this was no exception. During the photo-call, play scenes for *Little Malcolm* were run through specifically for photographers. Ewan was incredibly generous, re-doing scenes as many times as we needed. I used this shot because it was close up, with Ewan looking into my lens. When I printed the photo I "dodged" all background distractions out of shot.

CAMERA: Canon EOS 3
LENS: 135mm
ISO: 400 (set to 800)
APERTURE: f/5.6
SHUTTER SPEED: 1/60 sec
LIGHT CONDITIONS: Artificial, ambient

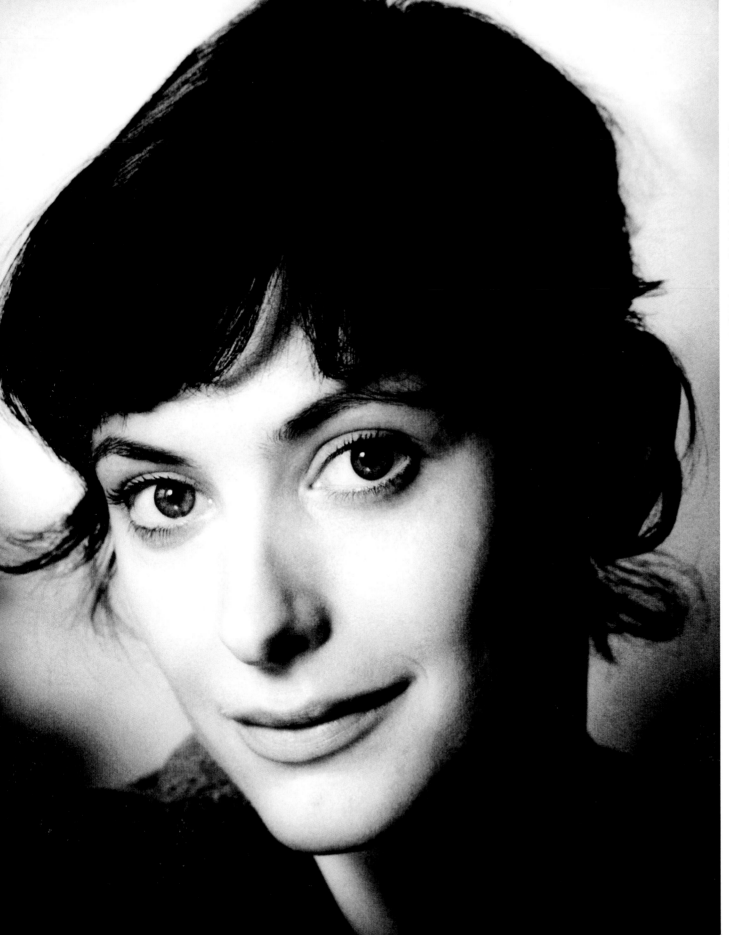

Celia Henebury, home studio, London
I always use a combination of tungsten and daylight when I photograph portraits in my home studio. Some subjects need coaxing, for which I have to be quite patient. It's a relief to have a subject like Celia Henebury, who was very much herself in front of the camera. Without realizing it, she lent a great deal to the picture.

CAMERA: Canon EOS 3
LENS: 135mm
ISO: 400 (set to 200)
APERTURE: f/8
SHUTTER SPEED: 1/125 sec
LIGHT CONDITIONS: Tungsten and daylight

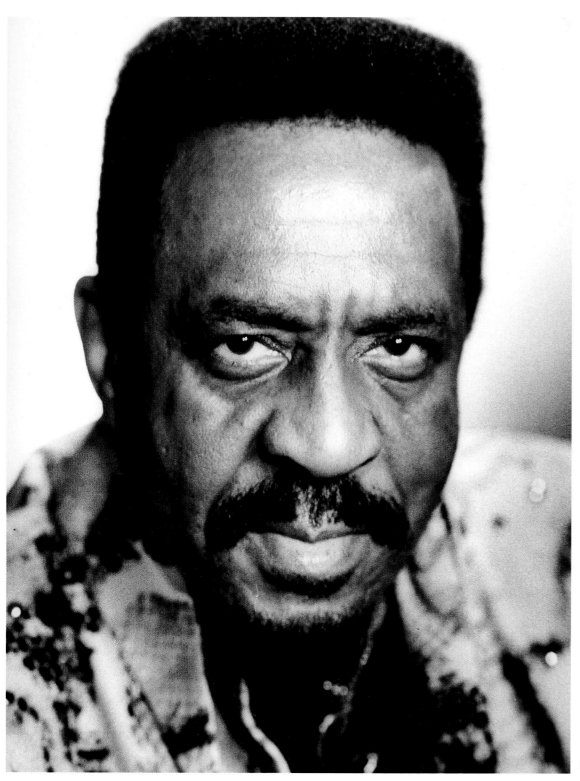

AS: How much of your work do you manipulate using imaging software?

SB: Cleaning up, tidying up. That's all. I like Photoshop CS and I mainly use the Clone Stamp and Brush Tool. The Lasso Tool is also useful. But I don't do major surgery.

AS: What do you consider your greatest photographic achievements to date?

SB: To have remained gainfully employed for almost 20 years.

AS: What does the future hold for you?

SB: I haven't got a clue! I'm satisfied—to a certain extent—and that's why I'm continually motivated to achieve more.

Ike Turner, home studio, London
The producers of a blues music magazine phoned to say they were sending a singer called Ikareus. I had only 20 minutes with him, as he had a flight to catch. When he arrived I made him a cup of tea and we chatted in the kitchen. He pointed to my Elvis fridge magnet, saying that he had worked with him. I didn't believe him until later. It was clear Ikareus was something very special—he had huge charisma and charm and he was very easy to photograph.

On this occasion the client needed the transparency film quickly, and I managed to take a few quick shots for myself in black-and-white. On his way out I asked him about his unusual name and he said, "I'm better known as Ike Turner."

CAMERA: Canon EOS 3
LENS: 135mm
ISO: 400 (set to 200)
APERTURE: f/8
SHUTTER SPEED: 1/125 sec
LIGHT CONDITIONS: Tungsten and daylight

Sheila Burnett: Immediacy is key

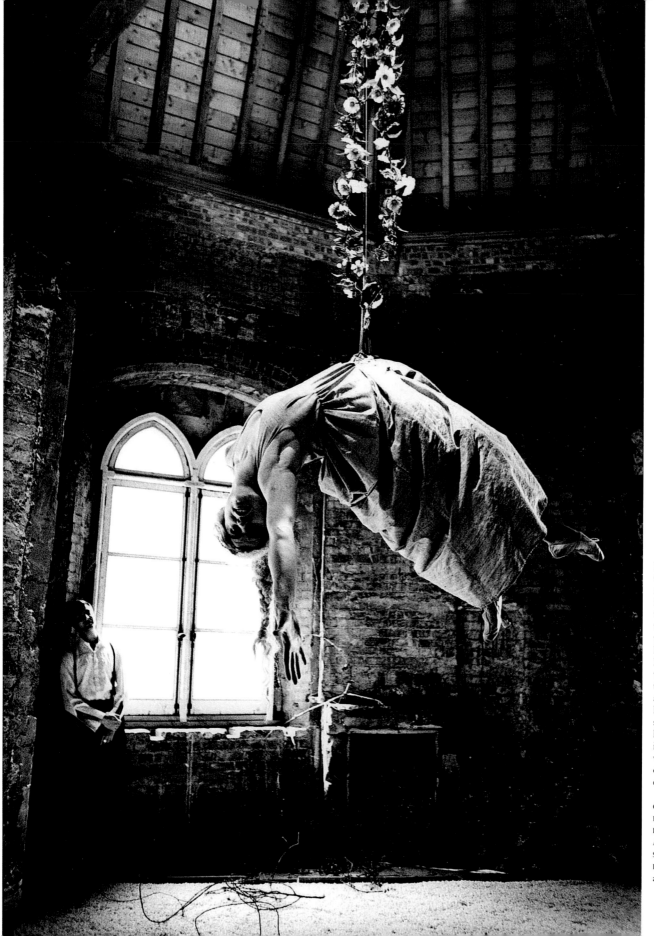

**Hanging Lady, Old Midlands
Grand Hotel, London**

A site-specific event such as this
is a theater-based one in which
the building is as important as
the performance. This young girl
was able to hang from her metal
hook for only a few minutes,
long enough for the audience to
walk through the room. I wanted
the shot without capturing the
audience, so I asked if she would
hang for an extra minute, which
she was happy to do. The natural
light makes this an arresting
image. All details of brick and
wood are picked out, and the
overwhelming smell of damp
enhanced the mood.

CAMERA: Canon EOS 3
LENS: 16–35mm
ISO: 400 (set to 800)
APERTURE: f/5.6
SHUTTER SPEED: 1/125 sec
LIGHT CONDITIONS: Artificial,
ambient

Tips for Success

1. Talk to people
Whenever I have someone visit my studio for a session, I make them a drink and have a chat before starting work.

2. Make sure your clients are relaxed
There's a simple way of doing this—I always play music and it has to be Mozart.

3. Be aware of the light
When using theater light or sunlight, try to position your subjects with tungsten light or the sun behind them. If you position yourself carefully you can get a halo effect and the quality of light on skin is very effective.

4. Make friends with the lighting designer
When shooting in-theater, I try to shoot from the sides as an alternative to face-on, as I can get good results from side lights. It's not a bad idea to make friends with lighting designers, too, as their work is important to the production and it will dictate the quality of your photographs. They also give me an idea of the sort of light setup I can expect.

5. Be level with the actors
When shooting a proscenium stage, I arrange with the stage manager to find me a ladder. It's good to be on the same level as the actors, eliminating unflattering shots from below, looking up.

6. Don't make assumptions
I never think a job is going to be easy, just because I've done it before. It doesn't pay to be too relaxed.

7. Always travel with two or more camera bodies
I never know what may go wrong, or whether I may require extra batteries or memory cards. I like to throw in a flashgun, too, just in case.

8. Use your leisure time
When I'm not working I travel with a small, compact camera. I never know what I might see, and if I don't have a camera I could miss something special. I use a Panasonic Lumix LX2, which has a Leica lens and RAW capture.

9. Stick to basic settings
I like to use basic settings, like shutter priority. I prefer to stick with what I know, so I can concentrate on what's happening. My Canon EOS 5D has a useful dial that enables me to capture one stop over-and-under exposure.

10. Invest in the best equipment you can afford
If you're planning theater photography as a career, always buy the best equipment you can. The lenses have to be fast, otherwise they can't cope with difficult light conditions. I started with just one really good lens—a Canon 24–70mm—and added to my

Rapunzel, Queen Elizabeth Hall, London
I attended a pre-performance photocall
for _Rapunzel_, during which the petals
were thrown in the air. Later, when
I took the production shots for the
actual performance, the moment with
the petals didn't work quite as well,
many of them refusing to float. It's
sometimes worth doing a photocall
before the actual performance—even
though you seldom get the spontaneity
and mood of the complete run-through.
A combination of the two is ideal.

Essential Equipment

- Two 35mm Canon EOS 5D
 camera bodies

- 24–70mm f/2.8 lens

- 70–200mm f/2.8 lens

- 135mm f/2.8 lens

- Lens hoods for all lenses

- Flashgun

- Tungsten lights (studio)

- Spare lithium-ion batteries

- Four 2GB CF cards

- Laptop computer

- Panasonic 35mm Lumix
 LX2 compact camera

Specification

CAMERA: Canon EOS 5D

LENS: 135mm

ISO: 800

APERTURE: f/8

SHUTTER SPEED: 1/125 sec

LIGHT CONDITIONS: Artificial

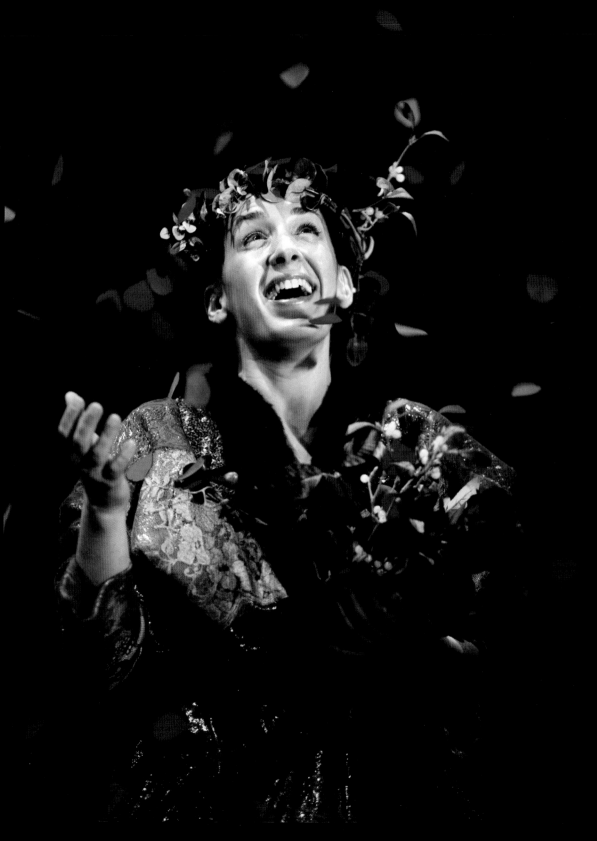

Sheila Burnett: Immediacy is key

James Cheadle

Editorial photographer

With a background as a magazine picture editor, James is very much at ease with the pressures he faces. "As someone who's commissioned photographers on a regular basis, I've got a good understanding of what the picture editor is going to want," he says. James began his career in 1990 as staff photographer at the *Bath Evening Chronicle*. His next permanent position was with EMAP Publications where he worked on *Total Sport* magazine.

Since 2000 James has been working as a highly successful freelancer and his career has gradually evolved to the point where he now undertakes international commissions for a host of different clients, specializing in celebrity portraiture and magazine features. He has photographed some of the world's most famous faces, and had work published in such publications as *USA Today*, *The Sunday Times*, and *Men's Health* magazine.

Boris Becker
I was in Milan where I was supposed to have a full half-hour session with Boris. With these types of shoots, however, time often becomes extremely precious, and instead I was allocated just three minutes. I fired off around 20 frames on a 35mm film camera and chose this photograph. I lit Boris from the left side, using a 3ft softbox to diffuse the light. He looked great in a suit, which made the picture.

CAMERA: Canon EOS 1N RS
LENS: 100mm
FILM: Fujifilm Velvia 50
APERTURE: f/8
SHUTTER SPEED: 1/250 sec
LIGHT CONDITIONS: Artificial (with softbox)

Robert Powell
I once read that when filming the 1977 movie *Jesus of Nazareth*, Robert had trained himself to not blink while in front of the camera, to give his eyes more presence. It certainly worked. During a close face shot I asked him to refrain from blinking, which he happily agreed to; the result was this striking glare.

CAMERA: Canon EOS 1Ds MKII
LENS: Lensbaby (c. 50mm)
ISO: 100
APERTURE: f/5.6
SHUTTER SPEED: 1/250 sec
LIGHT CONDITIONS: Artificial

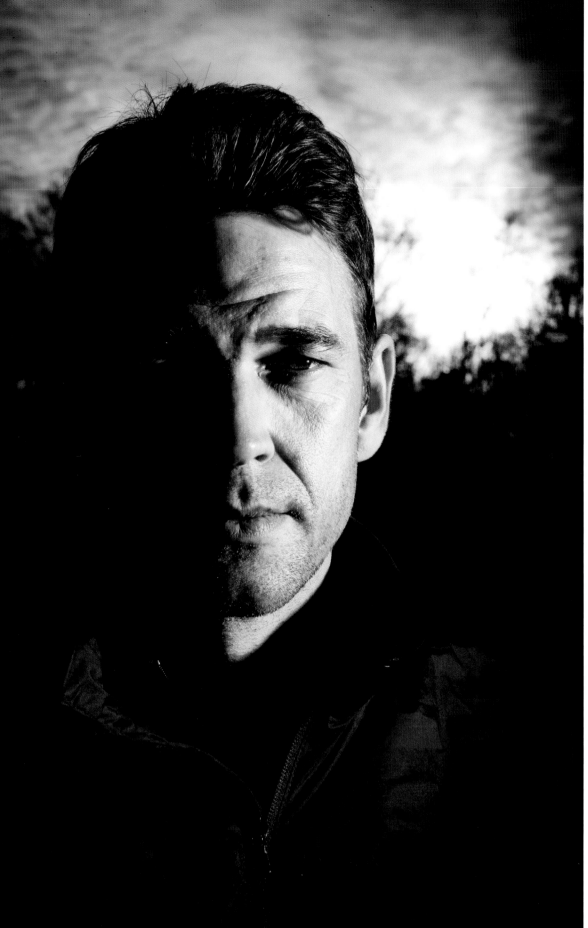

AS: What was your first ever camera?

JC: A fully manual, Pentax K1000 35mm film camera, with a standard 50mm lens. My dad would let me use it on our holidays in France, when I was about 13.

AS: Where do your ideas for innovative pictures come from?

JC: It's hard to say. I've always liked my portraits to be strongly lit, often with studio flash overriding available light. I also encourage eye contact in my photography. But I really couldn't say where I draw my influences from.

AS: Why did you decide not to do other types of photography, such as sports or nature work, for example?

JC: I started my career in newspapers, an industry in which one has to be a jack-of-all-trades to some extent. For this reason I've dabbled in different fields of photography. I still shoot sport, documentary, and automotive photography, but my passion is portraiture, and it has become the genre for which my work is renowned.

AS: Is it fair to say, like many successful photographers, that you had a "lucky break" at some stage?

JC: I haven't had one single moment I would say has been lucky. But I was fortunate to land three very useful staff positions in my twenties. First as a darkroom technician with the *Bath Evening Chronicle*, where I spent all week in the darkroom fastidiously producing black-and-white prints. I was let out of the dark on weekends to actually take photographs. I then worked for the nationals through a Southampton-based agency called Solent. This is where I really discovered my trade—shooting Premiership football, breaking news, and, of course, celebrity portraits. My final staff position was with publishing company EMAP, shooting for the now-deceased *Total Sport* magazine. I was flown around the world to shoot the world's biggest stars, from Becker to Beckham. After 10 years in full-time employment I had built enough contacts to freelance my skills.

Dougray Scott
Dougray Scott is a keen golfer, so for this shoot I met him on one of his favorite courses, early one January morning. We shot a number of different setups, but this frame stood out from the others. The sun popped out for five minutes and created the beautiful, dramatic sky.

CAMERA: Canon EOS 1Ds MKII
LENS: 28–70mm
ISO: 100
APERTURE: f/22
SHUTTER SPEED: 1/250 sec
LIGHT CONDITIONS: Artificial and natural

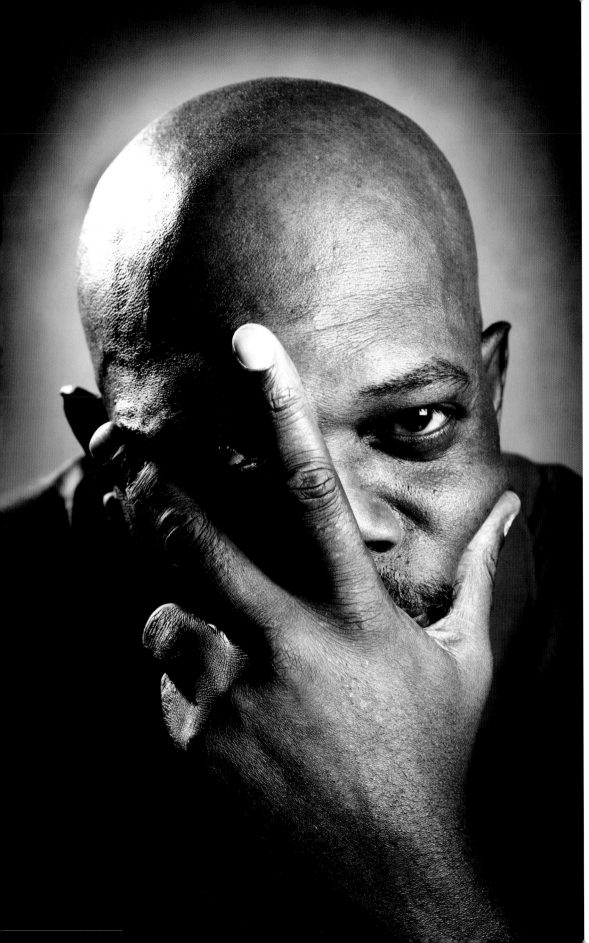

AS: Do you shoot what you want or do others generally define what's required of you?

JC: A bit of both. It's often impossible to know what I'm going to get; there's no brief other than to come back with a great set of shots. But from time to time a specific pose or expression is needed to suit an editorial angle. You can never really plan a portrait session with a celebrity, however. I seldom know what to expect.

AS: Where are you mostly based, and where are your most popular locations?

JC: I'm based in Bath, but professionally I rarely shoot in the same location twice, with the exception of Wentworth golf club—I must have shot around 30 professional golfers in this location throughout the past decade.

AS: Which types of places do you like to photograph in the most? Why?

JC: There's no specific type of place. I do, however, prefer any given location to be unusual. A great location can offer a massive head start to taking a great image, and vice versa—if you're stuck in a plain, magnolia hotel room you really have to dig deep to get the most out of your subject, to impress any picture editor.

AS: What things do you enjoy most about your job?

JC: I love the travel. My career has taken me to some of the most fantastic places on earth. I don't think I'll ever get bored with seeing new places. And I enjoy meeting the characters I photograph, of course!

Samuel L. Jackson
Sam is a keen golfer. This shoot took place at the world-famous Wentworth Club in Surrey, England. He was charming throughout the shoot. It was a real pleasure to be in his company, and this is one of the aspects of my job that I love. The session was actually split into three parts: some shots were taken on the course, some were taken on the roof terrace, and some in a tiny room just off the reception hall at the club-house. The last was used for this image. I took it in color, but later converted it to black-and-white, because it said more about his character.

CAMERA: Canon EOS 1Ds MKII
LENS: 70–200mm
ISO: 100
APERTURE: f/5.6
SHUTTER SPEED: 1/250 sec
LIGHT CONDITIONS: Artificial (with snoot and softbox)

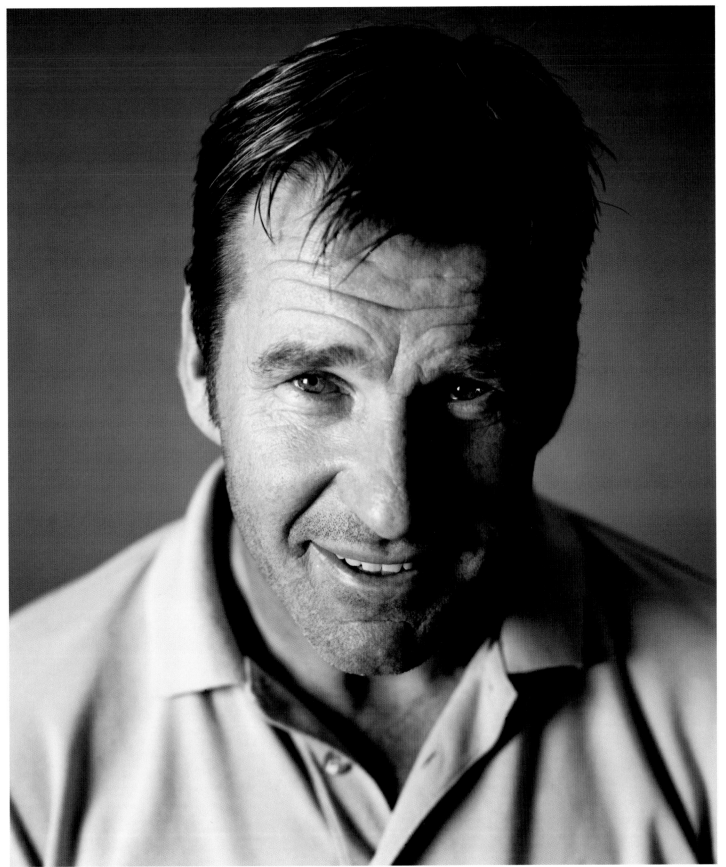

Nick Faldo
I was invited to Nick's home to photograph him. I'd shot Nick a number of times before, always in color, so I decided to capture him on monochrome film with a red background. I think it brings a warmth to him that's seldom seen. I used a spotlight to illuminate the background, with light head and softbox to his left, and reflector to his right side.

CAMERA: Mamiya RZ67
LENS: 110mm
FILM: Ilford HP5 400
APERTURE: f/5.6
SHUTTER SPEED: 1/200 sec
LIGHT CONDITIONS: Artificial (with softbox)

James Cheadle: Editorial photographer

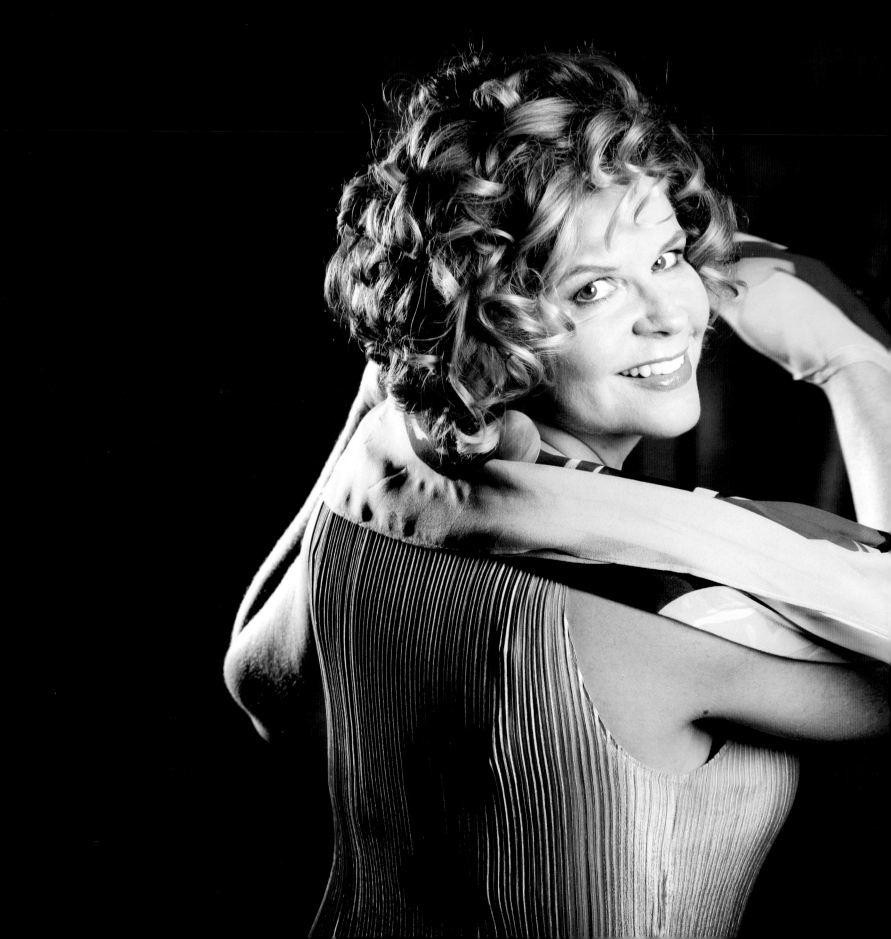

AS: From a technical aspect, what are the most difficult things about your photography?

JC: Every year my job gets more technical. Much of the uncertainty has been taken out of the job with the transition to digital capture, such as reducing the risk of losing pictures through backing up files. But it has brought its own set of difficulties. Sometimes I wish I didn't spend so much time glued to a computer, processing my shoots.

AS: How would you describe your personal style or technique?

JC: Bright and bold.

AS: What's in your kit bag? Which camera system do you use and why?

JC: I'm a Canon user and I carry two camera bodies: an EOS 1Ds MKIII and an EOS 1Ds MKII. My Canon lenses are a fast 16–35mm f/2.8, 24–105mm f/4, fixed 50mm f/2, and 70–200mm f/2.8. Other important pieces of kit are a Sigma 105mm f/2.8 lens, and three Canon Speedlite 580EX flashguns. I also use numerous Bowens and Hensel lights. Much of my portfolio is made up with pictures from my Mamiya RZ67 medium format camera, although I seldom use it nowadays.

Susan Graham
Susan is possibly one of my favorite subjects in recent memory. She was just so full of fun, knowing exactly what to do, and when to do it. This portrait was shot at the Berlin Philharmonic Hall, which added a sense of grandeur. Susan was captured using two Bowens studio light heads, with single grid back light, and softbox.

CAMERA: Canon EOS 1Ds MKII
LENS: 70–200mm
ISO: 100
APERTURE: f/5.6
SHUTTER SPEED: 1/200 sec
LIGHT CONDITIONS: Artificial
(with grid light and softbox)

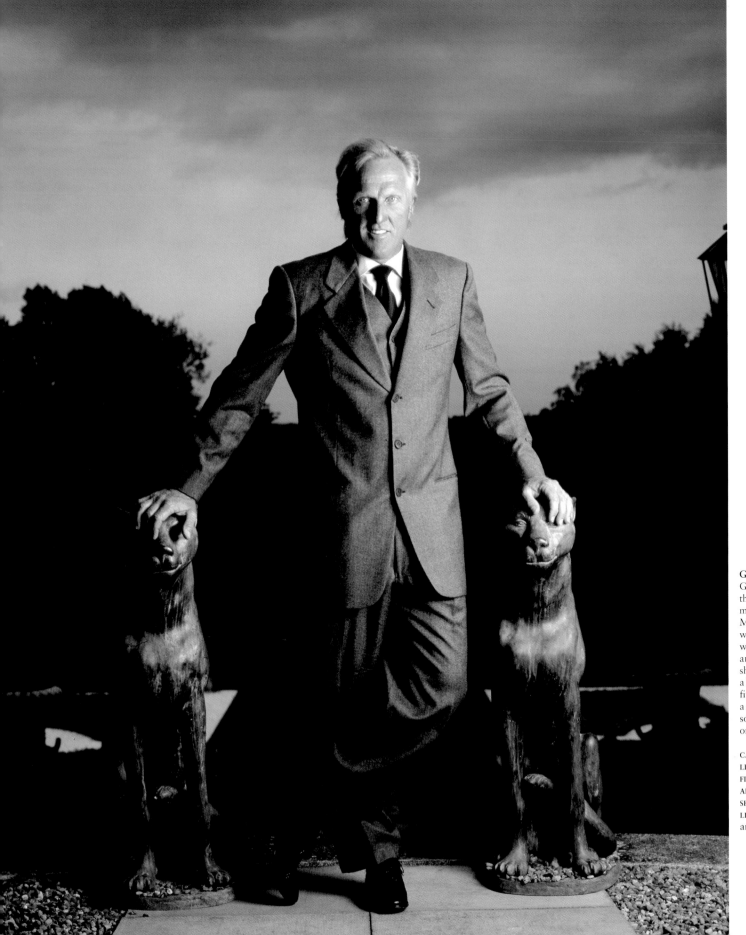

Greg Norman
Greg is a very busy man—all of the time. For this reason, when my assistant and I flew to Celtic Manor Golf Course in Ireland, we didn't expect to get long with the legendary golfer. We anticipated 15 minutes for the shoot; we were actually given a little over five. But we did get five minutes of Greg posing like a real pro in front of the camera, something he had clearly done on many occasions.

CAMERA: Mamiya RZ67
LENS: 110mm
FILM: Fujifilm Velvia 50
APERTURE: f/4
SHUTTER SPEED: 1/60 sec
LIGHT CONDITIONS: Artificial and natural

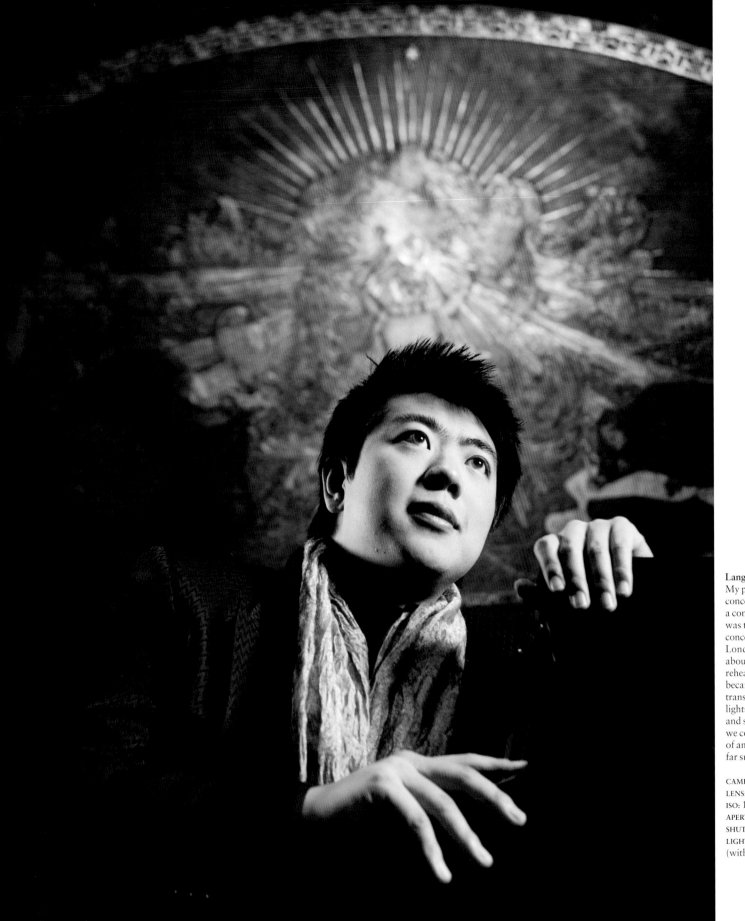

Lang Lang
My portrait of up-and-coming concert pianist Lang Lang, for a commission from the BBC, was taken at a small, classical concert hall off Oxford Street, London. After shooting for about an hour in a characterless rehearsal room, the main hall became free. In a mad dash we transported all the photographic lights downstairs into the hall, and set them up swiftly so that we could use the last quarter of an hour of the session in this far superior location.

CAMERA: Canon EOS 1Ds MKII
LENS: 28–70mm
ISO: 100
APERTURE: f/5.6
SHUTTER SPEED: 1/60 sec
LIGHT CONDITIONS: Artificial (with snoot and softbox)

AS: Do you try to make sure your work appeals to the widest possible audience?

JC: Not consciously. I always shoot the subject in a way I wasn't supposed to. It's the way I work. Moreover, the type of person the subject is has a strong influence on the way I photograph them. From time to time the client asks for a certain look, which, of course, is generally appealing to a wider audience.

AS: When are the busiest times of the year for you?

JC: There's no trend of consistency with how and when my commissions come in.

AS: Which places or things do you dislike photographing the most?

JC: I don't really have any dislikes. Every shoot has different challenges because I don't know what I'm going to get. For me, this is great—I'm seldom presented with that horrible feeling of having been there before, or of repeating myself.

AS: What types of pictures do you find the most difficult to take?

JC: Flat, gray skies can make a shoot difficult. And, while not wishing to name anyone, I've had a few celebrities who have tried their hardest to make things as difficult as possible during a shoot. It's rare, but this is the hardest thing to overcome. Impeccable manners and a smile—from me—usually help things to progress.

AS: Which do you prefer, digital or film, and why?

JC: I love both. I haven't been asked to shoot with film since 2005, which, in many ways, is a shame. Digital is great, however, and allows me to experiment in ways that are much harder with medium-format film. The digital postproduction process is more important now than ever before.

AS: How much of your work do you manipulate using imaging software?

JC: I simply correct basic levels in Photoshop, but on certain shoots I take the picture with knowledge of the things I'll do later in Photoshop, in my digital darkroom. For example, for the Michael Palin image, a lot was done in Photoshop after the picture was taken—even though it was shot on 6 × 7in film.

AS: What do you consider your greatest photographic achievements to date?

JC: It's an enormous achievement to make a decent living doing something I love. I look forward to starting work each Monday.

AS: What does the future hold for you?

JC: I don't know. My goals change every few years. I'm enjoying my work too much right now to think too hard about the future.

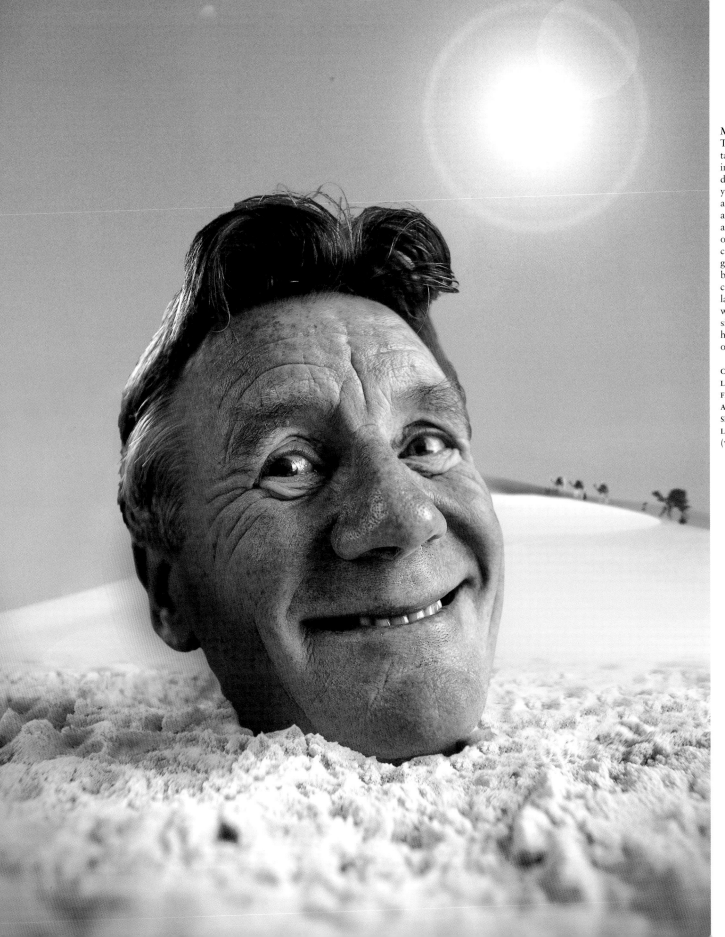

Michael Palin

This photograph was actually taken in Michael's agent's office in Covent Garden, London, during a hot summer day. As you may expect, Michael was an absolute star, prepared to do anything he was asked. We used an MDF board, with a hole cut out for Michael's head, and covered it in sand for the fore-ground. I shot it against a blue background, so the desert scene could be added in Photoshop later. One flash head was used, with softbox, to Michael's left side, and a cone was used behind his right ear, to bounce some of the light.

CAMERA: Mamiya RZ67
LENS: 55mm
FILM: Fujifilm Velvia 50
APERTURE: f/8
SHUTTER SPEED: 1/400 sec
LIGHT CONDITIONS: Artificial (with softbox)

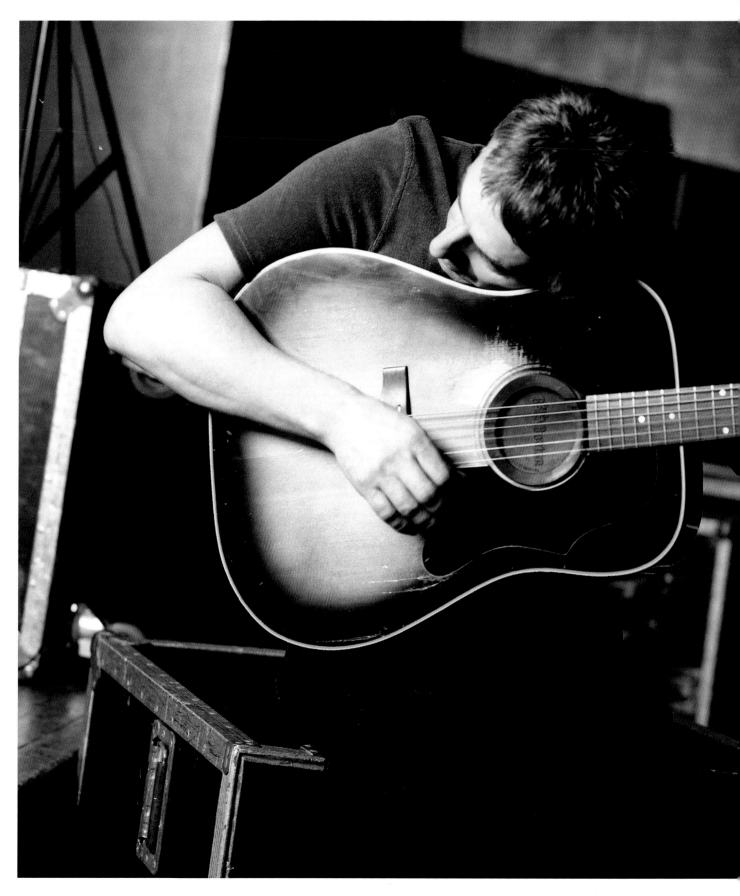

Paul Weller

I've always been a big fan of Paul and his music. I was pleased, therefore, when an offer to photograph him backstage at Colston Hall in Bristol came about. I spent 15 minutes shooting portraits on black-and-white Ilford film, against a white background. Paul then started tuning his old acoustic guitar. I quickly swung my Bowens light head around and, with diffused light through a small softbox, I fired off 10 frames from my Mamiya RZ67 medium-format camera.

CAMERA: Mamiya RZ67
LENS: 110mm
FILM: Ilford HP5 400
APERTURE: f/4
SHUTTER SPEED: 1/60 sec
LIGHT CONDITIONS: Artificial

Who Da Funk
I shot US musicians Who Da Funk in a bar in Manchester, England. The location didn't lend much to the shoot, so I decided to inject some action into the portrait. I had been toying with the idea of shooting Polaroids to use within a photo, and was just waiting for the right subjects to implement my plan. It worked, and added a new dimension to the picture. To get the correct exposure I diffused light through a softbox to the left of the subjects, using a large reflector to their right, and with spotlight on the drapes behind.

CAMERA: Mamiya RZ67
LENS: 110mm
FILM: Fujifilm Provia 100
APERTURE: f/8
SHUTTER SPEED: 1/60 sec
LIGHT CONDITIONS: Artificial

Tips for Success

1. Prepare for each shoot
Before each portrait session take a few frames, with an assistant as a model, to get everything as nailed down as possible. I always aim to be fully set up at least an hour before my subject is scheduled to arrive.

2. Think about the "safety" shots
Always have a couple of "safety" shots planned. It's good to experiment, of course, but things can go wrong—for all sorts of reasons.

3. Have equipment to hand
There is nothing more annoying for a subject than a photographer who's messing around looking for a certain lens. Celebrities are people with little time on their hands, so you have to be fully prepared.

4. Check everything works
Check and recheck that all of your gear is working. Shoots can be short so it's vital everything runs like clockwork. This should be done before you leave for the session so that you have time to identify and replace faulty pieces of kit if necessary.

5. Get to your location early
I always get to the location of a shoot two hours before my subject is due to arrive. This gives me time to scout for the best spots in order to get the best shots. Practice every frame to ensure the composition is correct.

6. Don't be afraid to try new ideas
Do tests on different aspects and compositions of the shoot—but only when you've got the basic pictures you need. Sometimes shoots can go over their allotted time, creating an ideal opportunity to try new techniques.

7. Consider using props
Sometimes simple props, such as a hat or cigar, can bring a portrait to life.

8. Look after your kit
Cleaning your digital SLR cameras' sensors regularly can save you hours of dust-spotting in Photoshop after a shoot. Look after your gear and it will look after you.

9. Buy the best you can afford
Buying cheap equipment really is a false economy. Buy the best you can afford: this will always enhance and improve your results.

10. Keep an eye on the skies
Use the sky to your advantage. Shooting into the sun on a cloudy day can produce some stunning effects, especially if you use artificial lights to illuminate your subject. Sunset and sunrise can be greatly exaggerated in this way by underexposing available light through adjusting your camera by two or three f-stops.

Zara Phillips

I shot this during a typically dull British December day, with virtually no available light. Despite this, Zara was great throughout the shoot, which helped immensely. It was so clear how comfortable she is around her horse, Toytown. It was also clear how used to being photographed Toytown was; my bright Hensel light head with softbox—to the left side of both subjects—did not seem to phase him at all. I use softboxes quite a lot in my photographs as they're very useful light accessories. This one was used just out of view of the camera, giving a lovely, soft, diffused illumination of Zara and Toytown.

Essential Equipment

- **Canon 35mm EOS 1Ds MKII and MKIII camera bodies**
- **16–35mm f/2.8 lens**
- **24–105mm f/4 lens**
- **50mm f/2 lens**
- **70–200mm f/2.8 lens**
- **Sigma 105mm f/2.8 lens**
- **Lens hoods for all lenses**
- **Three Canon Speedlite 580EX flashguns**

- **Spare lithium-ion batteries**
- **Range of CF media cards**
- **Mamiya RZ67 medium-format camera body**
- **Mamiya lenses ranging from 55mm to 110mm**
- **Collapsible light reflectors**
- **Small and large softboxes**
- **Bowens and Hensel light heads**

Specification

CAMERA: Canon 1Ds MKII

LENS: 28–70mm

ISO: 100

APERTURE: f/5.6

SHUTTER SPEED: 1/125 sec

LIGHT CONDITIONS: Artificial (with softbox)

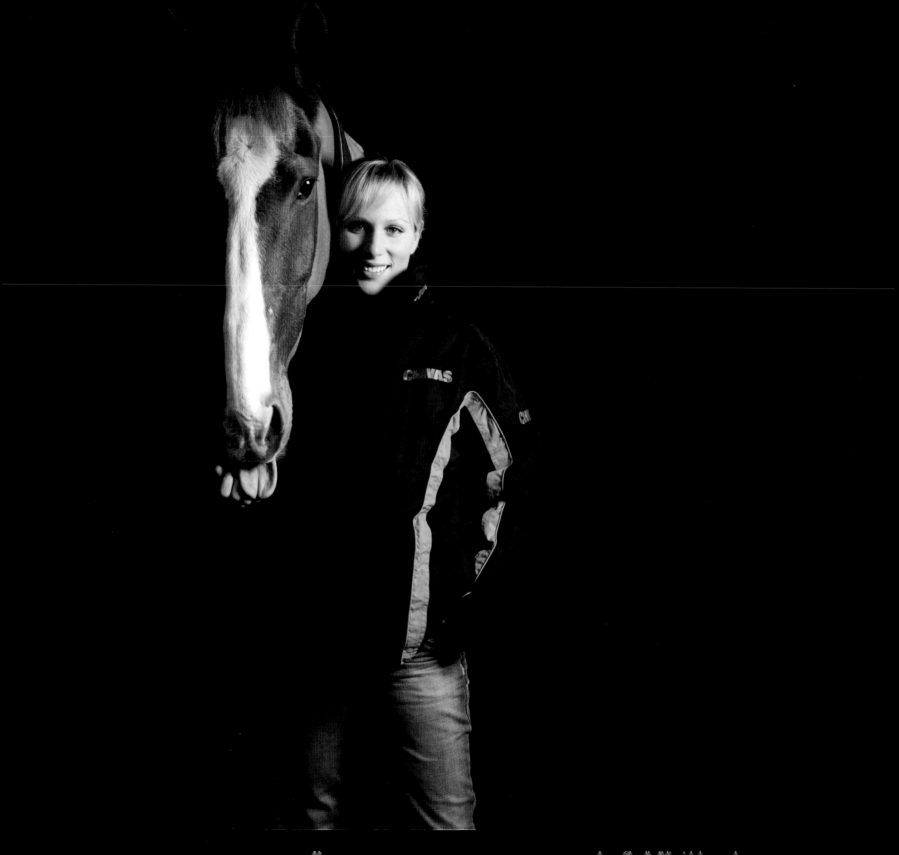

Russell Clisby

Airport paparazzo

Every successful newspaper or magazine needs hungry, knowledgable paparazzi—arguably the most resourceful professional photographers—who know where to look for the best and most profitable opportunities. Russell Clisby, by any standards, is an extremely successful photographer whose pictures fulfill the needs of such publications. The 47-year-old is the UK's leading airport paparazzo. He spends almost every waking hour sitting in airport lounges and terminals to record the comings and goings of the rich and famous. "I've been doing it for so long—15 years in fact—that my job has become second-nature. I know exactly where to look to get the best and most lucrative shots," he says. Such is his reputation, Russell has been given an official Resident Press Member pass, allowing him to go almost anywhere in and around Heathrow Airport—often inside the first-class cabins on the star-studded planes themselves. No two days are the same for Russell, and for this reason he must rely on his reactions and camera skills, thinking on his feet and responding speedily to changing priorities.

Michael Jackson
Jacko is always big news; many staff, passengers, and paparazzi were waiting to see him. Having already got full-length shots, I wanted to get close up, and this was the result. I just did my basic camera settings and made sure I got the picture. Because Michael was wearing gray, a color that often creates problems with my camera's autofocus—I thought it could affect the outcome of the picture, but it worked a treat.

CAMERA: Canon EOS-1Ds MKII
LENS: 24–70mm
ISO: 400
APERTURE: f/5.6
SHUTTER SPEED: 1/125 sec
LIGHT CONDITIONS: Flash, natural

AS: What was your first ever camera?

RC: A Rolleiflex 2.25 × 2.25in SLR with standard 80mm lens, which I started using in the 1980s.

AS: Where do your ideas for innovative pictures come from?

RC: Every story will lend its own innovation. I try to cut to the chase and get the picture that's required to match the story. I don't need to take a lot of pictures; I need the one that will get the result. My job is more about reacting to situations, rather than having an initial "idea."

AS: Why did you decide not to do other types of photography, such as sports or nature work, for example?

RC: I get a buzz out of meeting lots of famous people and the photography has become second nature. I love the airport, too—my father worked at Heathrow and my sister was a stewardess. I also have an interest in airplanes.

AS: Is it fair to say, like many successful photographers, that you had a "lucky break" at some stage?

RC: I think you make your own luck. But I did have quite a good apprenticeship at Heathrow, during which time I observed more experienced photographers. I've applied myself to make it to where I am today, however.

AS: Do you shoot what you want or do others generally define what's required of you?

RC: The story the newspaper may want, or the one you create as photographer on the day, defines the way I work. In the main, newspapers and magazines are unaware of what they're going to receive from me, unless it's a big news story that everyone is already familiar with.

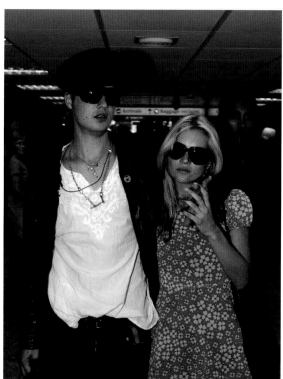

Left: **Pete Doherty and Kate Moss**
This picture reflected a big story at the time: Kate Moss's involvement with drugs. It was important to capture both Kate and Pete looking my way. I was surprised at how laid-back they both were, and even though there were about five or six other photographers fighting for position, with passengers galore, I managed to fire off the shot.

CAMERA: Canon EOS-1Ds MKII
LENS: 24–70mm
ISO: 400
APERTURE: f/5.6
SHUTTER SPEED: 1/125 sec
LIGHT CONDITIONS: Flash

Right: **Dennis Hopper**
Dennis is such a big star. He very kindly allowed me take a few shots. I had to work fast, though, taking a maximum of just five or six frames—I didn't want to keep him stationary for too long because people would have recognized such a Hollywood icon and started harassing him for autographs.

CAMERA: Canon EOS-1D
LENS: 24–70mm
ISO: 400
APERTURE: f/5.6
SHUTTER SPEED: 1/60 sec
LIGHT CONDITIONS: Flash

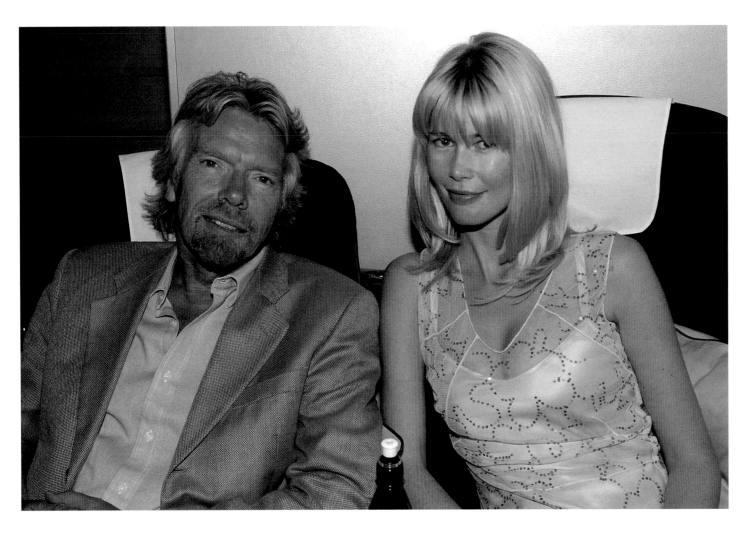

AS: Where are you mostly based? Where are your most popular locations?

RC: I have a pass that enables me to maneuver around Heathrow. Airport operator BAA is very good in allowing photographers—who know how to behave themselves—into most locations. I can also shoot outside, on the runways, wearing a safety jacket, though much of my time is spent in the first-class lounges. It's where celebrities wait before boarding flights. I also photograph away from Heathrow, and I've been commissioned by Airbus, Canon, and Bell Pottinger.

AS: Which types of places do you like to photograph in the most, and why?

RC: No one stands out more than any other. But having a knowledge of the airport is absolutely necessary, if you want to succeed.

AS: What things do you enjoy most about your job?

RC: I enjoy the freedom. I'm given free rein to work as I like. I love meeting celebrities and I love seeing my pictures published in the newspapers. It's a buzz, especially as I'm competing with others for page space. Any editorial photographer who doesn't see their own pictures in the papers is in the wrong job!

AS: From a technical aspect, what are the most difficult things about your photography?

RC: There's a lot of changing light at the airport and most corridors are glazed. You can use this to your advantage—but only if you know how to use light correctly. I can bounce light off the walls, and my experience means it's not a problem. I go through different phases where light changes and I have to be aware of when to change shutter speed, or I may miss the picture I'm looking for. I also have to go from photographing in artificial light to natural light very quickly—from inside to outside—and I have to take regular light meter readings. There are a million technical things to consider at once.

Richard Branson and Claudia Schiffer
This was shot on the then-new Airbus A-360. I managed to get a first-class shoot with Richard Branson and Claudia Schiffer, and I decided to bounce the flash off the airplane ceiling, raising my camera ever so slightly, to avoid background shadow. I used a slightly slower shutter speed because there was quite a bit of available, ambient light.

CAMERA: Canon EOS-1Ds MKII
LENS: 24–70mm
ISO: 400
APERTURE: f/5.6
SHUTTER SPEED: 1/60 sec
LIGHT CONDITIONS: Flash (bounced), ambient

Below: **David and Victoria Beckham**

Posh and Becks had just arrived at Heathrow from Hong Kong. They were quite exhausted, so when I showed up, neither really wanted to know. You can see this in the picture. The light wasn't great and my camera's autofocus wouldn't zone in, so I decided to focus the lens manually. I knocked the shutter speed up to 1/125 sec, at f/5.6, to help pick up available light.

CAMERA: Canon EOS-1Ds MKII
LENS: 24–70mm
ISO: 400
APERTURE: f/5.6
SHUTTER SPEED: 1/125 sec
LIGHT CONDITIONS: Flash

Right: **Britney Spears**

I needed a faster shutter speed here. Some of Heathrow's departure areas are brightly lit by the artificial skylight systems overhead; these bounce light off reflective tiles to fill shadows underneath subjects, so it is crucial to balance the light as much as possible by using a combination of ambient and flash light. One of the pitfalls of airport photography is the regularity with which light-to-dark areas come along—if you don't get it right, you'll end up with motion blur.

CAMERA: Canon EOS-1Ds MKII
LENS: 24–70mm
ISO: 400
APERTURE: f/6.3
SHUTTER SPEED: 1/250 sec
LIGHT CONDITIONS: Flash, ambient (artificial)

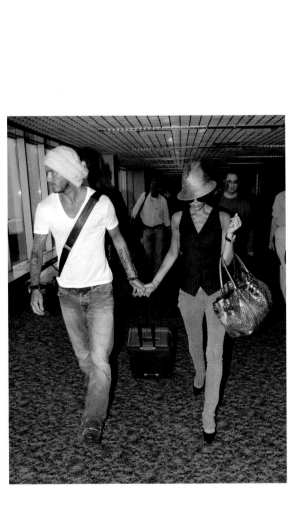

Russell Clisby: Airport paparazzo

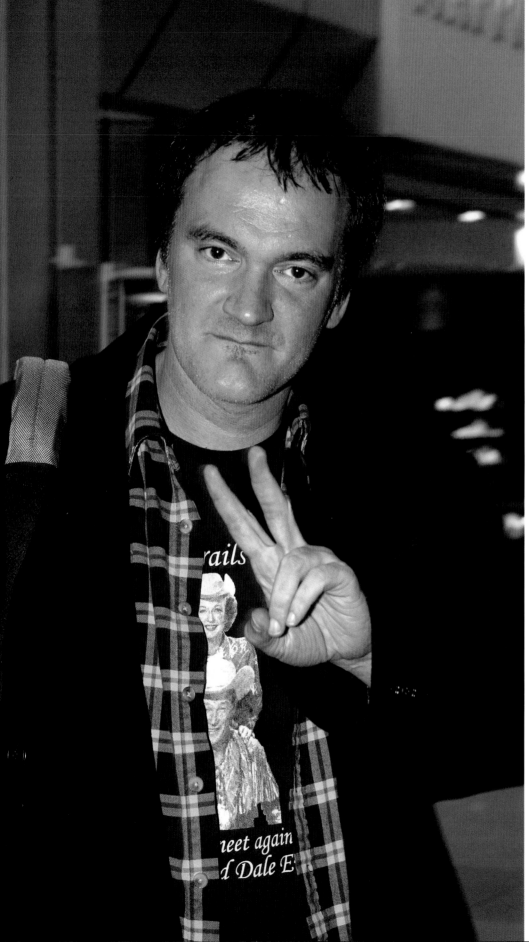

AS: How would you describe your personal style or technique?

RC: I am very light on my feet and I have a good eye. I walk backward with one eye over my shoulder and one on the subject. I'm a fast photographer and able to display a situation in its correct context. Being aware and judging when a situation is going to unfold is more of a skill than a personal style or technique. As a general rule, I take half- and full-length shots, and one of the celebrity looking straight at me.

AS: What's in your kit bag? Which camera system do you use and why?

RC: Two Canon EOS-1Ds MKII bodies—it's the best camera system I've ever used. My workhorse lens is a 24–70mm. I also have 16–24 and 35–350mm lenses, the latter being really handy for unexpected situations—it covers everything. I also have an 80–200mm and I use this when I know exactly where my subjects will be. Flash is an important part of my job and I use a Canon 580EX Speedlite, with 550EX as backup. I own two CompactFlash cards—made by Lexar Media—a 1 and a 2GB. Otherwise my office is a cell phone and laptop, from which I communicate and send images.

Quentin Tarantino
I'm a huge Tarantino fan and was naturally excited to learn of his arrival at Heathrow—he's rarely seen in the UK. He was very approachable and turned around to pose for this shot. There's a little bit of motion-blur on the fingers, but the face is perfectly sharp. I think they work well together. The light wasn't brilliant so I chose a slower shutter speed to try to pick up some background light.

CAMERA: Canon EOS-1Ds MKII
LENS: 24–70mm
ISO: 400
APERTURE: f/5.6
SHUTTER SPEED: 1/60 sec
LIGHT CONDITIONS: Flash

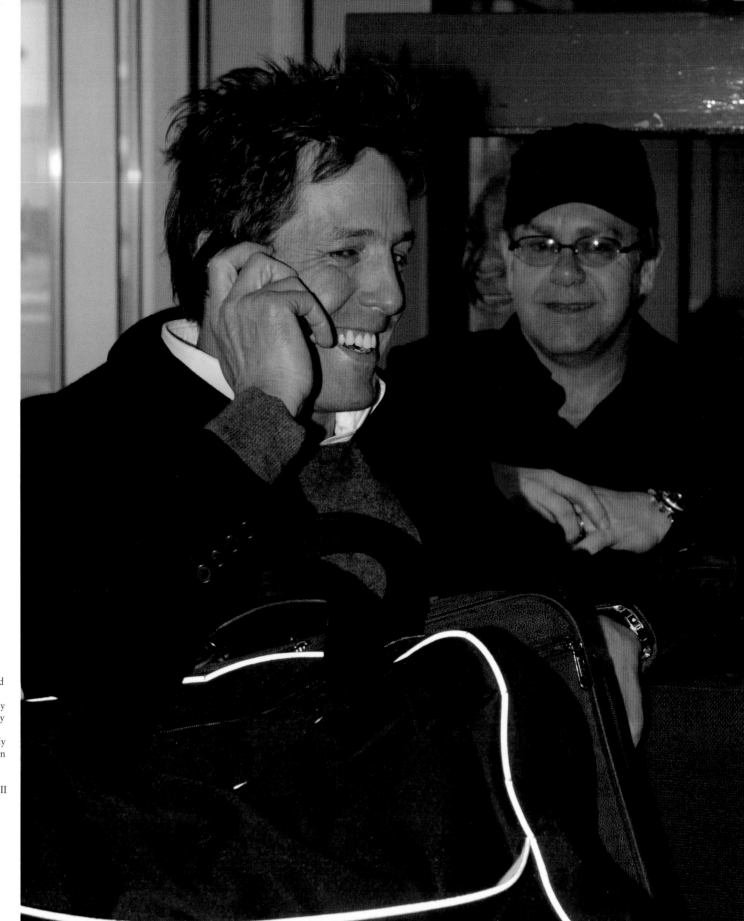

Hugh Grant and Elton John
Two iconic celebrities—Elton John and Hugh Grant—came off a flight together from LA. Both climbed onto a buggy and I raced to the front, capturing them looking straight down my lens barrel. Elton is notoriously difficult to photograph, but, on this occasion, was extremely amused at what Hugh had been saying on his cell phone.

CAMERA: Canon EOS-1Ds MKII
LENS: 24–70mm
ISO: 400
APERTURE: f/5.6
SHUTTER SPEED: 1/125 sec
LIGHT CONDITIONS: Flash, ambient

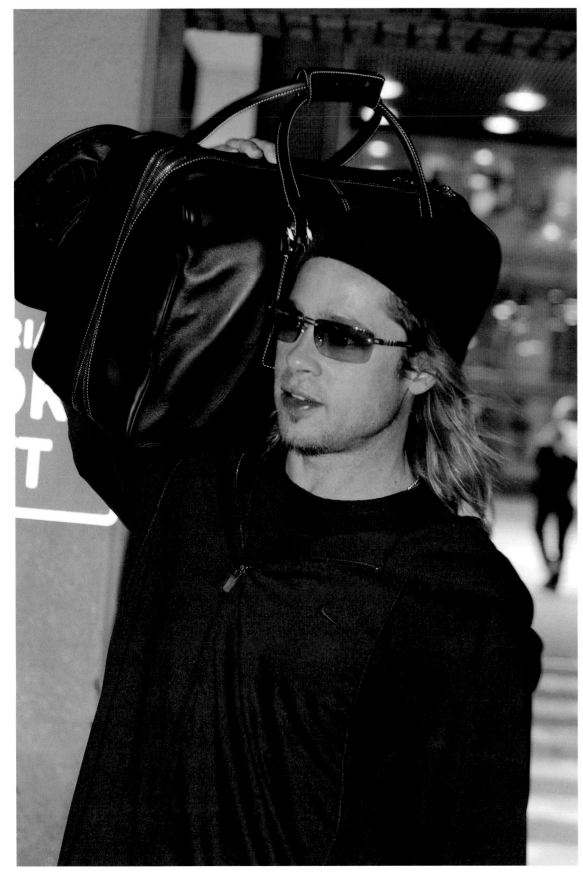

AS: Do you try to make sure your work appeals to the widest possible audience?

RC: I only think about newspapers and the picture that goes with the stories they want. Once I've done the basics I can come off the pace and look for things which are quirky—a celebrity laughing in a natural way, tripping up, or a poster framed behind them, which may have some relevance to the story.

AS: When are the busiest times of the year for you?

RC: There's no structure. But I do find Christmas and the height of summer generally more newsworthy.

AS: What types of pictures do you find the most difficult to take?

RC: Some celebrities make my day more enjoyable than others— there are those who don't want their pictures taken—but most are real pros and know how to behave in front of the lens.

AS: Which do you prefer, digital or film, and why?

RC: Digital has given me back the idea of how I see the picture when I take it. It's natural. It's also given me back the darkroom I crave for, rather than have a film lab do the processing. I can shoot loose and crop in because the quality is just so good. I never use a tripod because, with digital ISO settings, there's always sufficient light. My Canon 1Ds MKII enables me to shoot in darker conditions at up to ISO 1000 without the picture looking too grainy. I could never do that with film.

Brad Pitt
I got wind that Brad Pitt had arrived on a private jet. I had to act fast, making my way outside to the Terminal 4 parking lot. I took a quick light-meter reading and tried to bounce flash off the canopy above. It worked. And there he was. And I got the shot.

CAMERA: Canon EOS-1Ds MKII
LENS: 24–70mm
ISO: 400
APERTURE: f/8
SHUTTER SPEED: 1/250 sec
LIGHT CONDITIONS: Flash

Penélope Cruz

Penélope Cruz is usually very shy, but on this day she looked right at me. I only fired about five frames because I felt I had the picture I wanted, and I didn't wish to outstay my welcome with someone renowned for being timid.

CAMERA: Canon EOS-1D
LENS: 24–70mm
ISO: 400
APERTURE: f/5.6
SHUTTER SPEED: 1/60 sec
LIGHT CONDITIONS: Flash

Pamela Anderson

The airport was crowded that day, with many onlookers. Pam came in from LA on a Virgin flight and looked very relaxed. I was able to get reasonably close and then she looked straight at me, making the shot look very personal. I used direct flash and it didn't look washed out.

CAMERA: Canon EOS-1Ds MKII
LENS: 24–70mm
ISO: 400
APERTURE: f/5.6
SHUTTER SPEED: 1/125 sec
LIGHT CONDITIONS: Flash

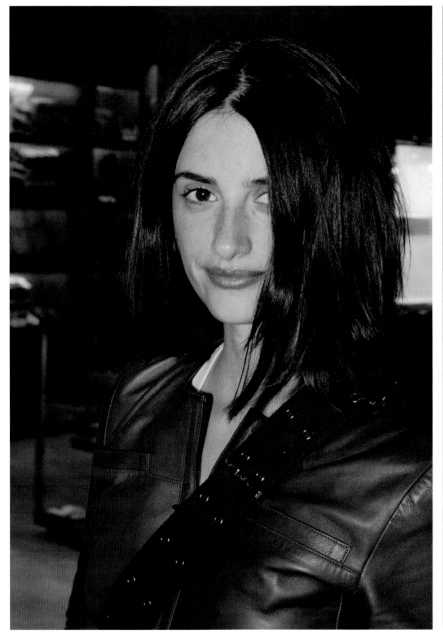
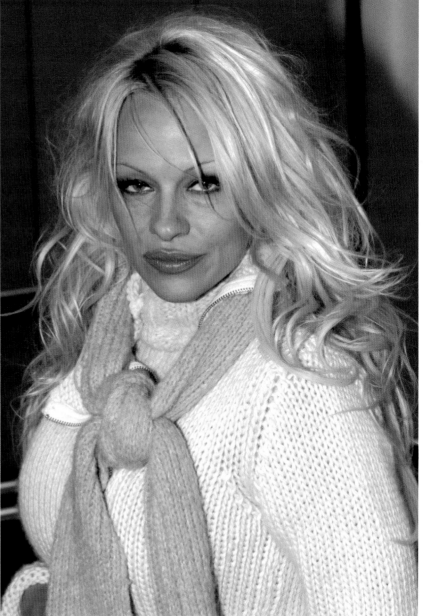

Russell Clisby: Airport paparazzo

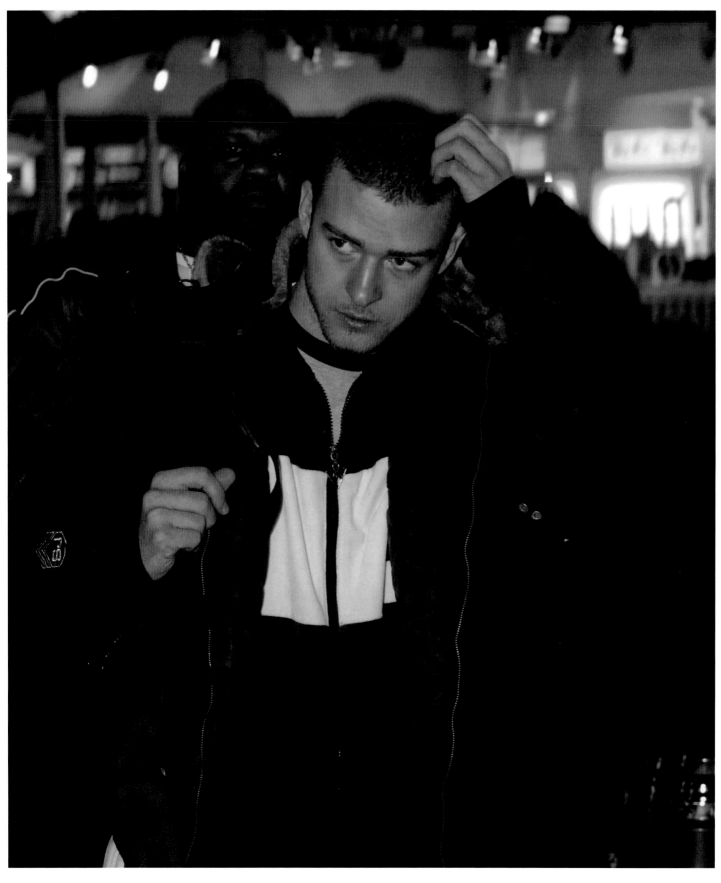

Justin Timberlake
The light was very low and I wanted to capture Justin Timberlake and his minder. I knocked the shutter speed down to 1/90 sec, waited until my autofocus locked onto Justin, and fired. The ceiling in Terminal 4 is high, so I had to shoot flash direct, rather than bounce it. I was quite far away and very little light reached my subjects, but the camera's ISO 400 setting helped make the picture. Everything about Justin is pin-sharp, apart from the top of his head.

CAMERA: Canon EOS-1Ds MKII
LENS: 24–70mm
ISO: 400
APERTURE: f/5.6
SHUTTER SPEED: 1/90 sec
LIGHT CONDITIONS: Flash

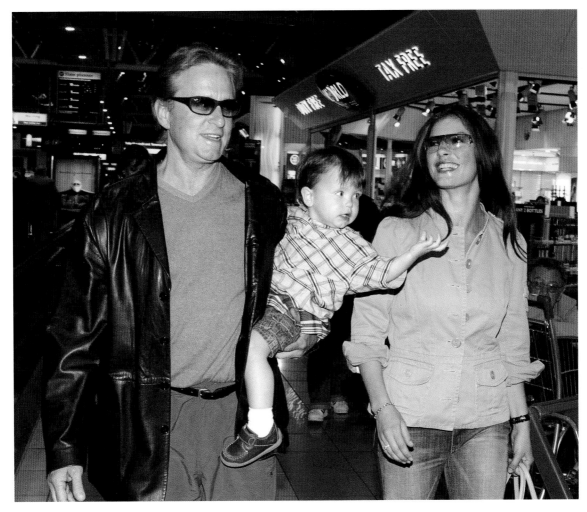

Michael Douglas, Catherine Zeta-Jones, and Dylan Douglas
Michael and Catherine are very easy to photograph, but when you're trying to get three people in the frame, it's a good idea to prompt some animation by talking to them. They were in a good mood and reacted to one another in a genuine way. It made a very salable picture.

CAMERA: Canon EOS-1Ds MKII
LENS: 24–70mm
ISO: 400
APERTURE: f/5.6
SHUTTER SPEED: 1/250 sec
LIGHT CONDITIONS: Flash

AS: How much of your work do you manipulate using imaging software?

RC: Things should be done in-camera because it's important not to muck around with the image too much, just the basics in Photoshop—auto color or curves. If you manipulate an image it will generally make the file size bigger and more difficult to transmit.

AS: What do you consider your greatest photographic achievements to date?

RC: Staying alive in such an industry. I'm totally reliant on celebrities and the situations that unfold. The biggest sales for me were the Diana Ross incident, in which she was pulled off a flight and arrested for being drunk and abusive, and the final flight of Concorde, which involved many celebrities.

AS: What does the future hold for you?

RC: That's simple. My prime objective is to carry on. I'm very happy in my job. Having said that, I'm looking forward to the challenges that may lie ahead outside of the airport, such as other requests and commissions.

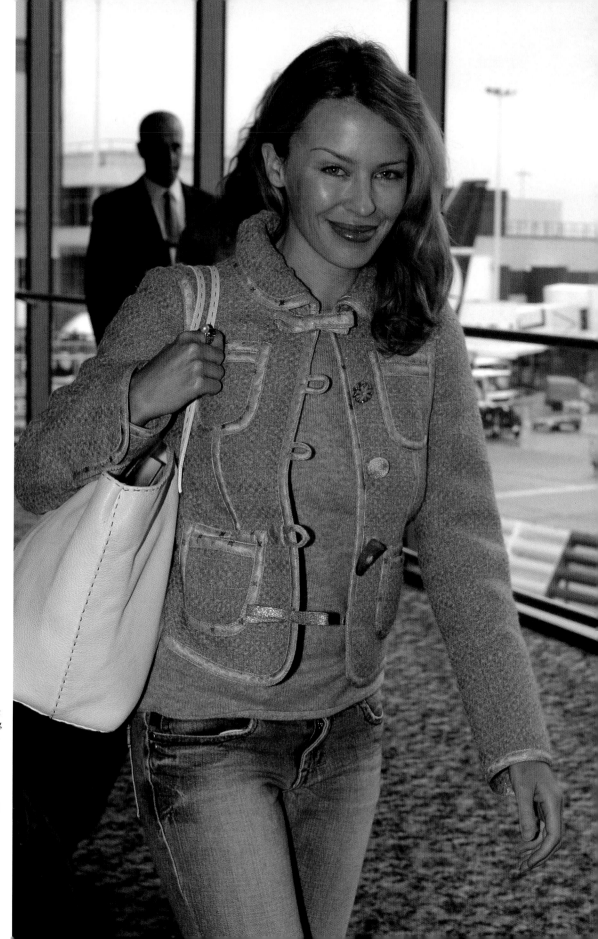

Kylie Minogue
Terminal 1 has lots of ambient light, so I needed to make some quick adjustments. I took a light reading and balanced everything in-camera, to get nice, balanced lighting. As Kylie came off the conveyor belt, she came toward me and looked right down the lens, giving me a nice smile.

CAMERA: Canon EOS-1Ds MKII
LENS: 24–70mm
ISO: 400
APERTURE: f/8
SHUTTER SPEED: 1/200 sec
LIGHT CONDITIONS: Flash, ambient

Tips for Success

1. The biggest file size isn't always the best

Capture with medium or large JPEG files, not RAW. These are easier to transmit quickly and they're good enough to blow up to letter paper size and still look sharp.

2. Continually check camera settings

In my line of work it's important to check all settings in-camera during a job. Settings need to be changed when walking around—you'll need to react quickly.

3. Keep your eyes on the subject

Do this at all times and be ready to shoot. It's very easy to miss a big-selling shot.

6. Use flash in poor outside light

Don't be afraid to use flash outside, especially if it is cloudy. Take a highlight reading and shoot against the light.

7. Experiment with bounced light

When a background is close to the subject, try bouncing the flash against another wall or ceiling to avoid shadows.

8. Don't crowd your subject

As with most genres of photography, better results are achieved by not crowding the subject. It makes them relax which, in turn, makes for a more natural photograph.

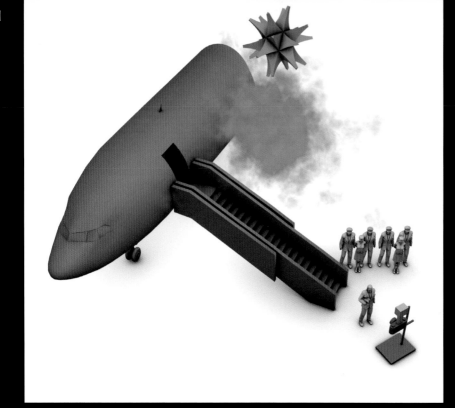

John Travolta

John is a respected pilot and was happy to pose with staff from his private jet. The sky was washed-out, so I "cheated" by selecting my camera's Shutter Priority mode. When you do this your flash compensates for everything automatically, giving you an even light balance, and in this case, fill-in flash. The composition works well because of the angle—even though I remember jostling with about 100 photographers to find position. When the chances come you have to take them.

Essential Equipment

- Two 35mm Canon EOS-1Ds MKII camera bodies

- 28–70mm f/2.8 lens

- 35–350mm f/3.5–5.6 lens

- 80–200mm f/4.5–5.6 lens

- Lens hoods for all lenses

- Canon 580EX Speedlite flashgun

- Lexar Media 1–2GB CF cards

- Laptop computer

- Cell phone

Specification

CAMERA: Canon EOS-1Ds MKII

LENS: 24–70mm

ISO: 400

APERTURE: f/16

SHUTTER SPEED: 1/250 sec

LIGHT CONDITIONS: Flash (fill-in)

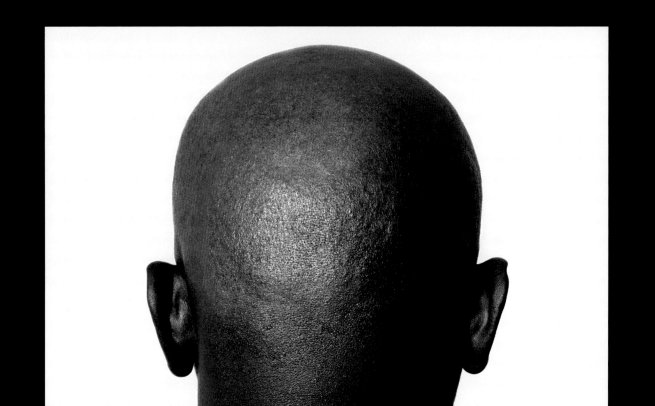

Perfect portraits

Even though celebrity photographer Andy Gotts is known for photographing Hollywood's A-list, he recently followed Plan B, at the completion of which he was awarded a photography MA from De Montfort University. "I don't get time to experiment as much as I'd like, so completing the degree created this new exploration for me," says the Norfolk-born 37-year-old. The irony is that Andy simply doesn't need to establish himself in the industry—he's already spent more than a decade as the photographic choice of Hollywood's greats.

His book, *Degrees*, is based on the concept of the six degrees of separation, which suggests you can link yourself to anyone in the world through only six people. "My theory is that if I get around the movie industry to photograph one icon, then I can ask them to set me up for a shoot with a famous friend, who would do the same, and so on." Andy's A-listers are too illustrious to mention, but he remains down to earth. "It would be easy to get carried away doing what I do, so from time to time I remind myself of how lucky I am."

Samuel L. Jackson
This shoot was in LA. Although Samuel turned up wearing an orange T-shirt, with hat and shorts, he still looked every inch a movie star. I seldom use the word "cool," but if I needed a physical embodiment of it, it is Samuel L. Jackson. We cracked on with the shoot and I got some nice face shots. He then span around on the chair and I got a perfectly symmetrical shot of the back of his head.

CAMERA: Mamiya RB67
LENS: 180mm
FILM: Kodak Tri-X 400
APERTURE: f/16
SHUTTER SPEED: 1/125 sec
LIGHT CONDITIONS: Single Elinchrom flash with softbox

Interview

AS: What was your first ever camera?

AG: The same one I still use now: a Mamiya RB67, which I bought second-hand in 1988 as a student. I bought the body, 90mm lens, and film back for £800. I've never owned a 35mm camera.

AS: Where do your ideas for innovative pictures come from?

AG: From movies, mostly. I love old black-and-white movies, and the way the lighting is done has influenced my photography hugely. *The Ladykillers*, *It's a Wonderful Life*, *Metropolis*, and *Psycho*, among many, many others, are good examples. I try to encompass the kind of grainy texture used in these movies in my photographs and printing techniques, coupled with hard lighting.

AS: Why did you decide not to do other types of photography, such as sports or nature work, for example?

AG: Stephen Fry. I was a 19-year-old photography student at Norfolk College of Arts and Technology, and Stephen came to give an AIDS awareness talk. I saw my first real-life celebrity in the flesh. It was an exciting time and I knew from that day on just what I wanted to do.

AS: Is it fair to say, like many successful photographers, that you had a "lucky break" at some stage?

AG: During the question-and-answer session of the awareness talk I asked Stephen if he'd let me take his picture. He agreed, so I promptly constructed a makeshift studio in one of the college rooms and we had a five-minute photoshoot. I had so much fun. It was my eureka moment and it defined my path. I sent Stephen my favorite print from the shoot and he ended up hanging it on one of his walls at home. He was good friends with Kenneth Branagh, who asked who had taken the photo and, from that moment on, my name became known.

AS: Do you shoot what you want or do others generally define what's required of you?

AG: If I'm agency commissioned I'll have an art director to guide me, or a picture editor expressing a specific shot. But the reason I'm employed in the first place is because of my style. I shoot alone, with one celebrity, and that's the way I operate. Most actors hate being photographed—they like acting a persona, not being themselves in front of a camera. It's my job to get to the core of that person.

Gwyneth Paltrow
I photographed Gwyneth at Shepperton Studios, while she was filming *Sylvia*. She was feeling poorly and had been filming all day, so the fact she agreed to sit for the project was very good of her. But to say she didn't want to be photographed this particular day is an understatement. She arrived with an entourage of people—driver, bodyguards, make-up artists, hair people, studio executives. And there she sat, in the same pose, for a couple of rolls of film. It wasn't until I was blatantly rude to her that she cracked a smile and started laughing. I managed to get about 10 good shots, this being my favorite.

CAMERA: Mamiya RB67
LENS: 90mm
FILM: Kodak Tri-X 400
APERTURE: f/16
SHUTTER SPEED: 1/125 sec
LIGHT CONDITIONS: Two Elinchrom flashes, one with softbox and one bounced

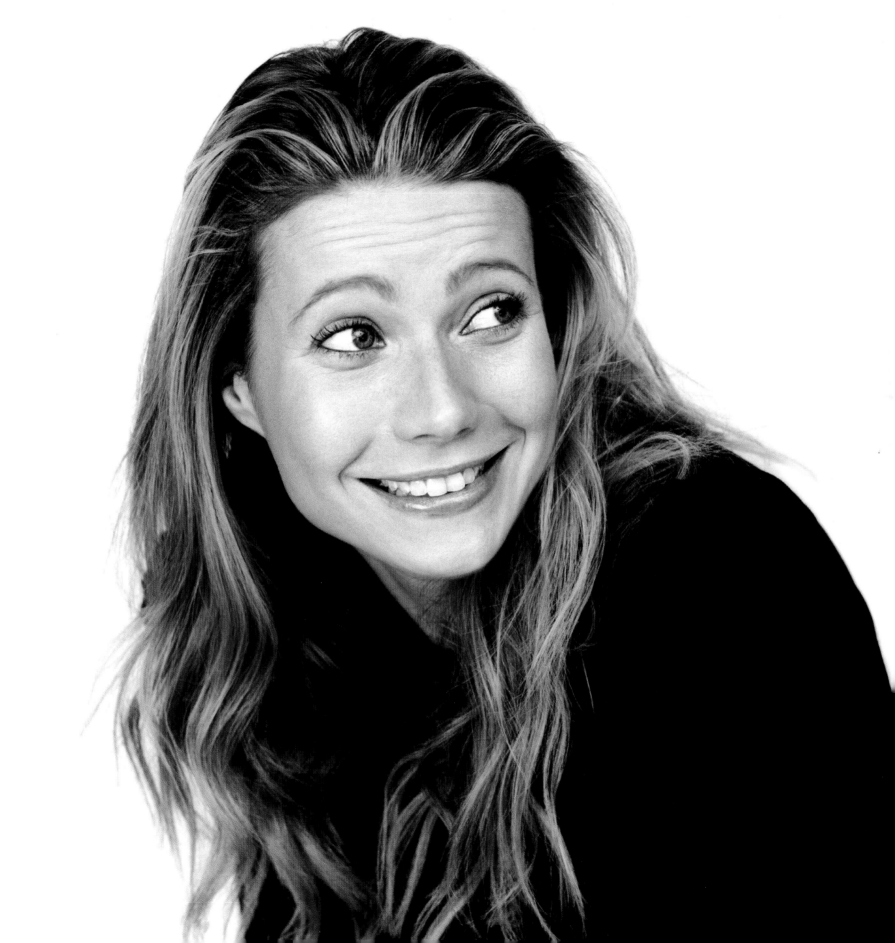

AS: Where are you mostly based, and where are your most popular locations?

AG: My photography is based in London, but I nearly always photograph in big cities throughout the world. Italy, Germany, the Czech Republic, and the USA are also popular destinations.

AS: Which types of places do you like to photograph in the most? Why?

AG: London is my favorite, it's familiar. But I also work in America quite a lot, mostly in New York and Los Angeles. Sometimes I photograph celebrities in the middle of nowhere, and I shot Adrien Brody in a wood in Wilmington, Delaware, USA. When I work abroad it's an extra challenge and nice occasion, especially in New York, which has become a home away from home.

AS: What things do you enjoy most about your job?

AG: That's easy. I get to meet icons of Hollywood, which for me, being a movie buff, is fantastic. A-listers open up to me during shoots and tell me things I should never know. That in itself creates a sense of trust and camaraderie. Being in a one-on-one situation with people you've grown up seeing on a movie-theater screen is an experience that cannot be put into words.

AS: From a technical aspect, what are the most difficult things about your photography?

AG: I like my pictures to look as if they're done in a studio, with a "polished" feel. So if I'm in someone's caravan, as I was when I took the portrait of Cate Blanchett, and I'm presented with natural or ambient light and can't use flash, it's technically very difficult. I also have a specific camera film I like to use—Tri-X 400—because I can "push" or "pull" it during processing as much as I wish. If it's not available to me, as it sometimes isn't when I'm abroad, it causes major problems.

AS: How would you describe your personal style or technique?

AG: Henri Cartier-Bresson coined the phrase "the decisive moment," and I completely relate to this. The relationship I have with my subject makes the picture, and this is captured at the precise moment I press the shutter button—it's that split second that creates a record or historical document. Underexposing film ever so slightly is a technique I use to create a style: bright whites and deep, silky blacks, with ideal mid-tones; and this helps to create the printing zone system, when pre-flashing my paper. [The printing zone system is a method of controlling the exposure and development of film, and of varying exposure to get the results you want; the exposure, development, and printing are all interrelated.]

AS: What's in your kit bag? Which camera system do you use and why?

AG: Kodak Tri-X 400 film, always. It gives me the texture I crave. And, of course, my trusty old Mamiya RB67. It's a mechanical, single lens reflex, medium format body that uses 120-roll film. I've got three different film backs and a Polaroid back that I use with it. I love working with Elinchrom studio flash lights, and softboxes, and I prefer direct light that's diffused rather than bounced. If presented with ambient light, and because the RB67 is heavy, I'll rely on my Manfrotto tripod. I also have a palmtop computer, to research my subjects via the internet and to send emails while I'm on the move. Most importantly, I have my cell phone in case someone cancels at the last minute.

AS: Do you try to make sure your work appeals to the widest possible audience?

AG: I know what I want and my clients employ me for what I do. I know in my head where I want the light to be coming from and the angle I want to take the picture from. To explore and to be creative, and to use photography as an artistic medium is not trying to appeal to the widest audience. I photograph things the way I like to see them.

Cate Blanchett
I actually shot Cate in a caravan in a London supermarket parking lot. She was filming *Notes on a Scandal* and it was a gray, rainy day. My challenge was to make my photo look as if it was taken in a studio, and for Cate to look stunning (even though it was 8.30am and she wanted breakfast). Cate is a warm and kind lady, with a gentle nature, which is captured in the photograph.

CAMERA: Mamiya RB67
LENS: 90mm
FILM: Kodak Tri-X 400
APERTURE: f/8
SHUTTER SPEED: 1/60 sec
LIGHT CONDITIONS: Single bounced Elinchrom flash with ambient light

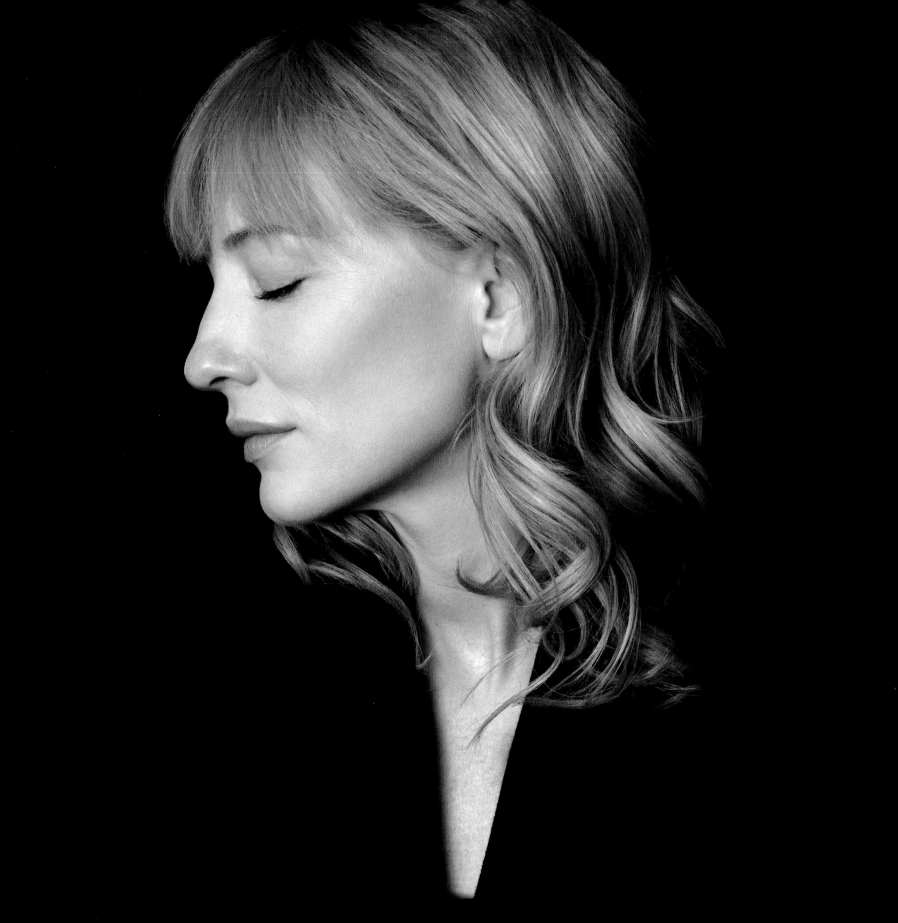

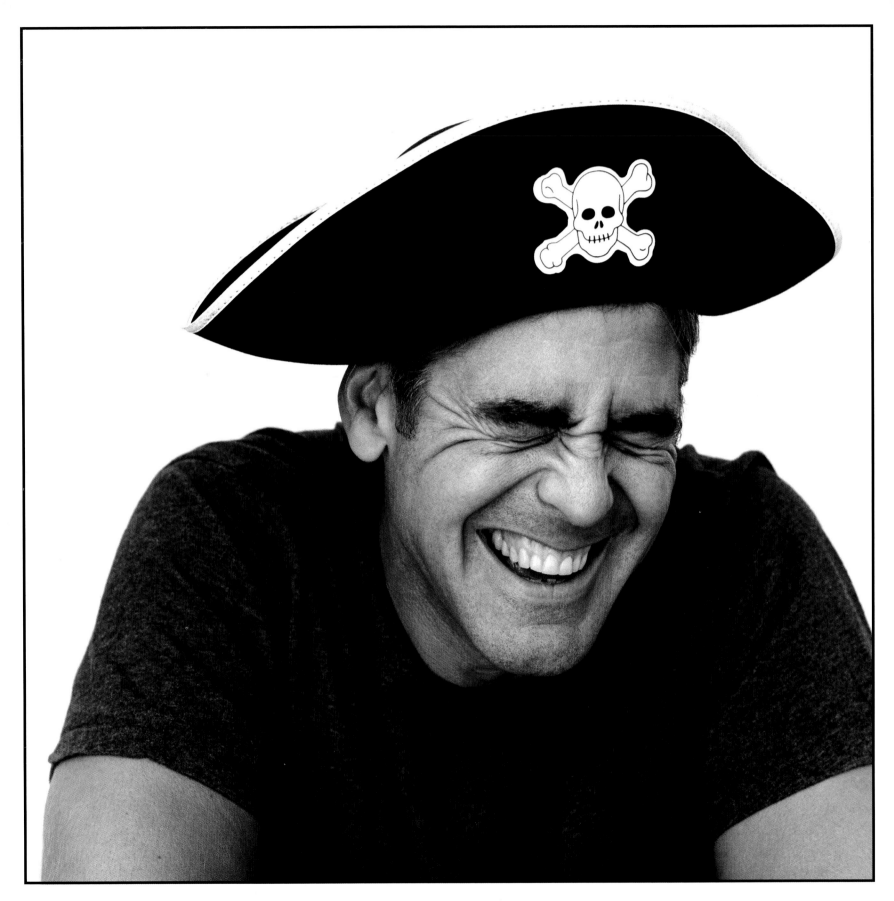

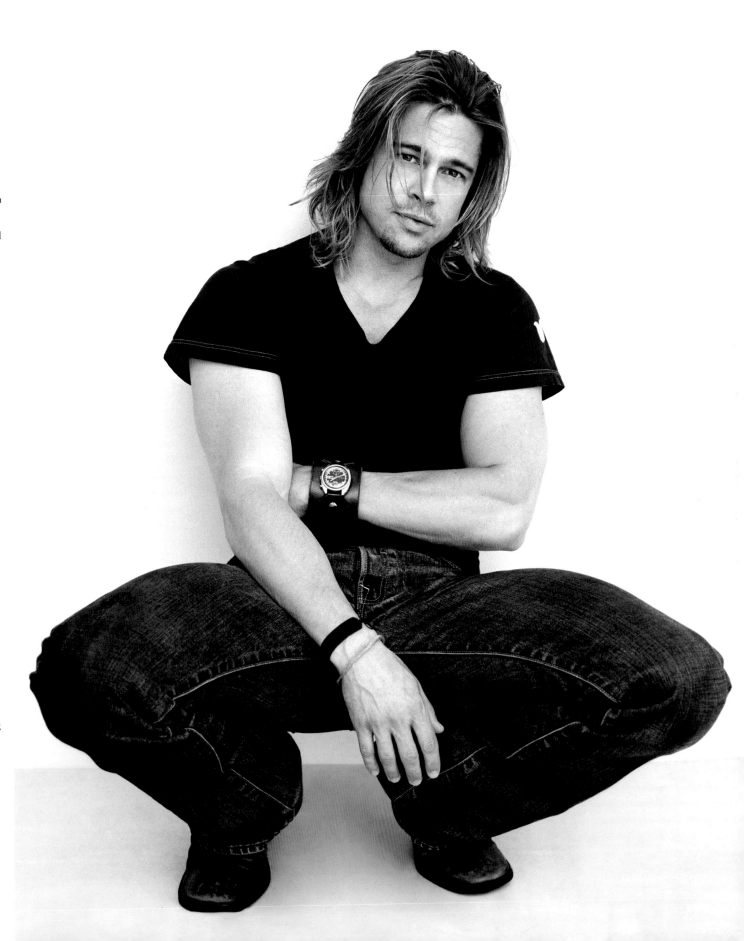

Left: **George Clooney**
I visited George at his beautiful Lake Como residence. When I arrived, breakfast was being served on the veranda and it seemed more like a five-star hotel than a private house. After breakfast, when George was telling me about his motorbike and planned ride to Rome, we adjourned into the house. I maneuvered my equipment around three obese ducks that frequented the hallways of the mansion, and was shown a room to use for the shoot. While I was setting up, George disappeared into his bedroom and reemerged wearing a pirate's hat, which he had worn during a dinner party the previous night.

CAMERA: Mamiya RB67
LENS: 180mm
FILM: Kodak Tri-X 400
APERTURE: f/11
SHUTTER SPEED: 1/60 sec
LIGHT CONDITIONS: Single bounced Elinchrom flash

Right: **Brad Pitt**
I met Brad at Shepperton Studios during the filming of *Troy*. The movie's publicity team were concerned with the amount of time allocated for the shoot, and told me I had just 12 minutes. I knew Brad traveled with an entourage of bodyguards, hair, and make-up people, so I wasn't looking forward to having a massive audience. I was pleasantly surprised when I answered a knock at the studio door and he was by himself. The 12 minutes stretched to over an hour and a half. We were having a great laugh and messing around like lads do— and comparing lists of which actresses we thought were hot! After the shoot he gave me a hug and said it was the most fun he had had in ages; he then picked up his cell phone and called George Clooney to help arrange my next shoot.

CAMERA: Mamiya RB67
LENS: 90mm
FILM: Kodak Tri-X 400
APERTURE: f/16
SHUTTER SPEED: 1/125 sec
LIGHT CONDITIONS: Single Elinchrom flash with softbox

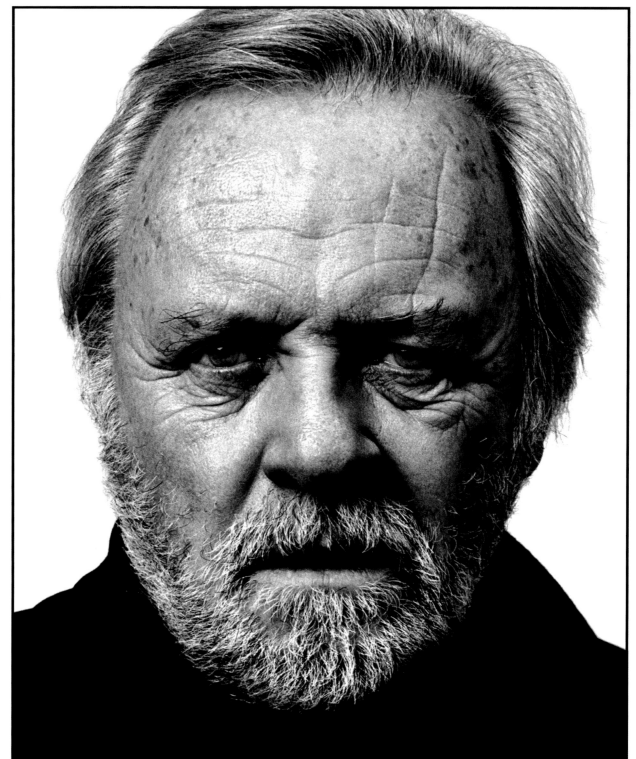

Anthony Hopkins

Anthony was in London filming *Proof* and the shoot was set for a Sunday morning. I set up my equipment in a hotel room on the same floor as his, so he could just pop along at his convenience. He had flu, and told me he had gotten out of bed just for the shoot, and that after we had finished, he would be going straight back. The fact he was ill added to the shot, because he has this really intense look in his eyes. There's nothing quirky about it, nothing weird, but it's one of my favorite pictures.

CAMERA: Mamiya RB67
LENS: 180mm
FILM: Kodak Tri-X 400
APERTURE: f/16
SHUTTER SPEED: 1/125 sec
LIGHT CONDITIONS: Two Elinchrom flashes with softboxes

Morgan Freeman
I shot Morgan in London while he was filming *Batman Begins*. All set and waiting, I wasn't disappointed when this movie legend entered the room. I just couldn't get over how much he looked like Nelson Mandela; he had an almost regal quality about him. I mentioned this resemblance and it turned out he was working on *Long Walk to Freedom*, the story of Nelson Mandela. I suggested we did a series of passport booth–style photographs, with Morgan pulling faces—from the sublime to the ridiculous!

CAMERA: Mamiya RB67
LENS: 180mm
FILM: Kodak Tri-X 400
APERTURE: f/22
SHUTTER SPEED: 1/60 sec
LIGHT CONDITIONS: Two Elinchrom flashes with softboxes

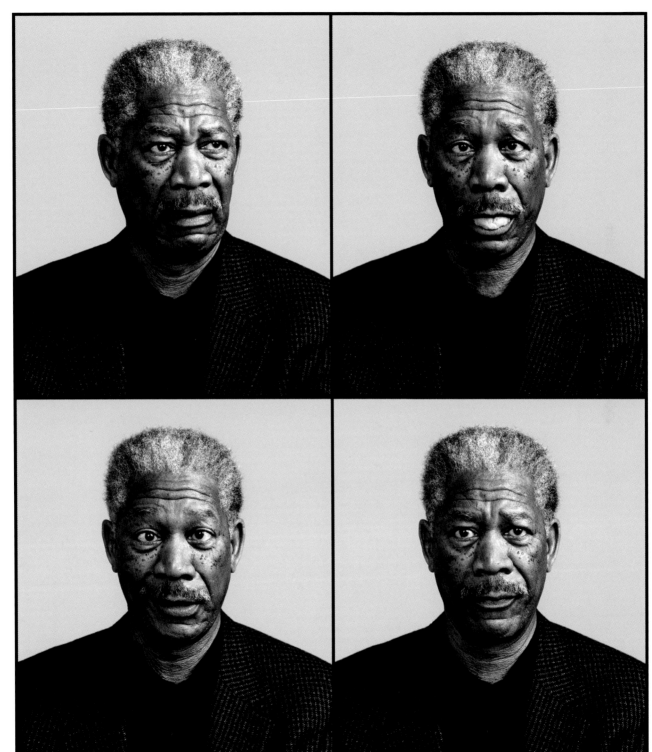

Andy Gotts: Perfect portraits

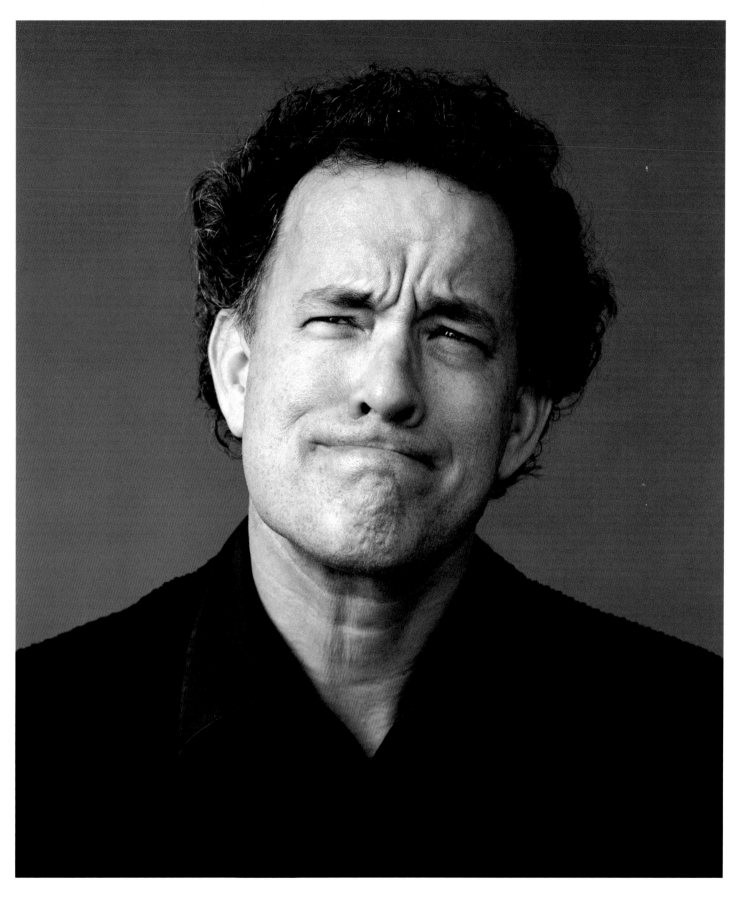

Tom Hanks

Tom is known as "the nicest man in Hollywood," but I never thought I'd find out for myself, as he was always unavailable. I was very surprised when I got an unexpected call from his assistant, who informed me that Tom would be in London rehearsing a movie, and that he could squeeze me in. I set up my equipment in a huge room and was told he would arrive between 12.30 and 5.00pm. A little before 5.00, Tom's security guard knocked at my door, wanting to check the room. Less than a minute later Tom arrived. He leafed through some previous shots I had taken and paused at Morgan Freeman's portrait, saying, "you're an artist, a genius!" I didn't know if he was joking, so I told him not to go over the top as Englishmen don't do sarcasm. After that we started the shoot.

CAMERA: Mamiya RB67
LENS: 180mm
FILM: Kodak Tri-X 400
APERTURE: f/16
SHUTTER SPEED: 1/125 sec
LIGHT CONDITIONS: Single Elinchrom flash with softbox

AS: When are the busiest times of the year for you?

AG: Things are slightly busier around January and February because the Oscars are in March, and celebrities want their faces about, but there's no real peak.

AS: Which places do you dislike traveling to the most?

AG: I don't like background clutter or places with ambient light. I like simple setups with black, white, or gray backgrounds. When I'm invited to visit a celebrity's house and they say, "I don't have any blank walls," I can feel the blood draining from my face. I've photographed celebrities in their bathrooms, bedrooms, and garden sheds, because they're the only suitable places.

AS: What types of pictures do you find the most difficult to take?

AG: Worst case scenario: an actor doing the same "posing face" they've always done. Morgan Freeman is one such example— his portraits are all quite similar. I researched him and asked him to pull all of these weird faces, to exploit his wonderfully expressive facial lines, similar to what you would do in a passport booth, and it worked. A celebrity in a bad mood is also something that makes a shoot more difficult than it ought to be.

AS: Which do you prefer, digital or film, and why?

AG: Film is romantic; it's beautiful. And with the correct processing and printing, it's something I know how to use to my advantage. I don't know much about digital in-camera, but my negatives are scanned as digital files.

AS: How much of your work do you manipulate using imaging software?

AG: Every picture is put into Photoshop, for backup and storage. At this point hair and spots are tackled, if they're unsightly, but all of my shots look natural and untouched. This is what I strive for.

AS: What do you consider your greatest photographic achievements to date?

AG: I love the fact that when I photograph people they can be themselves in front of me. And I have the opportunity to sit down with Hollywood gods and exploit a side of their character no one else has, often hearing stories that you wouldn't read in newspapers. Spending nine years photographing my *Degrees* project was also a major achievement.

AS: What does the future hold for you?

AG: Actors aside, I'd like to dabble with bands and musicians— a new and exciting challenge. I'd like to explore the fashion field, too. I've also got plans to do color photography. When I was awarded an MA from De Montfort University I was inspired to put some of my photographs together to create moving images; this has also made me think about music videos and directing.

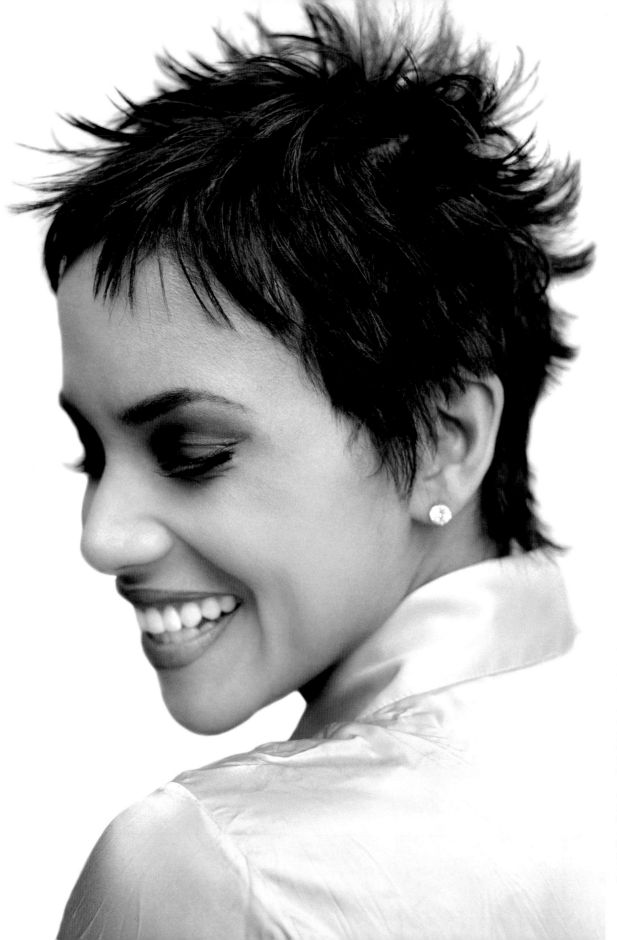

Halle Berry

I photographed Halle in LA soon after she won an Oscar for best actress in *Monster's Ball*. Everyone and their dog wanted to photograph Halle, and I had heard that her publicist was turning down everything. As I was going to LA I thought it wouldn't hurt if I dropped her a line. To my delight the answer was positive and a date was set. She came to the shoot like a little bundle of dynamite and was very gracious, thanking me for wanting to include her in my project. At the end of the shoot she asked me where my car was parked, and gave me a hand carrying my equipment to it.

CAMERA: Mamiya RB67
LENS: 180mm
FILM: Kodak Tri-X 400
APERTURE: f/8
SHUTTER SPEED: 1/60 sec
LIGHT CONDITIONS: Single Elinchrom flash with softbox and ambient daylight

Tips for Success

1. Discover your own style
Don't go out and blatantly copy someone else's style. Try to find your own.

2. Be sure of your creative ability
Although advice should be taken on board, don't let people tell you the way you're approaching your subjects is wrong. You are the artist, and what you see in your mind can work for you, even though it may not work for someone else.

3. Travel and work light
Simple, but very useful advice: only use as much equipment as you can carry.

4. Get to know your equipment inside out
You will produce better photographs if you can fully exploit the ability of your equipment.

5. Explore using film, don't just shoot digital
It seems as though digital has taken the "skill" element out of photography. Lots of people can pick up a modern camera and have the automatic exposure do everything for them. Taking better pictures with film has more to do with attitude than gadgets and technology.

6. Use light to your advantage
When there's a lot of ambient light around, take a reading and meter your flash or lighting equipment to the same f-stop as your camera. This will give nice, even lighting. The use of light in a photograph is, of course, the deciding factor in whether it will be spectacular or terrible!

7. Keep backgrounds simple and clean
Good portrait photography depends on not distracting the viewer from the subject's face. Don't make the background more exciting than your subject.

8. Don't be afraid to crop
Experiment with cropping, even if it breaks the rules. For example, be brave and chop off the top of a head, as this will give the illusion that the person is bigger than the photograph, placing more emphasis on the subject's eyes.

9. Try to work quickly
Don't let your subject wait around while you're playing with your lights and equipment. Fast, spontaneous photo sessions contain more energy and fun, and you will see this in the final image.

10. Don't dream it, be it
Photography is a wonderful medium and you can do anything you want. Just because some photography seems very elitist, it doesn't mean it's not achievable.

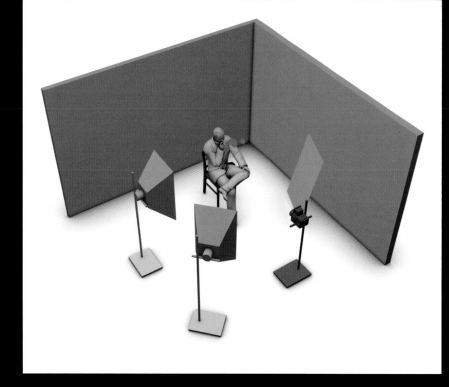

Christopher Lee

I met Christopher at The Savoy Hotel, London. I had been looking forward to the shoot for a number of reasons, the main one being that Christopher had been in more movies than anyone else in history—well over 250. I had spoken to Christopher many times on the phone and he has a very deep, level voice, like a headmaster. I couldn't help but feel like a schoolboy. My equipment was ready when Christopher sat in position and started to puff on a large cigar. It was fascinating to hear stories from the old movie days and his crowning glory, *The Wicker Man*, though his face did start to contort when he mentioned the movie's remake. I could have happily listened to his stories all day, but as my car was on a parking meter, I didn't.

Essential Equipment

- Mamiya RB67 medium format camera body
- Mamiya 50mm f/4.5 lens
- Mamiya 90mm f/3.8 lens
- Mamiya 180mm f/4.5 lens
- Kodak Tri-X 400 120-roll film
- Elinchrom studio flash lights
- Range of softboxes
- Manfrotto tripod
- Portable palmtop computer
- Cell phone

Specification

CAMERA: Mamiya RB67

LENS: 180mm

FILM: Kodak Tri-X 400

APERTURE: f/16

SHUTTER SPEED: 1/125 sec

LIGHT CONDITIONS: Single Elinchrom flash with softbox

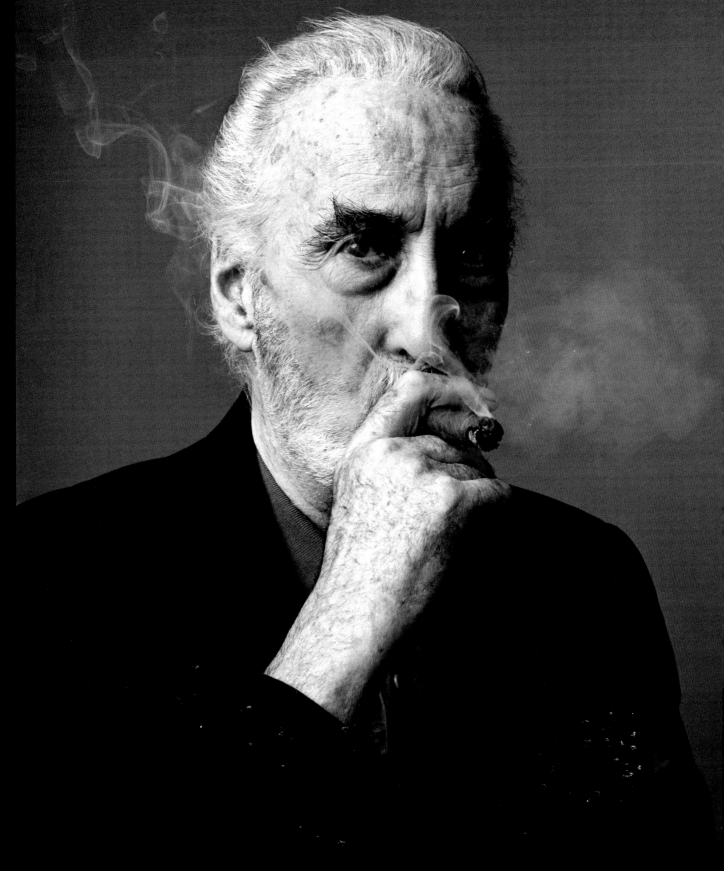

Andy Gotts: Perfect portraits

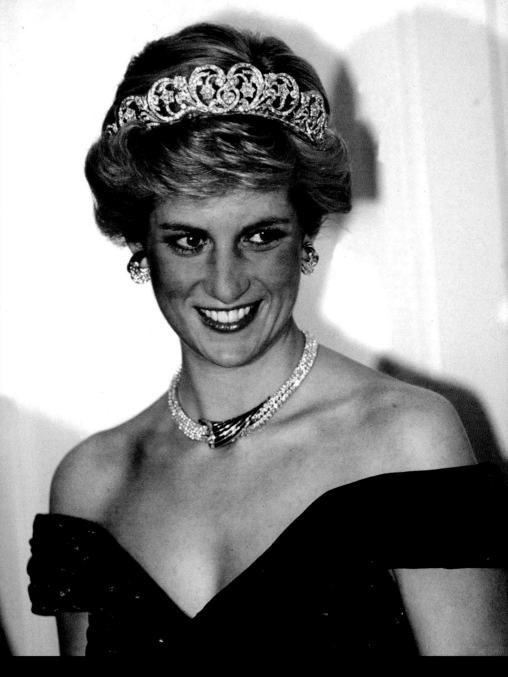

Regal images

Prior to becoming one of the world's chief image-takers of the British monarchy—well before Lord Lichfield's untimely death in 2005—Tim Graham was a promising freelancer. He recalls, "I started doing it in the 1970s. In 1977 the *Daily Mail* sent me to cover the Queen's Silver Jubilee tour around the South Pacific. I discovered a huge, worldwide interest in the Royal Family, so I gradually did less other work as the stories took up so much time."

His pictures of the honeymoon of Charles and Diana, in the early 1980s, won much acclaim, some by foremost members of the monarchy. "The honeymoon was spectacularly memorable because I managed to capture some of the couple's intimacy and magic."

The 59-year-old, who was born in Harefield in south-east England, feels privileged to have traveled to more than 120 countries to record the comings and goings of one of the world's best-known families. "Almost every member is a subject that publishes time and time again. As a photographer I like to see my work published; it's always a good feeling."

There's a very good chance that you will have seen Tim's pictures on the pages of the world's leading newspapers, magazines, and books, such is the constant international lure of the British royals. "I can't imagine having a more interesting job. It has given me the opportunity to sit in on various moments of history, ones that a lot of people would give their right arm to have witnessed."

Princess of Wales, Bonn, Germany
For me, this is the archetypal Diana picture. It has the obvious glamour that magazines were seeking in those days, and the light caught by the diamonds adds to that glamour. You may think Diana wore them a lot, but she didn't. Often, she chose understated jewels. The picture wasn't an easy one to pull off, because of the push-and-shove that's inevitable when photographers work in a crowded press situation.

CAMERA: Nikon F5
LENS: 80–200mm
ISO: 100
APERTURE: f/4
SHUTTER SPEED: 1/125 sec
LIGHT CONDITIONS: Natural, flash

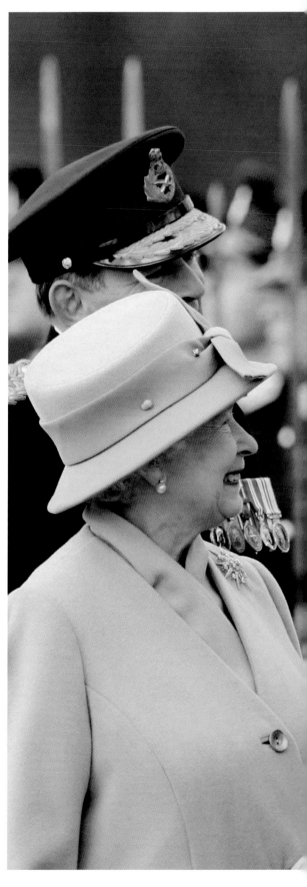

Interview

AS: What was your first ever camera?

TG: A Box Brownie. I was aged 13 and on holiday with my folks in Wales. I spent all my money on the camera and two rolls of film. When I saw the results, I was hooked.

AS: Where do your ideas for innovative pictures come from?

TG: On the spur of the moment, but it's difficult to be innovative while working in what is essentially a news environment.

AS: Why did you decide not to do other types of photography, such as sports or nature work, for example?

TG: During my freelance years I shot royal pictures as well as taking other assignments from magazines. As the royal photographs took up more and more of my time, I started to form an archive. I wanted to build on it and ensure there were no significant gaps, which led me naturally in the direction of specializing in royal photography. I still enjoy taking general stock photographs, but I'm known mostly for my specialist royal coverage.

AS: Is it fair to say, like many successful photographers, that you had a "lucky break" at some stage?

TG: Every photographer needs a lucky break, such as a picture editor who encourages you, or an image that gets you noticed and remembered. But you need to work hard and be reliable if you want to succeed in what's becoming an increasingly competitive profession. My first private session with a member of the Royal Family came after my coverage of a visit by Prince Charles to India and Nepal; it was featured extensively in British magazines. The spreads included not only the Prince's tour, but also images I had taken of scenes and sights during the trip. I was told the Royal Family had noticed my photographs and it brought my name to their attention.

Prince Harry, Sandhurst Military Academy, England
As the Queen inspected soldiers during their passing-out parade at Sandhurst, there was one soldier who really mattered: Prince Harry. It was difficult to capture both royals clearly in one frame. I was presented with a tiny window of opportunity to get the shot between the cadets' swords and ceremonial guardsmen marching in front of the Queen. Covering the event many times before was a great help for me, and I was able to get into a position where I could see Harry's face. I used a fast shutter speed of 1/1000 sec because of the 500mm lens and the fact I was working within a jostling crowd of photographers. The light was ideal—cloudy and bright with no shadows forming under the hats.

CAMERA: Canon EOS-1D MKII
LENS: 500mm
ISO: 200
APERTURE: f/5.6
SHUTTER SPEED: 1/1000 sec
LIGHT CONDITIONS: Natural, bright

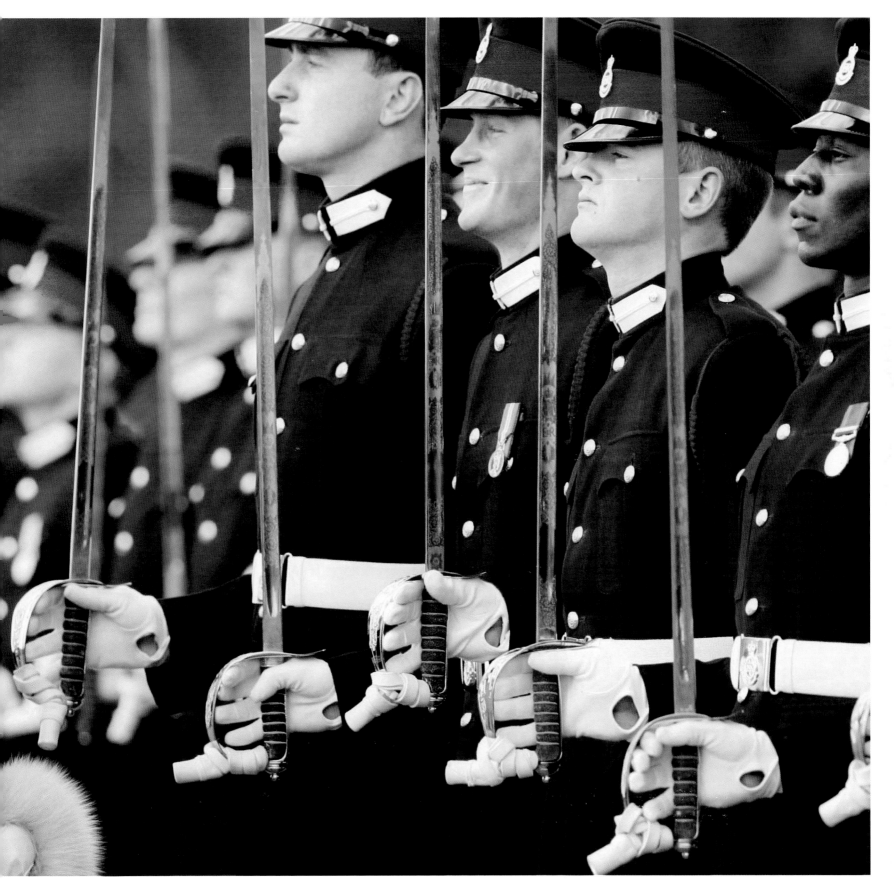

Tim Graham: Regal images

AS: Do you shoot what you want or do others generally define what's required of you?

TG: I always shoot what I want, but subconsciously I shoot with the end-user in mind. In forming my royal archive I've consciously aimed for depth and breadth of coverage, so my collection contains every possible aspect of royal life, including their work, homes, and pageantry—even the royal corgis!

AS: Where are you mostly based, and where are your most popular locations?

TG: Anywhere in the world that a royal trip takes me. Over the past 30 years I've visited more than 120 countries, some of them several times.

AS: Which types of places do you like to photograph in the most, and why?

TG: The more remote, the better. Places in which sounds, smells, sights, and people are different. I find such locations stimulating. A royal trip is less formal in these types of places, and it's often easier to get a memorable picture. India, Nepal, Bhutan, Patagonia, Central Asia, and the South Pacific islands have all been memorable.

AS: What things do you enjoy most about your job?

TG: Getting a good picture from a difficult or fleeting situation; the travel and camaraderie with fellow photographers. Within the royal press corps there are some real characters. We're all fiercely competitive, but none of us takes the others too seriously.

AS: From a technical aspect, what are the most difficult things about your photography?

TG: Having no control over who stands in front of me at the crucial moment. Having limited control over light, such as working in low-light conditions with a long lens. Digital cameras have been a revelation, however, and the latest generation is quite superb. Comparing these with the quality of 100-speed film transparencies from just 10 years ago gives me a shock.

Prince Harry, Queensland, Australia

It is rare to see a British royal looking so relaxed. Harry was working on a ranch in Queensland during his gap year, and the photo's informality is its appeal. It sold to quite a few publications. It wasn't an easy shot to take because of the harsh Australian sun, which can create shadows. I don't like to use fill-flash unless it is absolutely necessary; here there was just enough light bouncing off the ground to avoid using it.

CAMERA: Nikon D1X
LENS: 80–200mm
ISO: 100
APERTURE: f/5.6
SHUTTER SPEED: 1/1000 sec
LIGHT CONDITIONS: Natural, strong sunlight

AS: How would you describe your personal style or technique?

TG: Shooting bold and tight. Look at magazine spreads and covers—it's what they use all the time. They're the first pictures to catch a client's eye on the internet.

AS: What's in your kit bag? Which camera system do you use and why?

TG: I've been using Canon for the past few years. It's the manufacturer that's been ahead of the game with digital file quality as far as I'm concerned. My lenses are diverse, from 15 to 500mm, used with extenders where necessary, and the body I choose is an EOS-1Ds MKIII. The incredible resolution and quality enables me to crop to a smaller area of the frame if I need to. I also use an EOS-1D MKII when I need a higher frame rate. I find the level of personal customization on the latest Canon cameras a great asset. Prior to these I used Nikon for 30 years and, for me, they're still the most rugged lenses and cameras. My other main pieces of kit are Gitzo carbon-fiber tripods and monopods. Each is useful because weight is always an issue when lumbering kit to any location.

Prince William and Claudia Schiffer, Steventon, England
Every summer in England there are a lot of polo matches that feature the royal princes. Many, including this one, raise funds for charity. I knew this picture would generate much interest. The secret of a good kiss shot is to harness the power of suggestion and capture it before the kiss is actually planted. That way you get to see both faces.

CAMERA: Nikon D1X
LENS: 80–200mm
ISO: 200
APERTURE: f/5.6
SHUTTER SPEED: 1/500 sec
LIGHT CONDITIONS: Natural, fill-flash

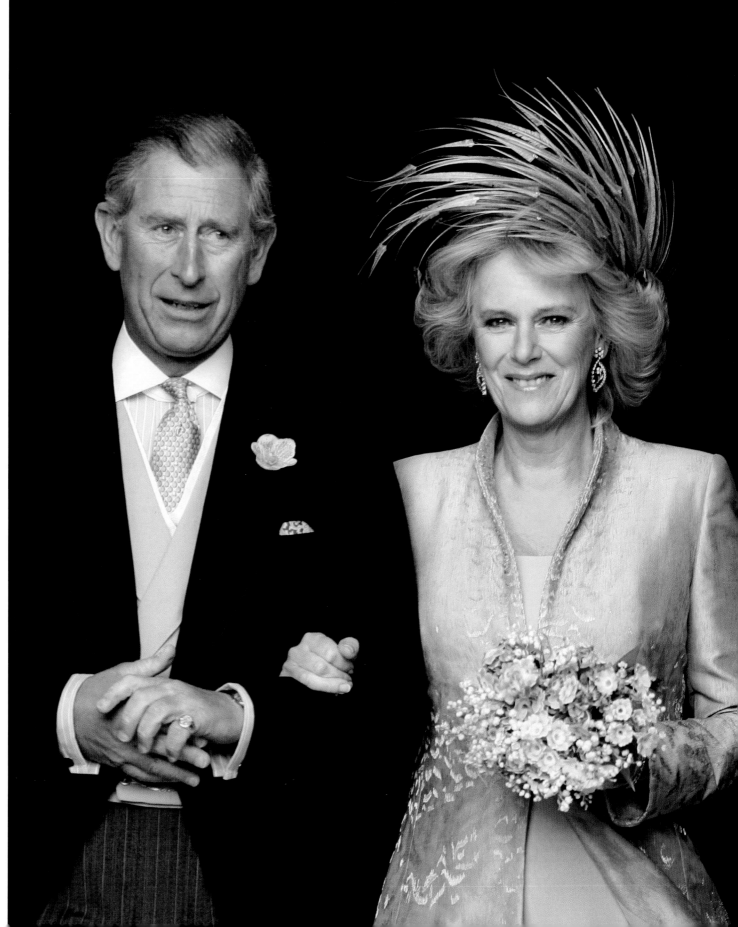

**Charles and Camilla,
Windsor Guildhall, England**
This shot was taken in 2005
following the couple's marriage
blessing in St. George's Chapel,
Windsor Guildhall. I was one of
only six photographers allowed
to work there. I'd purposefully
picked a central position at the
entrance to get a good, clean
background as the couple left
the chapel. This made the picture
ideal for magazine covers—
something I always look for.

CAMERA: Canon EOS-1D MKII
LENS: 500mm
ISO: 400
APERTURE: f/4
SHUTTER SPEED: 1/500 sec
LIGHT CONDITIONS: Natural,
cloudy

AS: Do you try to make sure your work appeals to the widest possible audience?

TG: Yes. I aim to shoot pictures for tomorrow's daily papers and the coming week's magazines. Different pictures are required for different media. I'll take more photos of an actual event for up-to-date magazine use; and I'll take more stock-orientated close-up shots for future use in books and for TV. There are also many commemorative uses for my photography, such as royal stamps. Having compiled a royal archive over more than 30 years, I'm aware that many images have historical significance, and I've arranged for all my photographs to become part of Getty Images' Hulton Archive. This ensures the collection stays easily accessible, active, and intact for years.

AS: When are the busiest times of the year for you?

TG: It parallels the royal calendar. I'm busiest from February to early August, and from October to Christmas.

AS: Which places or things do you most dislike photographing?

TG: Massive events in which over-the-top, part-time security personnel have little understanding of my role and working methods. Some of the general public are actually unaware of how well-served they are by today's photographers. Every time people open a newspaper or magazine there are images informing, educating, and entertaining them.

AS: What types of pictures do you find the most difficult to take?

TG: The boring ones; those unlikely to be published, but ones I feel I should record because I'm there. Unfortunately, however worthy they are, some events just don't make a good photograph: a member of the Royal Family unveiling almost anything, cutting a ribbon, or planting a tree. They're almost never published. It's sometimes frustrating that organizers don't give more thought to a picture opportunity that identifies the event or charity more decisively. Princess Diana instinctively knew what would make a good picture, one that would sum up her visit or focus world attention on one of her causes. She knew exactly how to get in tomorrow's papers.

AS: Which do you prefer, digital or film, and why?

TG: Digital. Its convenience and the ability to check everything is working correctly before shooting cannot be matched by film. With digital I'm able to check immediately that I've got the shot, while digital camera quality—particularly at higher ISO settings—is now excellent. There's the backup ability, too. I used to freight home 10–20 rolls of film per day on royal trips. Hours were wasted at airports. I never lost a shipment, but some were badly delayed. Digital allows a picture to get to market within minutes, even seconds if necessary. The files can be backed up or transmitted home securely.

AS: How much of your work do you manipulate using imaging software?

TG: All photographs come out of my EOS camera as RAW files and totally unsharpened. They're color-adjusted and sharpened in Photoshop, but obviously—as they are essentially news photographs—no other manipulation is appropriate.

AS: What do you consider your greatest photographic achievements to date?

TG: Staying as a successful freelance in a very competitive profession for this long.

AS: What does the future hold for you?

TG: More time off! But also more picture situations that will publish well.

Princess of Wales, Al-Azhar Mosque, Egypt
As Diana was making her way through a shady alley around an Egyptian mosque, she stopped to look up momentarily. I was able to capture the moment. This image works well because Diana seems alone; it was rare to get a picture in which she was not surrounded by an entourage.

CAMERA: Nikon F5
LENS: 300mm
ISO: 100
APERTURE: f/2.8
SHUTTER SPEED: 1/125 sec
LIGHT CONDITIONS: Natural, shade

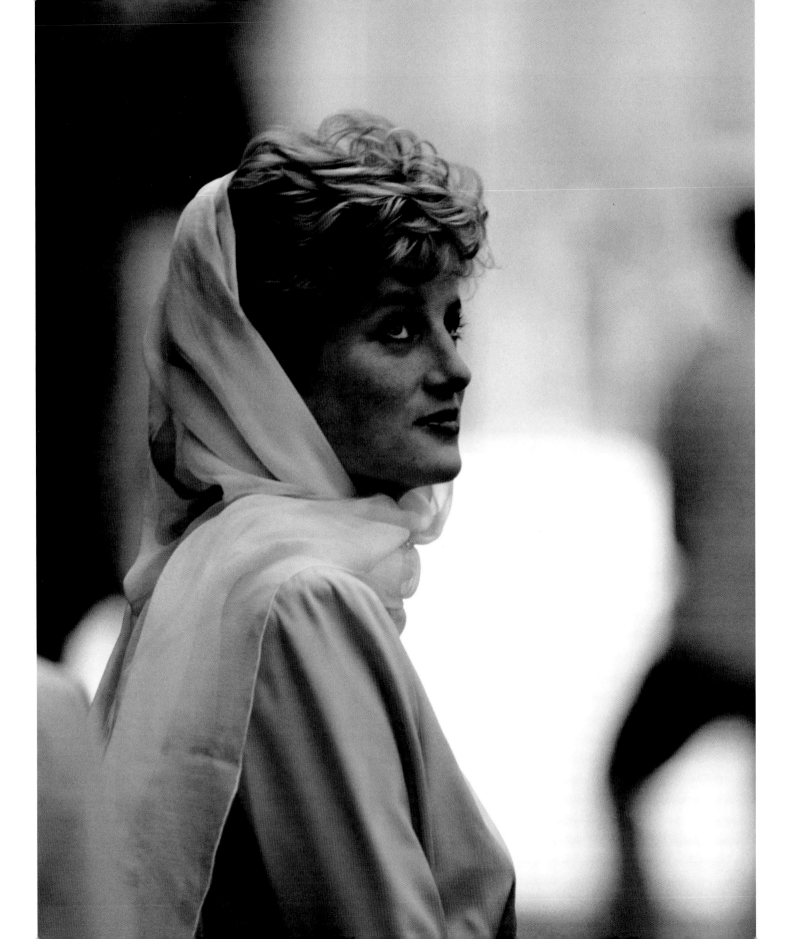

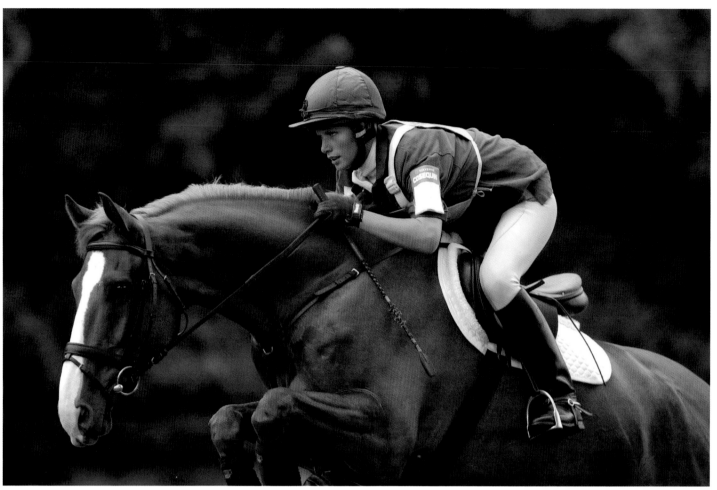

Right: **The British Royal Family, Clarence House, England**
It's unusual to get so many members of the Royal Family in one large group; it had been 35 years since such a gathering took place. Even though I had requested everybody to look at my camera, the Queen is looking away, and so is Prince Harry. The BBC was filming a session for inclusion in the Queen's Christmas broadcast and she became distracted by a cameraman as I took the shot. There were other frames, but in each one a different member of the group was captured with eyes shut, or with an unflattering expression. I would have liked more time, and to get a more perfect result.

CAMERA: Canon EOS-1D MKII
LENS: 24–70mm
ISO: 100
APERTURE: f/14
SHUTTER SPEED: 1/60 sec
LIGHT CONDITIONS: Elinchrom flash and umbrellas

Above: **Zara Phillips and Toytown, Oxfordshire, England**
I love taking sporting pictures such as this. Zara was riding Toytown during the Cornbury Park horse trials. I was looking for a tight shot of rider and horse, with a clean background, which is what I achieved.

CAMERA: Nikon D1
LENS: 600mm
ISO: 400
APERTURE: f/4
SHUTTER SPEED: 1/1000 sec
LIGHT CONDITIONS: Natural, cloudy

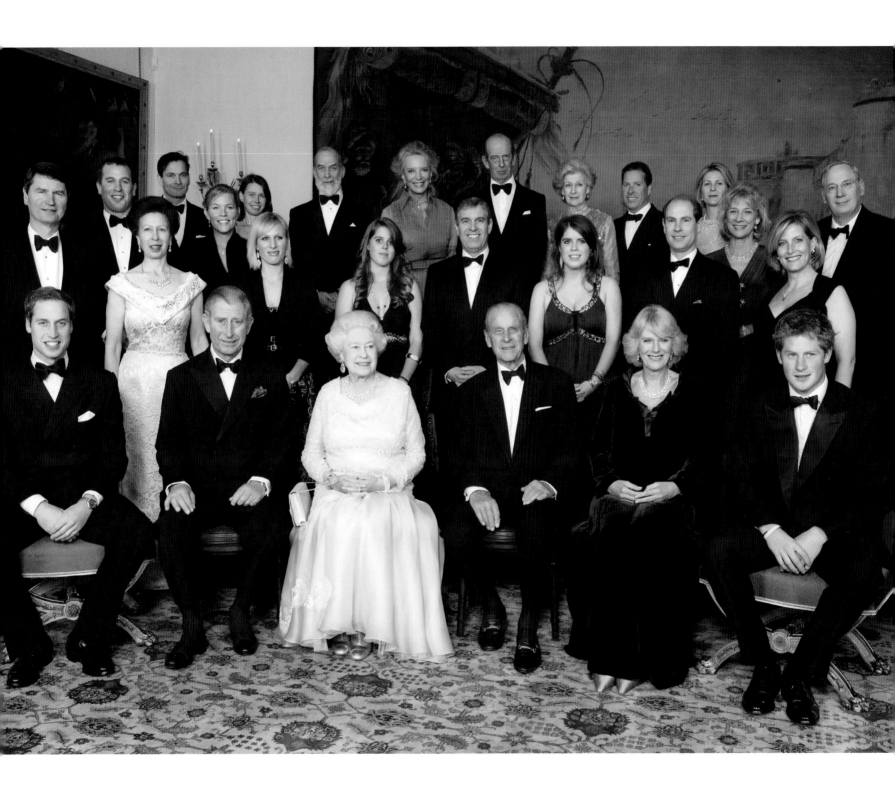

Tim Graham: Regal images

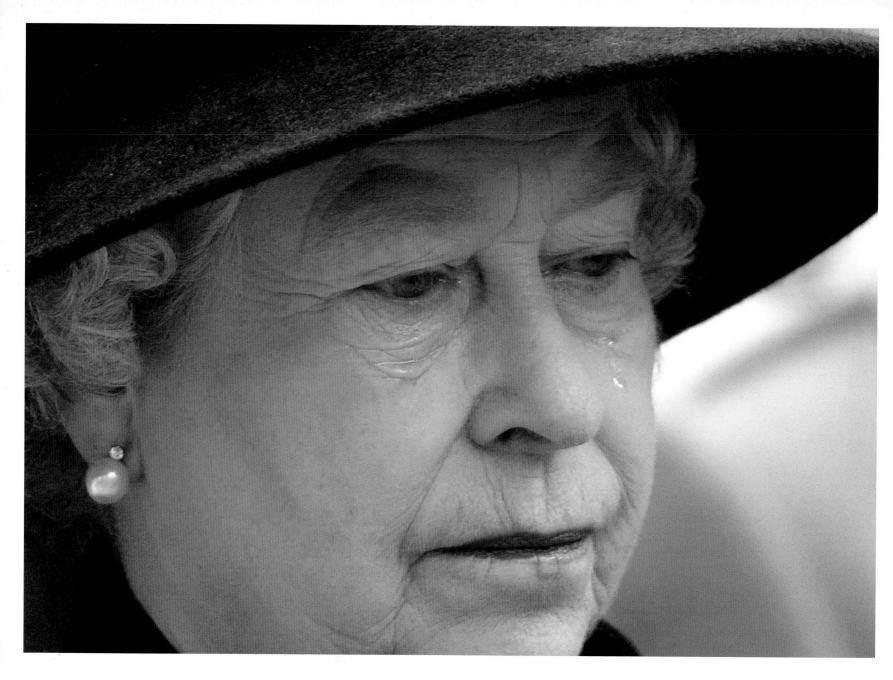

The Queen, Westminster, England

I had seen tears in the Queen's eyes before, but I'd never seen her cry in public. This picture showed her human side. There was a lot of speculation at the time—in 2002—as to why. She was attending the Service of Remembrance at St. Margaret's, shortly after the deaths of the Queen Mother and Princess Margaret. I think they were on her mind. It was a ceremony that had been the Queen Mother's own. The shot made a double-page spread in *Paris Match*.

It is a good angle, taken from a tight, pre-allocated press position. Light was very low, so I shot at ISO 800. Any higher and the digital quality—at that time—wouldn't have been good enough. I used a monopod to get a sharp frame.

CAMERA: Nikon D1X
LENS: 600mm with 1.4×
converter
ISO: 800
APERTURE: f/4
SHUTTER SPEED: 1/125 sec
LIGHT CONDITIONS: Natural

Tips for Success

1. Take lots of pictures
The digital era is a wonderful, low-cost learning curve. The more pictures you take, the better chance you'll have of creating the perfect shot. Be your own strongest critic and ask others for honest opinions too.

2. Look at other photographers' work
We all learn from other people's ideas and techniques. Why is a particular lens used? Why this angle? Does it work? Don't feel bad about picking up ideas from others: it's how you learn. We all do it, by visiting exhibitions, looking at photo magazines and books, and noticing trends.

3. Keep portfolio pictures to a minimum
If you're seeking work and need a portfolio, cut the number of pictures down. Picture editors are short of time and many can see talent in just a few pictures. Show no more than 10 or so images, and ensure they are suitable for the style of a specific publication.

4. Leave your camera settings ready to shoot
When you pack your camera away, try to leave it with the settings you would most often use to shoot with. For me these are medium ISO, high shutter speed—say 1/500 sec—set in Shutter Priority mode, and file quality set to RAW. You could miss a vital picture if you have to fiddle with settings after switching on.

5. Know instinctively which way your shutter speed dial rotates
Is each click on the dial a third of a stop or a full stop, to give higher or lower shutter speed? A few clicks right and you could freeze the action, while a few clicks left may produce a longer exposure time. I know I could look at the viewfinder display, but, if everything is happening fast, I want to be looking at the subject only.

6. Have a clear idea of the picture you want
When shooting a portrait, for example, have the picture you want clear in your mind, and shoot that first. Try the secondary pictures only when you're happy with the main image. Importantly, don't be indecisive, as your subject may lose patience and confidence in your ability.

7. Use light to your advantage
Light is both the photographer's friend and enemy. Try using soft shade with a reflector, bouncing light into the shadows. Window light with a reflector to light the shadows produces good results. If you can't afford studio lights, try to work with available light, or use a standard, dedicated flashgun, firing it through a softbox in order to diffuse the light.

8. Early light is best for landscapes
If you enjoy shooting landscapes, the best light is during the first hour after dawn. In spring and summer that may mean being in your location by 5.00am, waiting for those first rays of sunshine. It's a magical time and you'll have the world to yourself.

9. Think about the publication
When taking a classic portrait, leave space above the subject's head so a magazine title can be inserted. In my field we do this all the time—the image will have a better chance of making a cover than a quarter-page. Additionally, when shooting a landscape image, make sure the gutter of a double-page spread won't go down an important part of the image; shoot offset, left or right, to give designers space to play with, as well as room for including words.

10. Shoot portraits with a very wide aperture
This works well with lenses such as 35 and 85mm. A very wide aperture, such as f/2, will give a background with wonderful softness. You'll give an impression of the subject's environment without it intruding on the face.

The Queen's Irish State Coach, House of Lords, England

The Queen's ornate Irish State Coach is used for important state visits and, for me, sums up the pomp and ceremony of the British monarchy. The picture is a mixture of daylight streaming in from the iron gates and fill-flash, to fill the shadows with light. I chose to shoot with an aperture of f/4, because I needed some speed to prevent movement. The chap giving a salute is actually one of the Queen's personal protection officers, dressed as a footman.

Essential Equipment

- Two Canon EOS-1Ds MKIII camera bodies

- 15mm f/2.8 lens

- 17–40mm f/4 lens

- 24–70mm f/2.8 lens

- 24–105mm f/4 lens

- 70–200mm f/2.8 lens

- 300mm f/4 lens

- 500mm f/4 lens

- 1.4x and 2x teleconverters

- Canon 580EX Speedlite flashgun

- Lexar Media 8GB CF cards

- Portable 160GB hard drive

- Gitzo carbon-fiber tripod/ monopod

Specification

CAMERA: Nikon F5

LENS: 28–70mm

FILM SPEED: 400

APERTURE: f/4

SHUTTER SPEED: 1/125 sec

LIGHT CONDITIONS: Natural and fill-flash

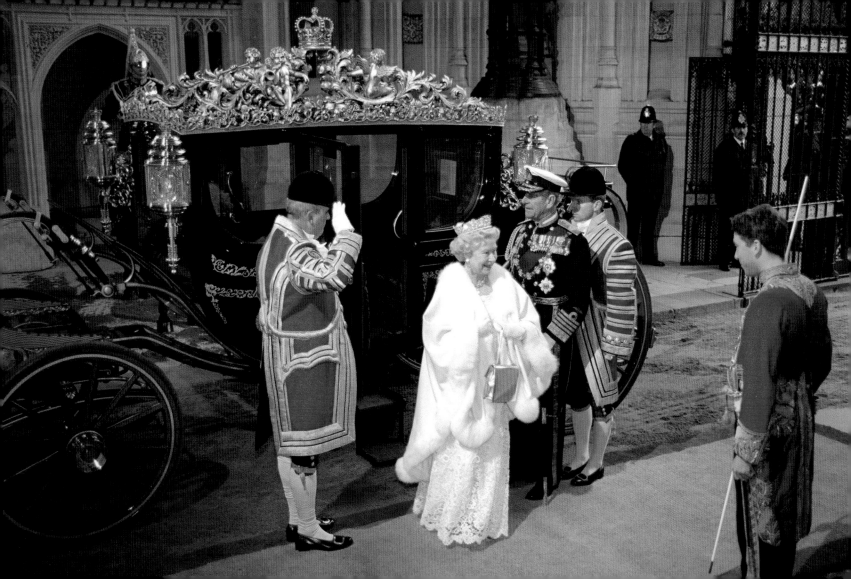

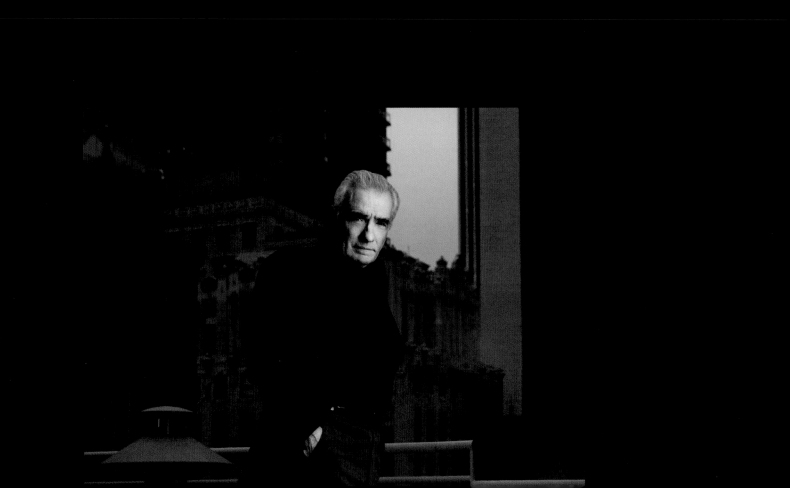

Michael Grecco

Hollywood A-lister

Michael's progress from his cheerless days as a fast-paced news photographer to an LA lifestyle befitting his ambitions is a motivating story. "I used to hate my job," he confesses, referring to a 13-year stint that included the *Boston Herald* and Associated Press. "Being able to use my imagination is really important and I like to show it in my work. The pictures I take now enable me to do this." He photographs beautiful, rich, and talented people of the entertainment industry; the stars of movies, television, and music.

It would be easy to get carried away with your own importance if you spent much of your life photographing Hollywood's rich and famous, but not Michael Grecco—for him, the craft of photography is the most important thing, and celebrities are merely other professionals doing their jobs. Working from his base in Santa Monica—where he has a small studio in his home as well as a main place of work—his pictures appear in magazines, on posters, and as publicity material all over the world.

Martin Scorsese
I wanted this image to speak of Manhattan and the "mean streets" of New York, which many of Martin Scorsese's movies are associated with. I wanted him on a roof overlooking the city, but he didn't want to travel far from his office, because of his busy schedule. His office—in the Director's Guild of America Tower on 57th Street—offered me the roof deck. I liked the view, but hated the railing that blocked it; to solve the problem I decided to put Scorsese on a platform of apple boxes, which is standard equipment on a movie set.

CAMERA: Hasselblad H1
LENS: 50–100mm
ISO: 100
APERTURE: f/11.5
SHUTTER SPEED: 1/250 sec
LIGHT CONDITIONS: Overcast with strobe

AS: What was your first ever camera?

MG: A Mamiya-Sekor 35mm unit. I had to screw the lenses on and off. This was—at the time—the cheapest 35mm camera you could buy!

AS: Where do your ideas for innovative pictures come from?

MG: I try to exploit personality. If someone is playing a particular role in a movie, I'll try to base my photography on his or her character. Sometimes it's an organic process. The set-building and finished product evolve while we're working on the day, once we know more about each other. But usually my subjects have been photographed before and they know what to do. My concepts are seldom irreverent to them.

AS: Why did you decide not to do other types of photography, such as sports or nature work, for example?

MG: Imagination is important to me and I like to show that in my work. I used to work as a news photographer. I hated it. I suppose I was totally out of sync in that role—I had specific ideas of what might happen and if they didn't happen I was very disappointed after the shoot. Ultimately I had no interest in capturing reality; I'm more interested in creating a picture that's part me and part my subject.

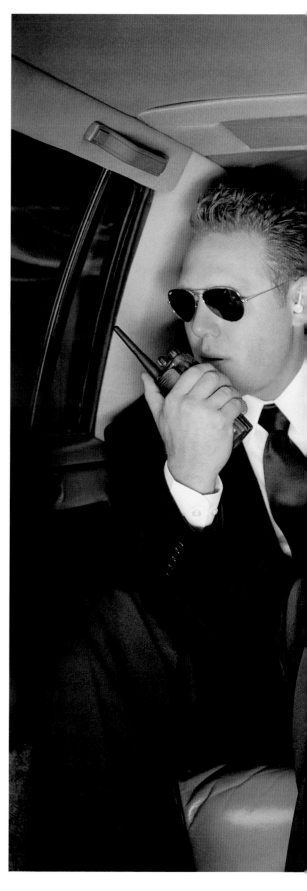

Chris Rock
Chris was making *Head of State*, in which he played the first African-American US President. Including bodyguards in the shot would tell that story well, particularly if I captured them in a presidential limousine. Rather than shooting in a real limo, facing the challenge of how to squeeze my equipment into a confined space, I rented a rear limo section designed to function as a set. I had complete freedom to position the lights where I needed them. To enhance the reality of the shot, I lit the entire scene from below with a horizontal, medium-strip Chimera softbox. This underlit everyone as though they were lit by a light inside the car. The background in the windows was added digitally afterwards.

CAMERA: Fuji GX680 III
LENS: 80mm
ISO: 100
APERTURE: f/8.5
SHUTTER SPEED: 1/125 sec
LIGHT CONDITIONS: Interior strobe

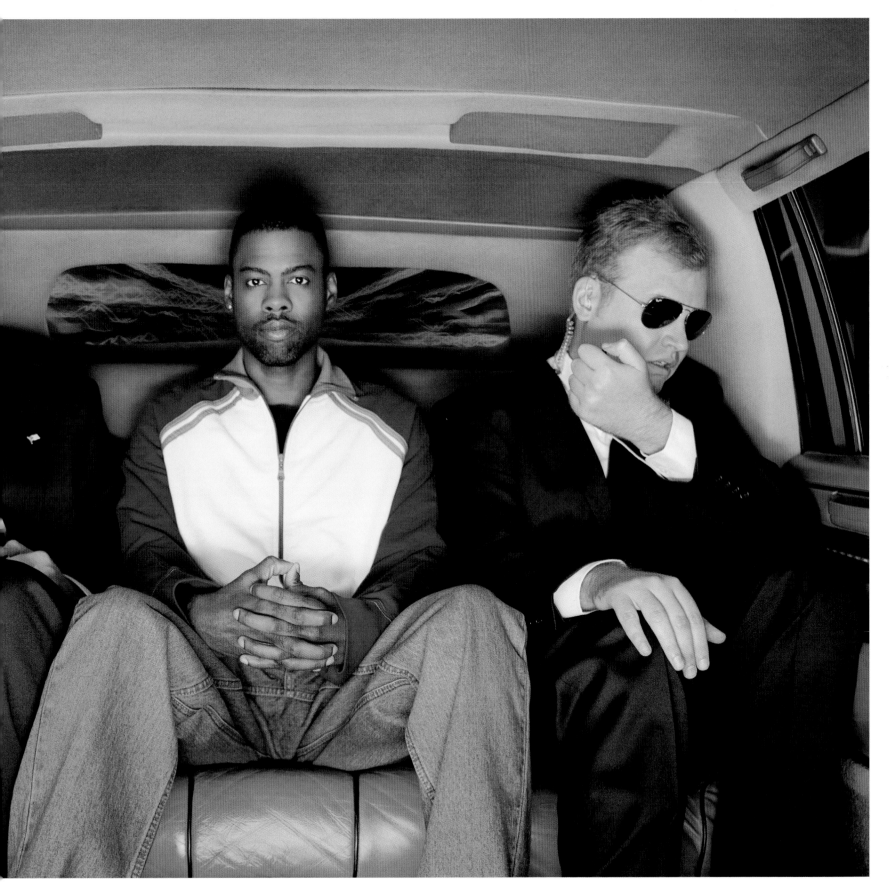

Michael Grecco: Hollywood A-lister

Johnny Knoxville
I shot *Jackass* supremo Johnny Knoxville for *TIME* magazine. I wanted to create the idea of just how crazy Johnny was in his TV shows and movies, but when he walked through the door, he refused every idea I suggested. In the end this shot came about because of the subtleties of his expression, as well my efforts to coax a little playfulness from him. When he broke out his moustache comb I knew that I had succeeded.

CAMERA: Fuji GX680 III
LENS: 120mm
ISO: 100
APERTURE: f/11
SHUTTER SPEED: 1/125 sec
LIGHT CONDITIONS: Interior strobe

AS: Is it fair to say, like many successful photographers, that you had a "lucky break" at some stage?

MG: I see my career like a wave—it's been a steady ebb and flow, and there's been no particular event that has shot me through the roof.

AS: Do you shoot what you want or do others generally define what's required of you?

MG: People choose me for my style—I have my vision and they have their needs, and we collaborate together. I bring to the table what I can offer and, of course, I want to make the client happy.

AS: Where are you mostly based? Where are your most popular locations?

MG: My main studio is in Santa Monica and I live nearby. I also have a small office and shooting space in my home. I shoot in New York a lot, where I tend to photograph on location.

AS: Which types of places do you like to photograph in the most, and why?

MG: LA, naturally, but New York is the other big place. I've also shot in the UK, Switzerland, Singapore, Korea, Australia, and New Zealand, among others. But I go to shoot personalities— not the characteristics of the country.

AS: What things do you enjoy most about your job?

MG: Experimenting brings results. I'm creative and it makes me happy to work this way. I try to embrace all aspects of my job, not just technical, but also being a businessman and continually promoting my brand to elevate my career. There are other enjoyable aspects of my work than just photography.

AS: From a technical aspect, what are the most difficult things about your photography?

MG: The challenge each day is to maintain my diligence and to work efficiently. Some personalities are difficult to work with, but most are professional. Technical things such as lighting become second nature.

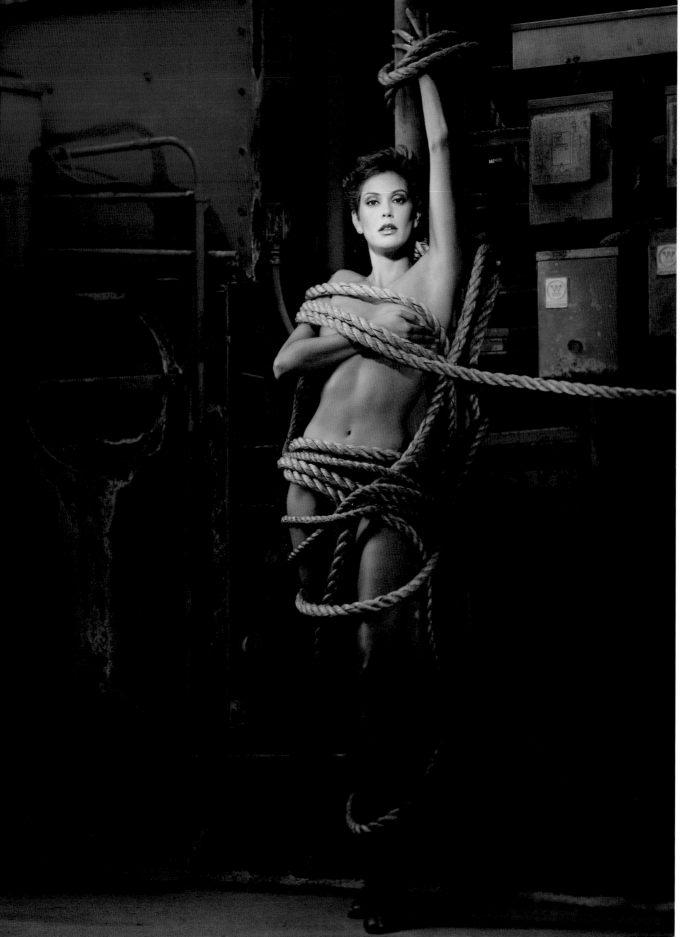

Teri Hatcher

I thought I could combine a very sexy cover of Teri Hatcher, with the concept of Lois Lane being tied up and left for Superman to save—but it was a no-go. Teri was leaving the TV show for the movies. She did, however, agree to go through with the rest of my concept, to take off her clothes and allow me to tie her up. The image was still pretty successful. It was shot in the middle of the day and lit to look like nighttime in a basement.

CAMERA: Fuji GX680 III
LENS: 80mm
ISO: 100
APERTURE: f/11.5
SHUTTER SPEED: 1/400 sec
LIGHT CONDITIONS: Exterior strobe, natural midday light

AS: How would you describe your personal style or technique?

MG: Conceptual portrait photographer. Importantly, I don't take the same types of pictures every time I walk out the door.

AS: What's in your kit bag? Which camera system do you use and why?

MG: I currently use two camera systems. The first is a Leaf Aptus 75 with 33-megapixel digital back. It shoots 1.1fps (frames per second) and I keep a core range of lenses with focal lengths that suit my methods: 50mm wide-angle, 80mm prime, and 150mm for portraits. The second camera is a Canon EOS-1Ds MKIII; it was one of the first to arrive in the USA and it's ridiculously amazing. I have a 24–70mm lens and, when using available light for portraits, an 85mm lens. I also regularly use a beautiful, pin-sharp 135mm unit. Any time I need a longer focal length I shoot with a 70–200mm lens, but this is rare. There are times to use a prime lens, and times to use a zoom lens. I keep a lot of SanDisk CompactFlash 4GB cards. I never use hotlights, only Dyna-Lite custom-made light packs and, in my Santa Monica studio, I almost always use M-2000X packs. I also own a Canon 580EX Speedlite flash, although I seldom use it.

AS: Do you try to make sure your work appeals to the widest possible audience?

MG: My client is the magazine or advertising agency. If I take engaging images of people within the entertainment industry, and my clients like what they see, I don't care whether it appeals to a wide audience or not. The widest audience doesn't necessarily have the best taste.

AS: When are the busiest times of the year for you?

MG: There is no rhyme or reason to my schedule. I react to work as and when it happens. I always have projects on the go and I'm a busy person.

AS: Which places do you dislike traveling to the most?

MG: I'm not a big fan of Singapore—it's too hot. And how can you really love a place if people get arrested for spitting out chewing gum on the street? More positively, Europe is attractive, and I like being there and working there.

Owen Wilson and Ben Stiller
This image was made during a long press coverage for *Starsky and Hutch*. Owen Wilson and Ben Stiller were both totally exhausted. Every time I tried to control the shot and direct Ben, he looked at me with a blank stare—the exhaustion really showed. This was for a large feature for *TIME* magazine and the pressure was on to illustrate the story of the movie, not the actors' tiredness. I recognized early on that I had no control over the situation, so I just let go. In the end I let Owen tell Ben jokes and shot the images as the laughs unfolded.

CAMERA: Fuji GX680 III
LENS: 120mm
ISO: 100
APERTURE: f/16
SHUTTER SPEED: 1/125 sec
LIGHT CONDITIONS: Interior strobe

Quentin Tarantino
I photographed Quentin as part of a full-page image for *Playboy* magazine's 20 Questions. This shot came to me by chance. I didn't want to duplicate the many photos I had seen of Quentin with guns, dead bodies, or blood. As I was walking down Main Street in Santa Monica, I saw this great prop in the window of a store—a Frankenstein-esque voltage generator, which enhanced his status as a high-voltage director. Quentin was great; he played with the prop and the shot really worked. We did it in the back of the Hollywood Cantina, where they have an old Airstream trailer. I used just one light, my Fresnel. It was barn-doored in a slit, just to place the light on Quentin. I then blended the available light to fill in the shadows by increasing the exposure time with a strobe.

CAMERA: Fuji GX680 III
LENS: 120mm
ISO: 100
APERTURE: f/8
SHUTTER SPEED: 1/60 sec
LIGHT CONDITIONS: Overhead daylight with strobe

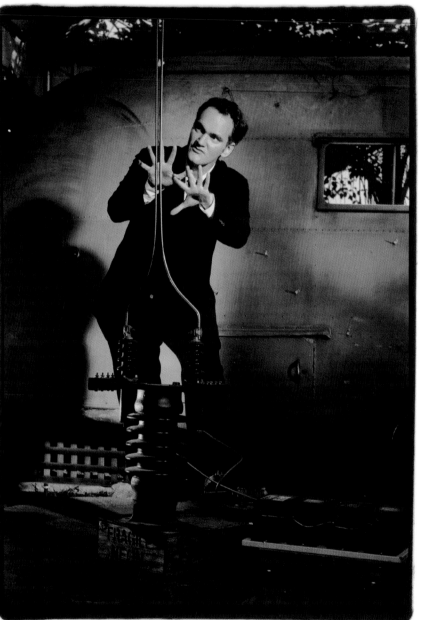

AS: What types of pictures do you find the most difficult to take?

MG: Kids and animals.

AS: Which do you prefer, digital or film, and why?

MG: I was wary of conversion to digital. I used to think being tethered to a computer and having everyone look over your shoulder wouldn't be a good thing. But since switching to digital the experience of looking at my images as they are coming up live is unbeatable. I get immediate feedback and so do my clients, which makes them more relaxed. I know immediately if I made the shot or not—and I know how to improve on it, immediately. I'm not left wondering, as with film, whether I got "that shot." Digital suits the way I work.

AS: How much of your work do you manipulate using imaging software?

MG: I try to shoot things as close to reality as possible. My images are ultimately based in reality and I want them to look real. That said, I retouch everything on the commercial side. I may retouch a wrinkle, or make minor alterations to make someone look better. But I don't want to change what people look like. Photoshop CS3 enables me to do this.

AS: What do you consider your greatest photographic achievements to date?

MG: My book, *Naked Ambition*, is my first coffee table–style publication. It's the most comprehensive illustration of my work and an amalgamation of the photojournalism and portraiture in my career.

AS: What does the future hold for you?

MG: I'm in love with photography, but I'm interested in taking my work into the moving image. I'm fascinated by how this would work, and I'm trying to find a way. We had a major show of *Naked Ambition* at the Stephen Cohen Gallery in LA and I'm looking for similar shows in England, France, and Germany.

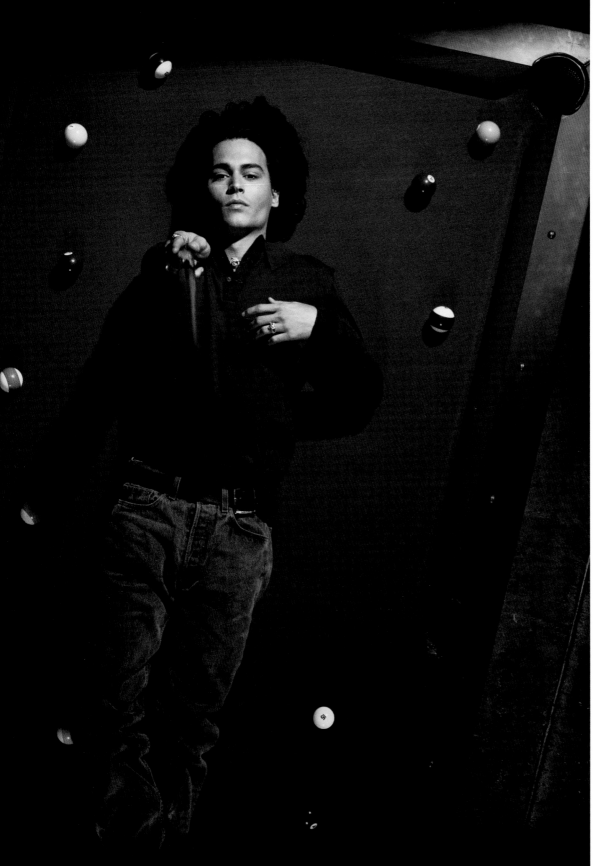

Johnny Depp

The Johnny Depp shoot was in a studio called Smashbox, in LA, which has a pool table. I wanted an image that was totally different. I decided to shoot straight down on Johnny, who lay on the table. Since he wasn't feeling well that day, it became his favorite place. I asked the studio owners for a ladder, to shoot from the rafter above the pool table. The complicated part of this setup was the logistics of securing the camera, so that it wouldn't fall on our subject. I opted to hand-hold the camera with safety line, so if it fell, it wouldn't fall far. I was balanced on a six-inch piece of wood and I couldn't move for fear of falling or, literally, messing up the shot. Thankfully it all came together.

CAMERA: Hasselblad H1
LENS: 80mm
ISO: 100
APERTURE: f/8
SHUTTER SPEED: 1/125 sec
LIGHT CONDITIONS: Interior strobe

Hugh Hefner

I was to photograph Mr. Playboy himself—Hugh Hefner—with some of his "friends." But I had no idea it would be six girls and a dog! I needed three different shots inside, plus a gatefold cover for a TV magazine. I had 30 minutes to shoot everything and knew I had to provide correct lighting for the hardest image—the gatefold. Several shots were variations of the cover image. When the dog poked his head into the middle of the crowd, I knew I had the shot. Everything went well and I even had five minutes to spare. I've received my holiday card from the Playboy Mansion ever since.

CAMERA: Fuji GX680 III
LENS: 80mm
ISO: 100
APERTURE: f/11
SHUTTER SPEED: 1/125 sec
LIGHT CONDITIONS: Interior strobe

Will Smith

Will Smith had his own clothing brand and wanted to wear this coat in the shot. I used the all-white outfit against a very neutral environment, on the stairs, hoping it would all work together, but I had a problem because his white trousers were very close to the light. I grabbed one of my fabric grid spots for the softbox, tucked up just above the camera, in the stairwell. Not even the white fabric showed up very well, because there was no fill-light anywhere, so I invented a little trick—I opened up one portion of the grid to expose the white of the silk (this left some of the softbox focusing the light through the grid), and some of the softbox scattering the light around. As Will got more comfortable he started really "putting out" for me, and gave me a great shoot.

CAMERA: Hasselblad H1
LENS: 80mm
ISO: 100
APERTURE: f/8
SHUTTER SPEED: 1/8 sec
LIGHT CONDITIONS: Skylight and strobe

Tips for Success

1. Look at what you're shooting

This point might sound silly, but it's not. Visualize the light and scene before taking the shot. I sometimes squint and make the picture in my mind, to become my first "Polaroid."

2. Ask yourself what do you want to say about the person

Figure out where a good place to shoot them may be. This works on both intellectual and emotional levels, as far as locations and your styling are concerned. Think about the "feel" you want and then communicate this in your image.

3. Use professional support whenever possible

If you can bring in talented hair, make-up, and wardrobe stylists, do so. Stylists often work to get images in their portfolio, with some advance notice. Develop a relationship with talented people such as these.

4. Study your subject's face as you shoot

You'll need to see if your lighting is working as you take photographs. Where you put the light can make a big difference to how good someone looks. I often move lights from one side of the face to another, or up and down, just because it will make someone look better.

5. Use rectangular softboxes and strips in the vertical position

This is a must for portrait photography—unless you're shooting a large group of people with light coming from underneath the camera.

6. Avoid the midday sun

This is only true in sunnier climates, but a useful tip because of the intensity of light. You can use certain aids to reduce the effects of the sun, such as a small, portable silk, or turning your subject, so they become backlit by the sun. But the simple fact is that you can't overpower strong outside light.

7. Start by lighting a set with your subject lit first

Create the hardness, mood, and contrast by lighting your subject before anything else—then increase light around the scene, one light at a time.

8. Always look at what you're doing on a color-calibrated monitor

Use a laptop or digital imaging cart; don't rely on the back of the camera's LCD screen to make subtle lighting adjustments, because it will always throw you off course.

9. Learn from others

Try to see how an experienced crew sets up and uses lighting effectively. I learned much of what I know from visiting movie sets.

10. Bring as much lighting gear as you can

I light just about everything; often I like to walk outside and grab a shot, not just be confined to indoors. Bring everything you can to each shoot. Leave it in your car, and if you don't use it, at least the option has been there.

Joaquin Phoenix

Joaquin Phoenix is very private and reserved. I had taken him outside for the shoot—but he wasn't comfortable. I quite liked the look of the waiting area in the nearby studio, and decided to photograph there. I didn't want to disturb the soft, beautiful way the sun naturally lit the room, so to light Joaquin, I used a small softbox on the lowest setting to supplement the light that was illuminating the room behind him. This made the exposure of his face balance with the rest of the room.

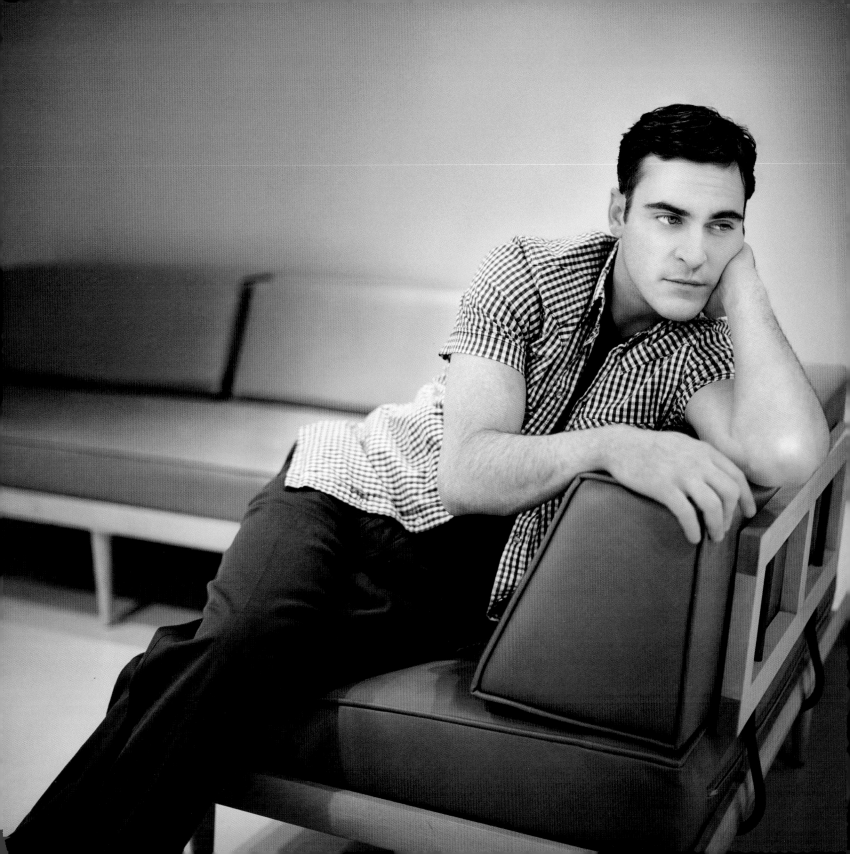

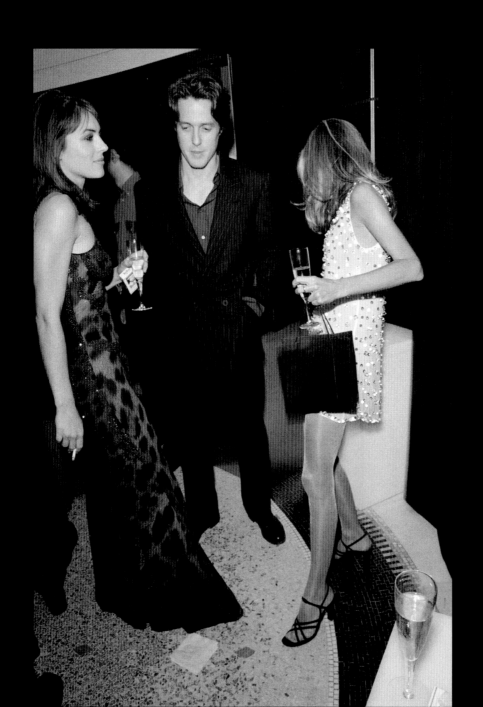

Photographic artist

I'm not interested in flattery or in making pretty pictures," says Miles Ladin. "If my images end up on gallery walls or magazine pages, then I feel joy that my commentary is out in the world and has the possibility to affect it." These words could only come from someone who is passionate about their vocation—someone who uses his camera in a reactive, spontaneous, and intuitive manner. Miles' unconventional style has earned him such a reputation in his native New York that he's attracted collaborations from many big industry players, chief among them legendary photojournalist Norman Mailer, who he worked alongside in the 1990s. Miles is a traditional photographer, using film and producing his own darkroom prints, but he is making a gradual evolution into the world of digital photography. He has published his work in two limited-edition books, *That Various Field* and *Lunch Poems*, each a collection of unbound photographs and poems. "I tend to work better under pressure. Sometimes at an event I feel like a dog chasing a bone. I often take my best pictures if I'm on the hunt and need to rely on pure instinct."

Liz Hurley, Hugh Grant, and Candace Bushnell
I was in a star-studded VIP room with my camera, waiting for the right moment, when I photographed the interplay between these three A-list celebrities. Shooting with a 28mm lens, very close to my subjects, I tilted my camera down to include a glass of champagne in the lower right-hand corner of the image. The foreshortening of the glass helps to create a visually claustrophobic composition.

CAMERA: Nikon FE2
LENS: 28mm
FILM: Ilford HP5 Plus 400
APERTURE: f/5.6
SHUTTER SPEED: 1/15 sec
LIGHT CONDITIONS: Artificial (flash diffused with tissue)

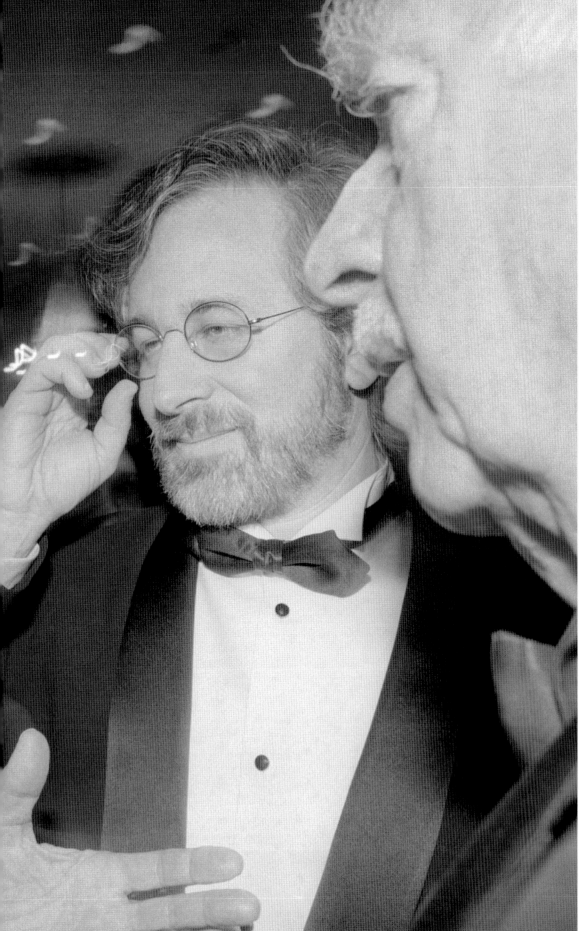

AS: What was your first ever camera?

ML: A Nikon EM SLR with 50mm lens.

AS: Where do your ideas for innovative pictures come from?

ML: From the social situation I'm shooting; a crowded and frenetic room or a project I'm interested in. Although I'm fairly intellectual, photography has been a much more intuitive reaction to the world in front of me.

AS: Why did you decide not to do other types of photography, such as sports or nature work, for example?

ML: My interest is in the human condition and in all aspects of how people relate to their world and the planet. I don't photograph celebrities out of adoration—nor am I trying to be mean-spirited. If my pictures reveal human frailty or reflect people's egos, I am in fact making them more "human," when compared to the mostly "surface" representations seen in magazines. I am a people person.

AS: Is it fair to say, like many successful photographers, that you had a "lucky break" at some stage?

ML: After working for some local neighborhood newspapers, shooting nightlife, I walked into *The New York Times* offices with my portfolio. I was hired the following week and eventually assigned to shoot a Sunday column entitled "The Night." This lasted for three years. I've never asked for favors, even though I did have a handful of connections that could have benefited my career. The only "lucky break" I had was when my mentor, photographer Larry Fink, gave my name to the creative director at *W* magazine, when he was unable to fulfill a photo shoot.

Steven Spielberg
At the Waldorf=Astoria Hotel, Steven Spielberg was given a tribute gala by his peers. In this picture, taken during the cocktail hour, Spielberg is surrounded by television journalists Mike Wallace (left) and Walter Cronkite. I love the idiosyncratic gesture of Spielberg touching his glasses. The slow shutter speed, which I normally use, allowed for the background lighting to "drag" into the image in order to create a sense of movement, whimsy, and delirium.

CAMERA: Nikon FE2
LENS: 28mm
FILM: Ilford HP5 Plus 400
APERTURE: f/8
SHUTTER SPEED: 1/15 sec
LIGHT CONDITIONS: Artificial
(flash diffused with tissue)

AS: Do you shoot what you want or do others generally define what's required of you?

ML: I was extremely fortunate at *The New York Times*, and later at *W* magazine, in that I was given freedom to shoot whatever I wanted, and however I wanted. My career has been this way since.

AS: Where are you mostly based, and where are your most popular locations?

ML: I'm based in New York. Over the years I've shot all around the USA, and in Paris, France.

AS: Which types of places do you like to photograph in the most? Why?

ML: I like photographing social situations that are new to me. When I first started shooting for *W* magazine, I'd never been to events in which the glitterati rubbed shoulders. It's not that I was starstruck, rather that it was a different environment, full of new sights, sounds, and smells that I could explore with my camera. When I covered fashion shows in Paris, it was also a very specific world that I had never seen before.

AS: What things do you enjoy most about your job?

ML: Making an image that I feel is really successful. It should be stylistically strong—or even unique—and at the same time reveal something about the subject.

AS: From a technical aspect, what are the most difficult things about your photography?

ML: I photograph celebrities almost exclusively with an old-school, hand-held flash. I'm recording moments and acting on intuition. A lot rides on dexterity: on my being able to see, predict, focus, and move the flash to light the scene in a very specific manner, and in a very short time. Often parts of the image are overexposed by flash. As good as my exposures can be, there's no way around this problem. Black-and-white film, however, is very forgiving—color film less so.

Robin Williams
During a Spielberg tribute night in New York, I captured a sardonic Robin Williams; he reminded me of the literary character Faust. Barry Diller and Diane von Furstenberg were on either side of him, but I focused on Williams. I included Diller's toothy smile, which echoes Williams' giddiness. The chandelier hanging above his head created a "drag" of light onto the image, due to the camera's slow shutter speed.

CAMERA: Nikon FE2
LENS: 28mm
FILM: Ilford HP5 Plus 400
APERTURE: f/5.6
SHUTTER SPEED: 1/90 sec
LIGHT CONDITIONS: Artificial
(flash diffused with tissue)

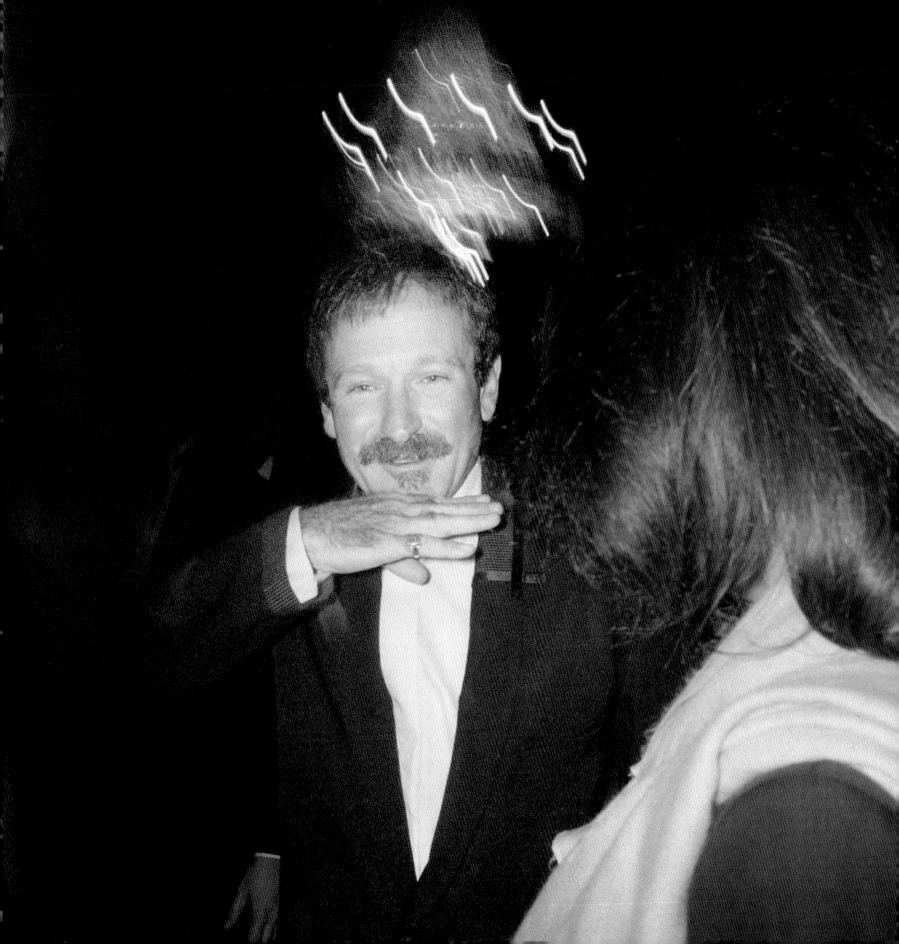

Stella McCartney
I took this picture at the opening of Stella's boutique, scheduled during New York Fashion Week. It was a very exclusive party—so exclusive that I wasn't granted access. After waiting around 20 minutes, the bigwigs from *WWD* magazine (my client) exchanged words with Stella's "people" and I was ushered in. After spending some time looking for the main celebrity, I spotted Stella and exposed two frames, including this image.

CAMERA: Nikon F100
LENS: 24–50mm
FILM: Kodak Tri-X 400
APERTURE: f/5.6
SHUTTER SPEED: 1/15 sec
LIGHT CONDITIONS: Artificial (flash diffused with tissue)

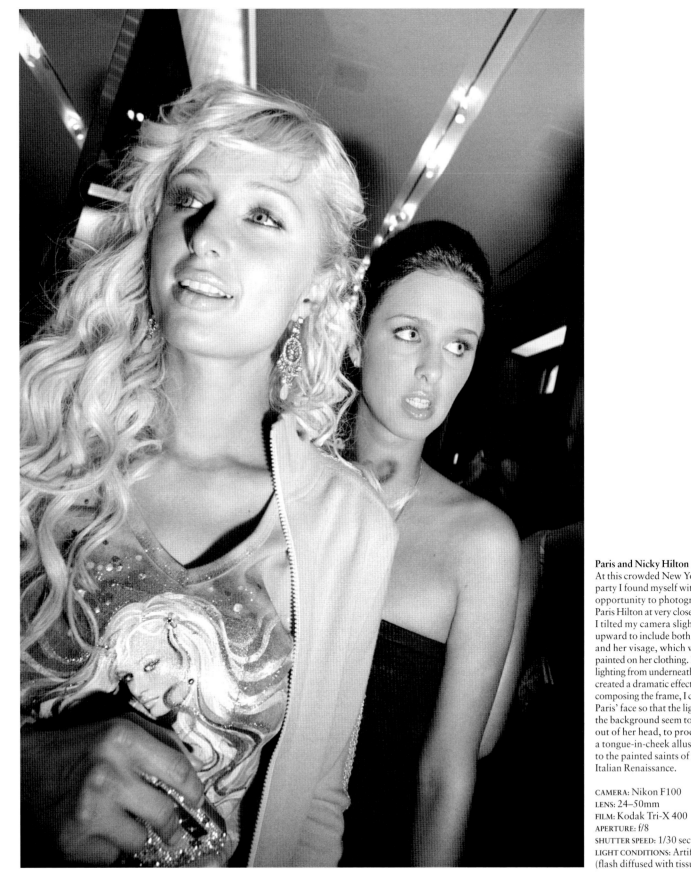

Paris and Nicky Hilton
At this crowded New York
party I found myself with the
opportunity to photograph
Paris Hilton at very close range.
I tilted my camera slightly
upward to include both Paris
and her visage, which was
painted on her clothing. I used
lighting from underneath, which
created a dramatic effect. While
composing the frame, I centered
Paris' face so that the lights in
the background seem to come
out of her head, to produce
a tongue-in-cheek allusion
to the painted saints of the
Italian Renaissance.

CAMERA: Nikon F100
LENS: 24–50mm
FILM: Kodak Tri-X 400
APERTURE: f/8
SHUTTER SPEED: 1/30 sec
LIGHT CONDITIONS: Artificial
(flash diffused with tissue)

AS: How would you describe your personal style or technique?

ML: It's an "in your face, I am there" style. Liquor is being served and the likes of Angelina Jolie give you a kiss on the cheek. I'm invited to these events and I'm part of the drama by invading the time and space of others. I take my pictures and present my spoils to the viewers, offering them a reaction to what I was feeling, experiencing, and thinking at a particular moment.

AS: What's in your kit bag? Which camera system do you use and why?

ML: I've always traveled light out of preference and need. I'd rather not carry a big, heavy bag at a crowded party. I usually take one camera body. Digitally, I have just purchased a Canon EOS 5D; I also rented a Canon EOS 1D MK III for a recent personal project. Sometimes I'll bring a variable wide-to-telephoto lens as well as my preferred, fixed 28mm lens. Besides being much lighter and less obtrusive, the fixed lens has a better aperture for viewing and autofocusing when shooting in darker conditions. It's also sharper. I rely on a Vivitar 285 flash, with Quantum Turbo battery. For 35mm film I shoot with Nikon SLRs, usually an F100 or FE2. For medium format I use a Fuji GA 645, which has a fixed, built-in lens with 50mm focal length.

AS: Do you try to make sure your work appeals to the widest possible audience?

ML: No. My audience is getting smaller as Western culture brings further deification of celebrities. Nowadays publications, for the most part, use either glamour shots of celebrities, or paparazzi-type pictures. They're becoming less interested in what I have to offer. In a way I see myself as a visual Tom Wolfe or Hunter S. Thompson—a bit unpredictable and unwilling to compromise.

AS: When are the busiest times of the year for you?

ML: During New York Fashion Week in February and September I work like mad for eight days straight, on each occasion.

AS: Which places or things do you dislike photographing the most?

ML: I will never shoot "staged" red carpet events, unless a favored client asks. I'd rather beg on the streets.

AS: What types of pictures do you find the most difficult to take?

ML: It's difficult to photograph some celebrities—they've been trained by their handlers to put on a fake face and present something they assume the photographer wants. I felt this way about child star Dakota Fanning who, aged just 12, seemed to have completely lost the true joy of being a child. It can also be challenging to shoot someone I hold in high esteem. I was awed to meet poet Maya Angelou, and because of that I don't think I captured anything deep or revealing.

Milla Jovovich
On the street, in New York City's East Village, Milla gets a nicotine fix before the start of a fashion show. I love to shoot my subjects with props; cigarettes and wine glasses are some of the best. For this picture I consciously tilted my camera. Sometimes I do this to create a more dynamic composition, sometimes just to fit in critical information that I want in the picture. Once a composition is arranged, I often wait for a moment of particular interest, or a series of moments. Typically I shoot three exposures of any given composition. For this photograph I waited until Milla was exhaling cigarette smoke from her nostrils.

CAMERA: Nikon FE2
LENS: 28mm
FILM: Ilford HP5 Plus 400
APERTURE: f/8
SHUTTER SPEED: 1/15 sec
LIGHT CONDITIONS: Natural and artificial (fill-flash)

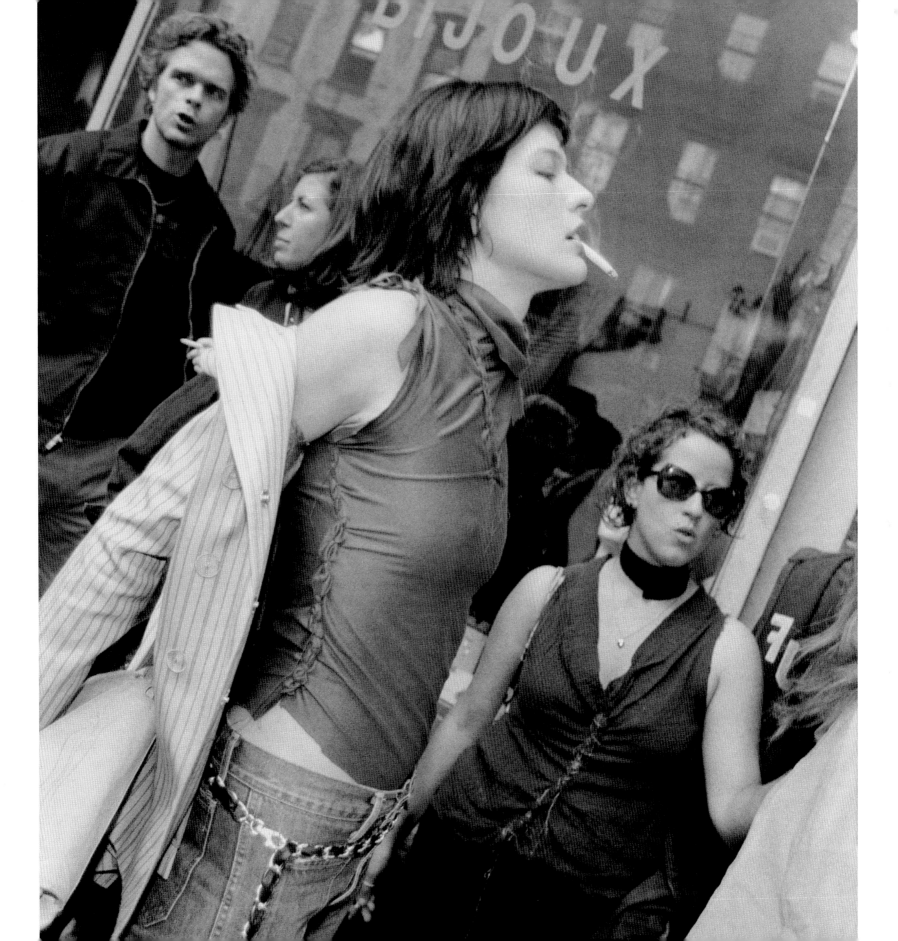

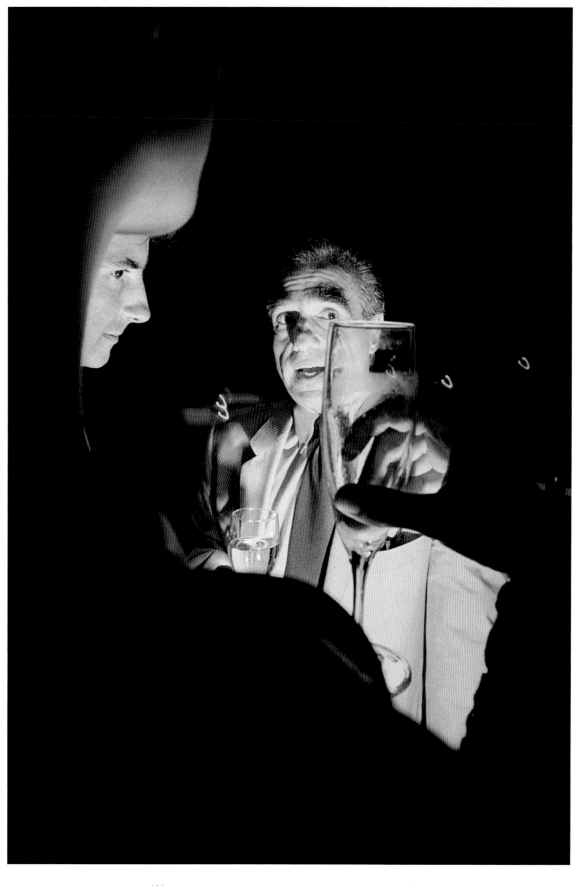

Martin Scorsese
For this shot of the legendary movie director I used the profile and arm of a woman in front of me to frame the picture. I lit Scorsese, in the center of the frame, by placing my flash underneath the woman's arm. The glass of champagne creates an interesting distortion on the corner of Scorsese's mouth, as well as bringing the viewer's attention to his eye.

CAMERA: Nikon FE2
LENS: 28mm
FILM: Ilford HP5 Plus 400
APERTURE: f/5.6
SHUTTER SPEED: 1/15 sec
LIGHT CONDITIONS: Artificial (flash diffused with tissue)

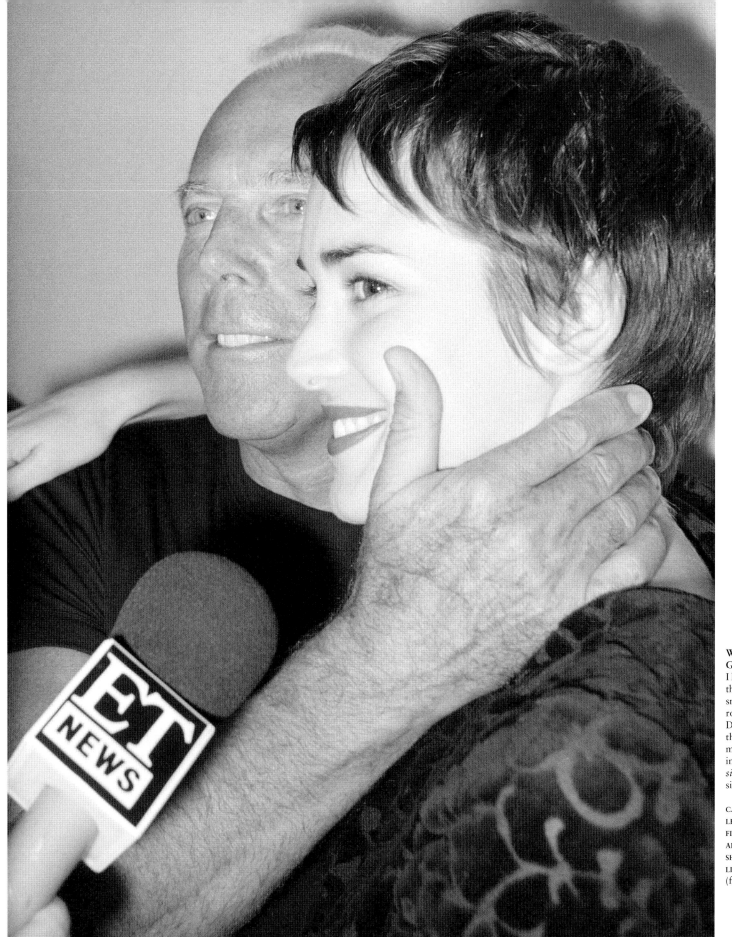

Winona Ryder and Giorgio Armani
I love this image because of the contrast between Winona's snow-white skin, and Giorgio's rough and suntanned hand. During the week for which the fashion giant had hired me to photograph him, I was instructed to shoot *solo la sinistra*—only to the left side of his face.

CAMERA: Nikon FE2
LENS: 28mm
FILM: Ilford HP5 Plus 400
APERTURE: f/5.6
SHUTTER SPEED: 1/15 sec
LIGHT CONDITIONS: Artificial (flash diffused with tissue)

AS: Which do you prefer, digital or film, and why?

ML: Digital cameras have improved dramatically, but I still put my money on film for flexibility, and to create very large exhibition prints. I trust film more, especially for my purposes. Last year I produced 44in prints from 35mm black-and-white 400 film. These mural-size prints look amazing. I also printed a similar digital image shot with a Nikon D100. Once interpolated to mural size, the file looked too soft and I actually added digital "noise" to duplicate the feel of traditional film grain, to make the image look sharper. My Canon EOS 5D is a much better camera, but my initial tests leave me feeling the same. Digital prints made from good-quality scans of 35mm film, however, are extraordinarily good.

AS: How much of your work do you manipulate using imaging software?

ML: If I shoot film and the image is going to press, I make the print myself in the darkroom. If the image is for the gallery wall or for one of my limited-edition books, I make scans using an Imacon scanner. I then manipulate the image in Photoshop with the same principles I use in the darkroom. Digital tools give me a power over the image that I've never experienced in the darkroom. I'm able to bring out things from the image that would not be possible using traditional methods. The latest version of Adobe's software—Photoshop CS3—takes this to a completely new level.

Scarlett Johansson
Scarlett showed up at the last possible moment, carrying a lily. This exposure was taken outside at night, hence the lack of detail in the background figures. I was able to brighten the entire scene in Photoshop, while darkening the collar of Scarlett's dress, which reflected a lot of light from my flash. The slow shutter speed created some blurred background lights, enhancing the sense of movement as Scarlett stepped forward.

CAMERA: Nikon F100
LENS: 24–50mm
FILM: Kodak Tri-X 400
APERTURE: f/5.6
SHUTTER SPEED: 1/8 sec
LIGHT CONDITIONS: Artificial
(flash diffused with tissue)

AS: What do you consider your greatest photographic achievements to date?

ML: Collaborating with Norman Mailer to document the 1996 American presidential race for *George* magazine for which I shot political conventions, as well as the campaign trail. Shooting for "The Night" column in *The New York Times*, as well as biannual pictorial features I shot for *W* magazine in the mid-1990s, were also memorable. I'm extremely proud of my limited-edition books, too, which have been acquired as special collections by the Museum of Modern Art in New York, and the Whitney Museum of American Art.

AS: What does the future hold for you?

ML: I consider myself a social critic. I hope in the near future the media will be more willing to be critical of society and not just pander to the common denominator. Meanwhile I will focus on personal projects, dealing with environmental concerns, class, and semiotics. Commercially speaking, I have one client that allows me the freedom to make the celebrity images I'm interested in producing. *Women's Wear Daily* (*WWD*) magazine engages me to shoot New York Fashion Week twice a year and lets me document it with black-and-white film.

P. Diddy
As Sean John (P. Diddy) entered the backstage makeup area of his own fashion extravaganza, all cameras were focused on him. He was walking down some steps from a VIP area and I decided to photograph him from behind and above, illuminating his shoulders and head with my flash. The background of the picture is exposed with the ambient light of the room. The fast 400, black-and-white film allowed for a good amount of latitude with the exposure. In postproduction I was able to fine-tune shadows and highlights to suit my ultimate vision of how the image should look.

CAMERA: Nikon F100
LENS: 28mm
FILM: Ilford HP5 Plus 400
APERTURE: f/5.6
SHUTTER SPEED: 1/8 sec
LIGHT CONDITIONS: Artificial (flash and ambient)

Sarah Jessica Parker
Sometimes shooting in an
unconventional manner can
bring an interesting result.
Photographing Sarah Jessica
Parker from behind and off to
the side, I aimed my camera into
another photographer's flash
to pull off this particular frame.

CAMERA: Nikon F100
LENS: 28mm
FILM: Ilford HP5 Plus 400
APERTURE: f/5.6
SHUTTER SPEED: 1/8 sec
LIGHT CONDITIONS: Artificial
(flash diffused with tissue)

Tips for Success

1. Blend in with your environment

Dress for the occasion because this will help put your subject at ease. There have been many shoots when my access to an event was not guaranteed, but dressing up definitely helped. There's nothing tackier than seeing a photographer in blue jeans at a black-tie affair.

2. Use your personality and physicality

Connect with the subject, scene, and moment. Use your personality as an asset to bring about the manner in which people react to you. I'm short and slim, which enables me to move in between groups of people and crowds with agility. I know a photographer who is extremely tall and able to take overhead shots I would not be able to take.

3. Your vision is unique

If you're on assignment you will not only need to fulfill the expectations of your editor, but also to stay true to your own vision. You were hired for the job, not the next guy, and there must have been a reason for that. What is it about your vision that makes your photography unique?

4. A portfolio goes a long way

When showing your portfolio to potential clients, present the types of images you are interested in shooting. Show the strongest pictures that contain your "signature" style.

5. Take advantage of intuition and accidents

Often the best pictures are those that evolve on the spur of the moment. Take advantage of an unexpected situation if it is presented to you.

6. Discover your correct working method

Just because others are shooting in a specific manner, it doesn't mean you have to follow the pack. Find a working method that enables you to realize your vision. For me, this is to shoot with flash off-camera, held by hand. Since I'm trying to light up different parts of any given scene in front of me, I prefer a hand-held flash that I can manipulate into the space.

7. Put yourself in your subject's shoes

As photographer Larry Fink taught me, empathy can be a powerful tool for revelation. You don't have to like your subject, but try to put yourself in their shoes, literally. How does it feel to be the person in front of the camera?

8. The best equipment doesn't guarantee results

Getting the correct image is more important than the equipment you use.

9. Be selective with image submissions

Show picture editors your select choice of shots. With film contact sheets, square off the images you like, in red grease pencil. For digital files, highlight them using your computer's color label, or place them into a separate folder. A good picture editor will consider your suggestions.

10. Learn how to manipulate your images

Learn how to print from your own negatives, or to adjust a digital file yourself. Since they are your images, you should be capable of producing prints or postproduction adjustments that are much closer to your intent than a lab or professional printer. Art directors usually do a bare minimum to adjust images, so it's really up to you.

Donatella Versace

I spotted Donatella at a fashion gala, surrounded by friends. She turned toward me and struck a flirtatious pose. I stuck my arm out in front of me, holding my off-camera flash, to illuminate her, and kept the woman and man to either side of the frame in shadow, creating the ghoulish lighting on the sides. The flash also created a shimmering effect on her dress. How the light looks on the subject is always a matter of technique, intuition, and luck. In postproduction I tried to keep plenty of detail in the shadows, without making the blacks too muddy. I wanted Donatella slightly overexposed so that she almost "pops out" of the frame. I "burnt" down the man to her immediate right, so the viewer's eye goes straight to Donatella, then moves around to investigate the rest of the composition.

Essential Equipment

- Nikon F100 camera body
- Nikon FE2 camera body
- Nikkor 24–50mm lens
- Nikkor 28mm lens
- Canon 35mm EOS 5D camera body
- 4GB CF cards
- Vivitar 285 hand-held flashgun
- Quantum Turbo battery pack
- Kodak Tri-X and Ilford HP5 400 films

Specification

CAMERA: Nikon FE2

LENS: 28mm

FILM: Ilford HP5 Plus 400

APERTURE: f/5.6

SHUTTER SPEED: 1/15 sec

LIGHT CONDITIONS: Artificial

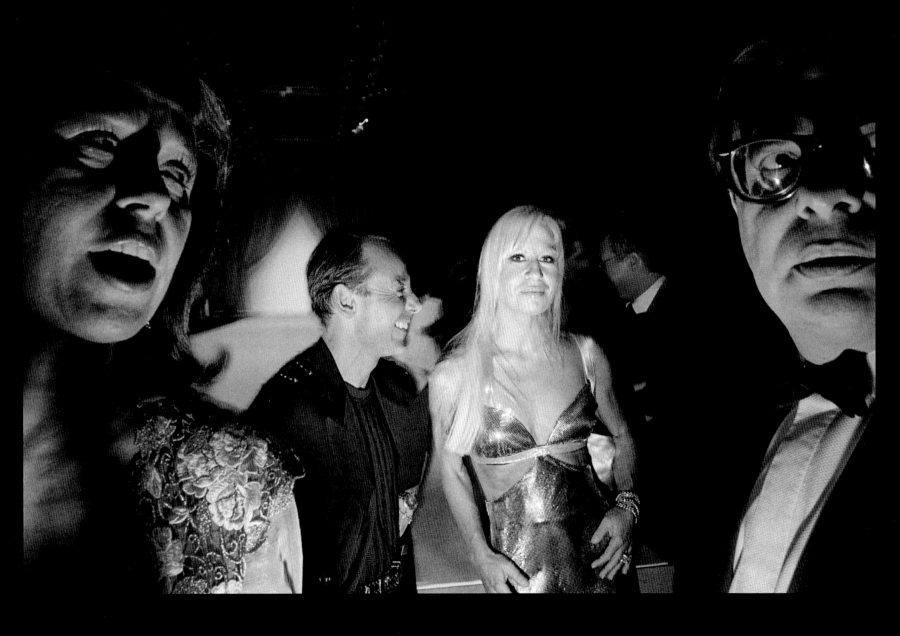

Miles Ladin: Photographic artist

Karen McBride

Music specialist

Raised in Manchester's Salford, Karen qualified with a degree in archeology and ancient history. But it's music that's always been at the center of Karen's life—borne from her days listening to her father's collection of Johnny Cash and Elvis records. "The music came before the photography," she remembers, "and listening to it helped me get through the poverty of growing up in Salford during the 1970s. But I knew I always wanted to be a photographer." Today, Karen is recognized as one of the most notable female photographers in Manchester, and one of the most sought-after music photographers in the world. She prides herself on paying as much attention to unsigned bands as she does touring with the world's legendary performers. Her clients include many big-name artists, record labels, music venues, and magazines. She was one of the first people to recognize the talent of the previously unsigned Scissor Sisters—with whom she has become friends—and in 2006 she was chosen as the official photographer to record the Robbie Williams "Close Encounters" European tour.

Scissor Sisters
Anna Matronic is a vibrant and colorful woman, so I composed the shot with plenty of space to show her off. There's no other detail in the picture to distract the viewer.

CAMERA: Nikon D1
LENS: 24–70mm
ISO: 800
APERTURE: f/4.5
SHUTTER SPEED: 1/30 sec
LIGHT CONDITIONS: Hotshoe flash (artificial)

AS: What was your first ever camera?

KM: A 35mm Nikon L35AF compact camera. I saved £80 and bought it from a shop in Salford quite a few years ago. I was earning £24 a week at the time, working as a printer.

AS: Where do your ideas for innovative pictures come from?

KM: I believe there's a little bit of Elvis in everyone, and that's what I try to capture. I try to exploit that extra bit of "star quality" in the people I photograph.

AS: Why did you decide not to do other types of photography, such as sports or nature work, for example?

KM: The music came before the photography. My brother was in a band and I was asked to take some shots—I asked him what my payment would be and he said, "Fame." Other photographic genres don't appeal to me in the same way.

AS: Is it fair to say, like many successful photographers, that you had a "lucky break" at some stage?

KM: I haven't had a "lucky break" as such. My biggest project to date, however, was photographing Robbie Williams' "Close Encounters" tour in 2006. His PR company Googled me and liked my pictures of Pete Doherty.

AS: Do you shoot what you want or do others generally define what's required of you?

KM: I set out to shoot the way I feel about music—to do what I want—and people employ me for the philosophy and style I bring.

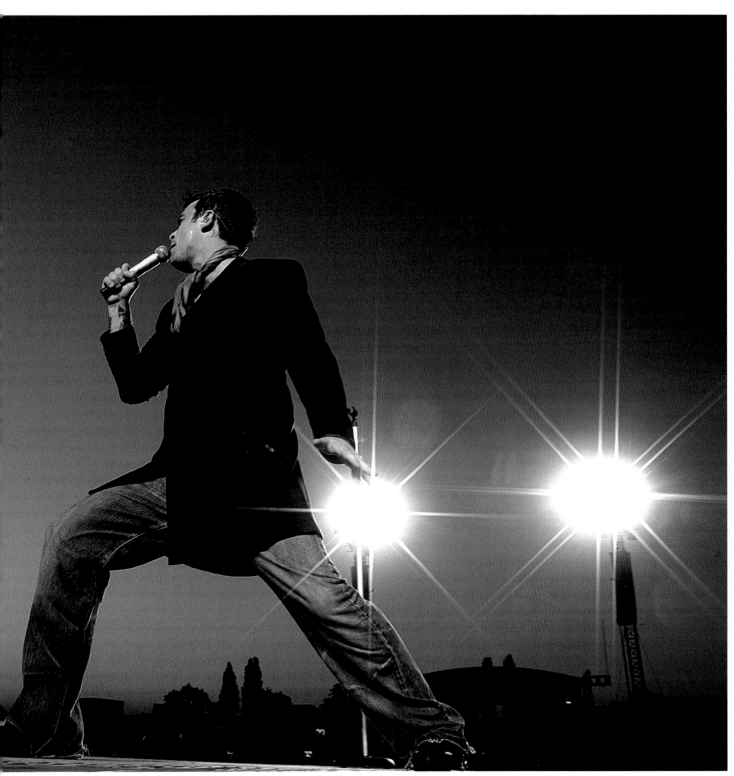

Robbie Williams
After the show, Robbie's manager asked me why I took this particular shot and I replied, "Because I wanted him to look bigger than the world."

CAMERA: Fuji FinePix S3 Pro
LENS: 17–35mm
ISO: 400
APERTURE: f/13
SHUTTER SPEED: 1/60 sec
LIGHT CONDITIONS: Artificial

Karen McBride: Music specialist

AS: Where are you mostly based, and where are your most popular locations?

KM: I live in Manchester and most of my photography is based there. It's got such a rich musical heritage. I've worked all over Europe—including Germany, Hungary, Austria, and Holland—as well as the USA.

AS: Which types of places do you like to photograph in the most, and why?

KM: You can't beat a British crowd at a gig. But for outdoor shows you can't beat Dresden in Germany—the organizers built a special stage for the Robbie Williams tour and the light was amazing. My picture of Alec Empire at Academy Three, in Manchester, which has a capacity of around 300, is my "signature shot," even though the lighting is quite basic. The atmosphere made the image.

AS: What things do you enjoy most about your job?

KM: Meeting people is a big part of the job and I enjoy looking for the next picture. For me, it's not the picture you've just taken, it's the picture you're about to take that gets you out of bed. I also get to experience new music, as well as the youth of the industry, and the crowds. The artists, fans, and photographers are all there for the same reason—to enjoy the music.

Alec Empire
I was front of stage, being crushed by adoring fans, and security kindly plucked me out of danger and allowed me to sit on the side of stage. The guitarist suddenly bent over and I instinctively fired off one shot, without looking through the viewfinder. I knew at the time I had captured something very special—it brought a tear to my eyes.

CAMERA: Nikon F100
LENS: 24–120mm
FILM: Ilford Delta 3200
APERTURE: f/5.6
SHUTTER SPEED: 1/60 sec
LIGHT CONDITIONS: Artificial

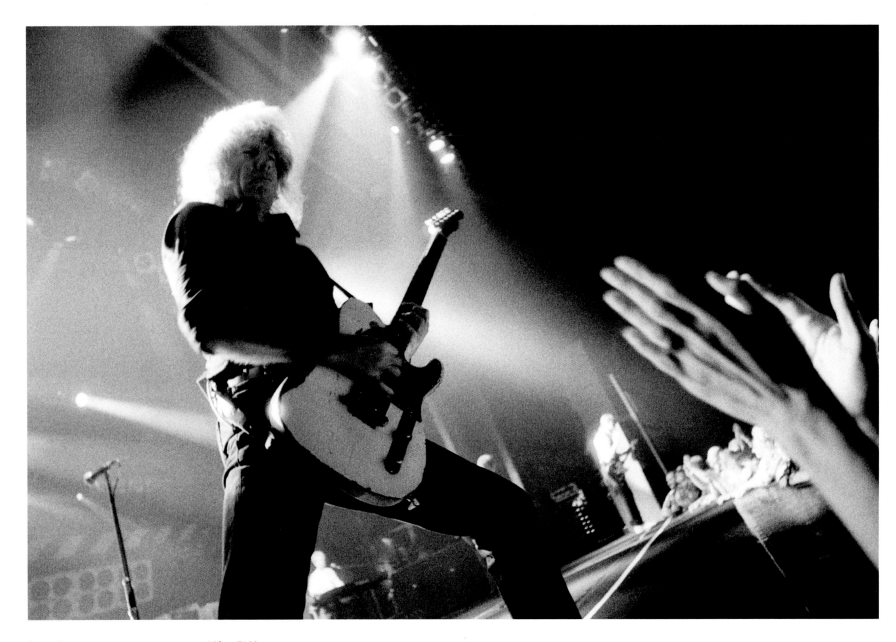

Status Quo

This shot, for me, is a religious experience. I saw hands come up from the crowd quite regularly and waited for the perfect moment to capture Rick Parfitt's presence and connection with the audience. The light is beautiful, beaming down on him, giving an almost godlike demeanor. The image was later published in Status Quo's "Riffs" tour program.

CAMERA: Nikon F100
LENS: 24–120mm
FILM: Ilford Delta 3200
APERTURE: f/5.6
SHUTTER SPEED: 1/60 sec
LIGHT CONDITIONS: Artificial

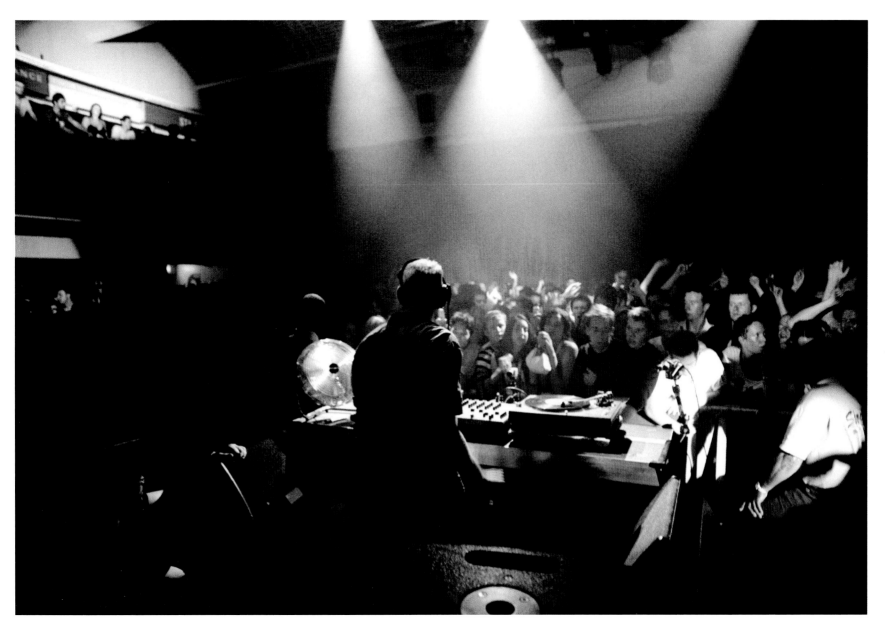

Fatboy Slim

I was commissioned by Skint
Records to shoot pictures of
Fatboy Slim performing at
Nottingham Trent University.
I asked what he was looking for
in the photos. His response was,
"Can you make me look like the
famous picture of The Clash by
Penny Smith?" I said I couldn't,
because he wasn't The Clash,
but I understood what he meant.
So I positioned myself behind
him, lying on the stage, and
framed the audience, waiting
for the right moment. The shot
is successful because the picture
has depth and the light focuses
in key areas.

CAMERA: Nikon F100
LENS: 24–120mm
FILM: Ilford Delta 3200
APERTURE: f/5.6
SHUTTER SPEED: 1/60 sec
LIGHT CONDITIONS: Artificial

The Ting Tings
I was commissioned to shoot a Manchester band for the cover feature of the Singapore International Airlines magazine. I chose the previously up-and-coming The Ting Tings. During the shoot we had torrential rain which, ironically, worked very well because it illustrated Manchester perfectly.

CAMERA: Fuji FinePix S3 Pro
LENS: 17–35mm
ISO: 800
APERTURE: f/6.7
SHUTTER SPEED: 1/90 sec
LIGHT CONDITIONS: Natural

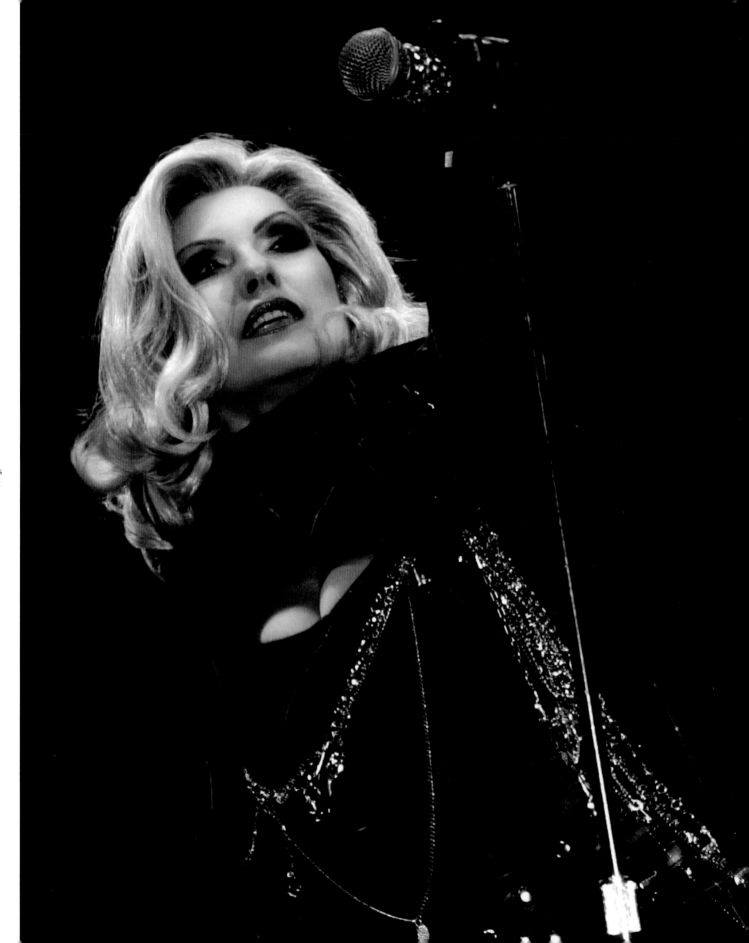

Deborah Harry

I was so in awe of Deborah Harry—I like to think of her as the goddess of punk—I almost forgot to take the photo. The light is front-on and captures her attitude perfectly.

CAMERA: Nikon D1
LENS: 70–200mm
ISO: 800
APERTURE: f/5.6
SHUTTER SPEED: 1/60 sec
LIGHT CONDITIONS: Artificial

AS: From a technical aspect, what are the most difficult things about your photography?

KM: I find it challenging working in changeable light. I don't really get time to choose ideal exposure settings because I have to react to things quickly. Strobe lighting can also be challenging, but I'm used to it. Access to the bands is becoming more difficult nowadays; access is an essential part of the job.

AS: How would you describe your personal style or technique?

KM: I think of my work as non-conformist. I shot black-and-white for five years while most others were shooting color, but when black-and-white became more in vogue, I started taking color pictures. My motto is "dedicated to photography, tempted by great music."

AS: What's in your kit bag? Which camera system do you use and why?

KM: In the past I've used a Nikon F3 HP, F90 X, F100, and Bronica ETR-S. My first digital camera was a Nikon D1, which is now retired. I've been using a 35mm Fuji FinePix S3 Pro and I have upgraded to an S5. I like the S5's settings, the handling—it fits my hand perfectly—and I like the viewfinder. My main workhorse lens is a Sigma 24–70mm, and I need the varied focal range it offers. It suits the way I work. I've also got a 10.5mm fisheye lens – this is my piece of rebel kit because, while many others were shooting with straight lenses, I wanted to create something different. My festival lens is a Nikkor 70–200mm, and for portraits a Nikkor 50mm. I carry CompactFlash media cards comprising 1, 2, and 4GB. My office is my laptop, portable broadband modem, and cell phone.

AS: Do you try to make sure your work appeals to the widest possible audience?

KM: I listen to what the artists want and I try to marry this with my style. I get a lot of thank-you messages from fans, often saying that one of my pictures has helped them to remember a specific gig. It's a bit of both.

AS: When are the busiest times of the year for you?

KM: Summer in the UK is centered around festivals and, at the beginning of the year, bands prepare press packs for shows and coming album releases. There are always gigs and concerts going on, and the workflow is constant. I like to start off each year with a project—usually an exhibition, to get my work out there.

AS: Which places or things do you dislike photographing the most?

KM: Weddings. They're my number one dislike.

AS: What types of pictures do you find the most difficult to take?

KM: Concerts, because of the variable light conditions. To get results I have to rely on my experience, and it's hard work. I don't like to rely on imaging software.

AS: Which do you prefer, digital or film, and why?

KM: Film for black-and-white, digital for color. The white balance facilities on digital cameras make a difference at concerts. With film, I can feel my pictures more—it has a physical element to it. With digital I'm a bit more removed. But digital nowadays is demanded by clients and it's become essential to the way I work.

AS: How much of your work do you manipulate using imaging software?

KM: I manipulate my photography as little as possible—maybe just the basics, such as curves and color levels in Photoshop. But manipulation has to be reasonable and approached with care. For example, with film I use "burning" and "dodging" techniques, and I use only these same principles for digitized images.

AS: What do you consider your greatest photographic achievements to date?

KM: Being commissioned to photograph the Robbie Williams tour in 2006. Being sponsored by Fuji is also a great achievement, as was having my "signature shot" of Alec Empire published by music venue promoter House of Blues, for use on its billboards in the USA.

AS: What does the future hold for you?

KM: I shot my first music video this year and I'd like it to be a contributing factor to my work in the future. Exhibitions are also becoming an annual event.

Slash
This is an invasive shot. I was up close and personal. It works well because Slash (of Guns 'n' Roses) is a legendary guitar player and the picture highlights the use of his huge hands. I was aiming to get a little lens flare in the shot, which adds depth. The light coming from the right side was actually positioned higher than it looks in the photo.

CAMERA: Fuji FinePix S3 Pro
LENS: 24–70mm
ISO: 1600
APERTURE: f/2.8
SHUTTER SPEED: 1/60 sec
LIGHT CONDITIONS: Artificial

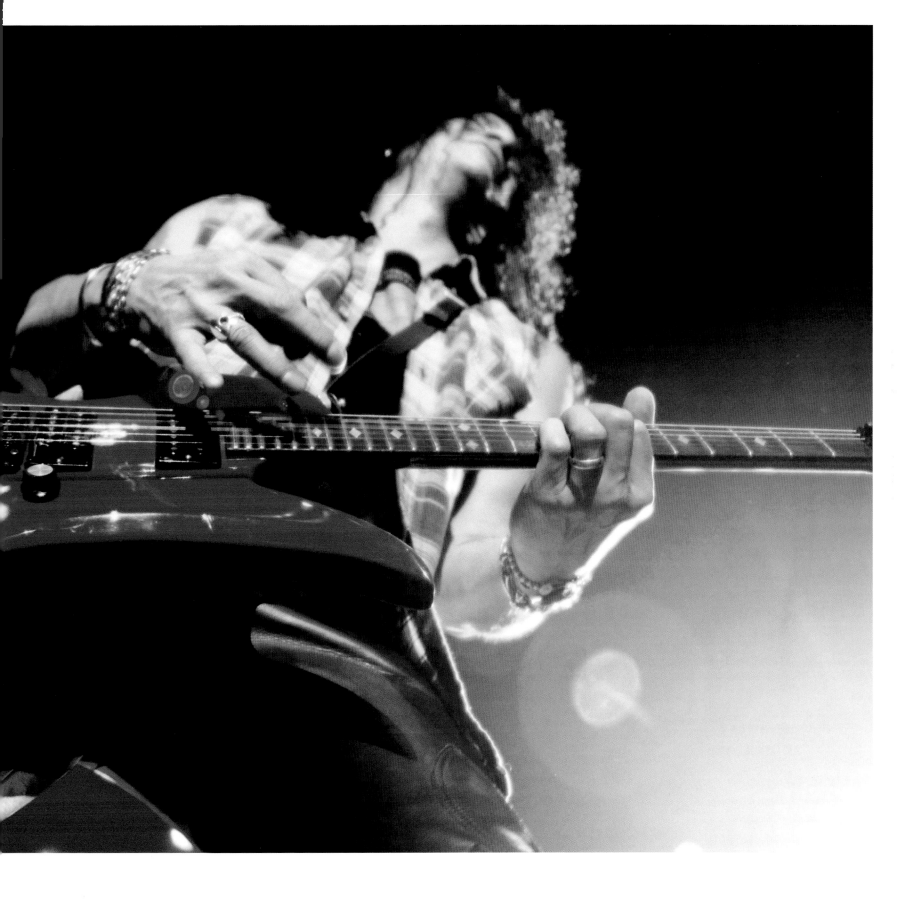

Graham Coxon
This is a special shot for me.
Jane Brown, one of the greatest
ever portrait photographers,
inspired me to approach the
shot with a particular style.
Graham Coxon, formerly of
Blur, was the perfect subject.

CAMERA: Fuji FinePix S3 Pro
LENS: 24–70mm
ISO: 1600
APERTURE: f/2.8
SHUTTER SPEED: 1/30 sec
LIGHT CONDITIONS: Artificial

Tips for Success

1. Have the right motivation

Ask yourself this: why do you want to be a rock photographer? Motivation is key, so if you think you're going to meet bands and live a life of fame and fortune, you'll have to work for it.

2. Get to know your style

You can't develop your own style until you start taking photographs. Get to know your local music scene by knocking on lots of doors.

3. Know your equipment

Don't worry about having the latest camera gear. Use the equipment you have and learn how to use it properly. Some of my best shots have been taken on older, 35mm film cameras.

4. Create a web presence

If your funds are limited, set up a MySpace web page. You'll be able to communicate with local bands and get the ball rolling.

5. Don't be shy

Confidence is an essential ingredient to success. Don't be shy about approaching musicians and offering your services to them.

6. Create access to venues

If you want to work in bigger venues, you'll need a photographer's pass. Don't expect an access all areas pass until you're working directly with bands.

7. Use available light to your advantage

Using venue lighting correctly boils down to understanding your camera equipment. Don't be afraid to experiment with different apertures and shutter speeds, and, if in doubt, shoot with your widest aperture. You'll seldom be able to use flash, so mastering exposure in-camera is vital. For this reason, many of my photos are captured using a light-sensitive setting, such as ISO 1600–3200.

8. Dress appropriately

I tend to wear black at gigs—you want to capture the spontaneity of the performance, not the artists' eyes.

9. Take it on the chin

Disappointment plays a part in any career, and music photography is no exception. The most successful professionals have been thick-skinned enough to take knocks. Determination will bring a better chance of success.

10. Get your pictures in the public domain

You've taken your shots, so now get in touch with the bands you've photographed. If they like your pictures, they'll want to use them. Think of it as free publicity, even though you might not get paid at first.

Karen McBride: Music specialist

Green Day

I'd noticed the light beaming past Green Day lead singer Billy Joe and I was desperate to capture the moment. So I risked being kicked out of the venue by security and climbed over the stage lights to rest my camera on the actual platform. I waited for my moment and pressed the shutter button.

Essential Equipment

- Fuji FinePix S5 Pro camera body

- Nikkor 10.5mm f/2.8 fisheye lens

- Sigma 24–70mm f/2.8 lens

- Nikkor 50mm f/1.4 lens

- Nikkor 70–200mm f/2.8 lens

- Nikon SB-80 flashgun

- Spare lithium-ion batteries

- Range of CF media cards

- Macbook Pro laptop computer

- Aperture and Photoshop imaging software

Specification

CAMERA: Fuji FinePix S3 Pro

LENS: 24–70mm

ISO: 1600

APERTURE: f/2.8

SHUTTER SPEED: 1/45 sec

LIGHT CONDITIONS: Artificial

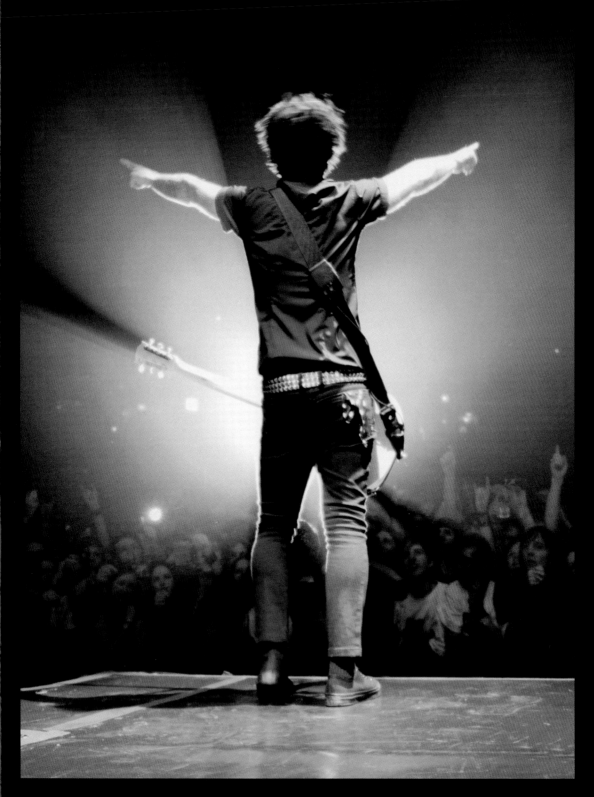

Kare

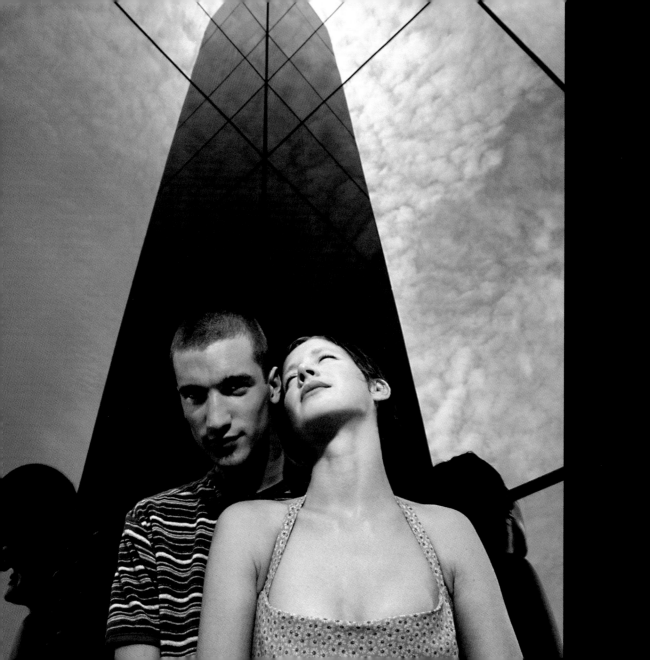

Inspired by style

"I was a little torn between my interest in photography and my desire to get involved in fashion," recalls Soulla Petrou, who was born in Leeds, England. "Fortunately I turned out to be a rubbish designer and it quickly dawned on me that I needed to change college courses— I chose photography." She decided to do a one-year foundation course at Jacob Kramer College, followed by a photography degree from Middlesex University. "When I graduated I put together a portfolio that I hoped would get me some work. I did part-time waitressing and theater costume design jobs to keep going."

Soulla has come a long, long way since those days. Her extraordinary portraits of the biggest names in the music and fashion industries have established her as a star in her own right. Her portfolio boasts many internationally recognized names including Blur, Kylie Minogue, Travis, Supergrass, Air, Norman Cook (aka Fatboy Slim), Todd Terry, The Chemical Brothers, and Sophie Ellis-Bextor. There's also a good chance that many have seen her colorful photography spread across the music industry's best-known editorial titles, such as *Pride*, *MixMag*, and *DJ Magazine*, as well as the *Evening Standard* and *The Times* Saturday style supplement, *Metro*.

Lamb, *The Face*
I had a call from *The Face* the day before the shoot and was asked to go to Manchester to meet the band. I knew the sort of music they performed, but I didn't know much about my location, so I got to Manchester early. I found an interesting office block covered in mirrors, which reflected the sky if you were at a low angle. I felt this looked serene and perfectly reflected their style of music. A moment arose when Louise tilted her head to bask in the sunlight, and the whole image was instantly softened.

CAMERA: Nikon F4
LENS: 18mm
FILM: Fuji Provia 100
APERTURE: f/16
SHUTTER SPEED: 1/60 sec
LIGHT CONDITIONS: Daylight, slightly cloudy

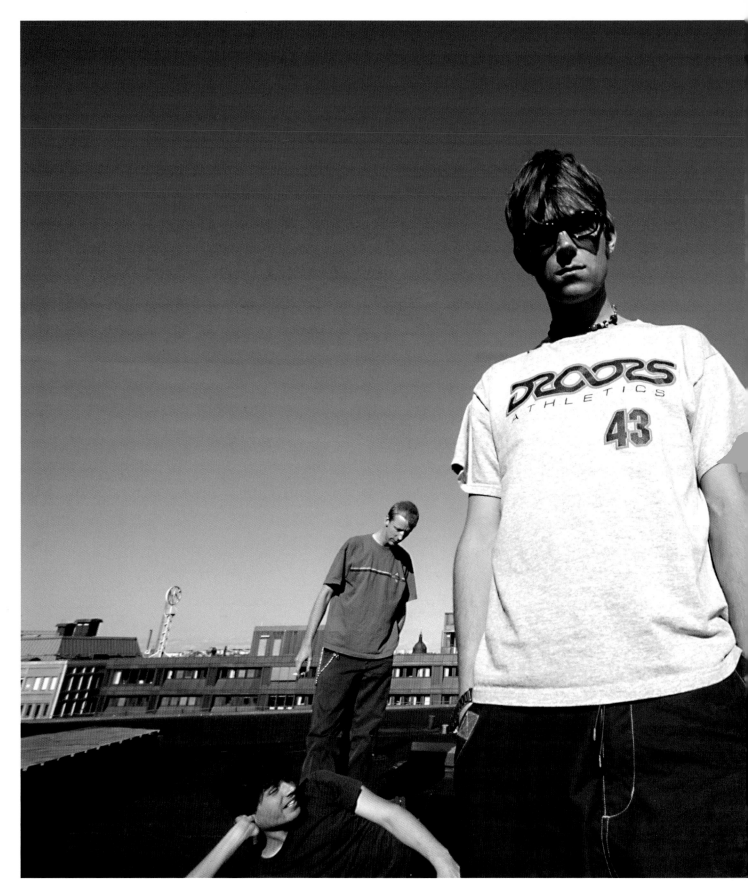

AS: What was your first ever camera?

SP: I fell in love with photography in my teens, when my parents gave me a Polaroid camera at Christmas. I couldn't put it down. I was hooked immediately.

AS: Where do your ideas for innovative pictures come from?

SP: My best ideas often come in the middle of the night—I keep a book of ideas next to my bed so I can make notes or draw thoughts. A typical commission may arrive at the last moment, sometimes the day before a shoot, and my notebook enables me to recall ideas that might suit the person or subjects. Technically, I try to shoot two or three different setups if I can, and include a variety of horizontal and upright shots, to give the client choice. I like to get to a location early so I can scout around for likely spots. Inspiration comes from movies and art, too—I'm a big fan of Alfred Hitchcock, Roman Polanski, and David Lynch.

AS: Why did you decide not to do other types of photography, such as sports or nature work, for example?

SP: I grew up watching the ITV *Chart Show* in the 1980s— a great combination of music and fashion. Music and visual imagery go together perfectly and both are important to me.

AS: Is it fair to say, like many successful photographers, that you had a "lucky break" at some stage?

SP: If you go out and meet people, things will start to happen. You might say it's a numbers game—the more people you see, the better chance of success you have. My big break came when *The Times* launched *Metro*, its Saturday style supplement, in 1994. The picture editor asked me to follow Blur on their tour of Sweden and come back with a set of pictures for the cover of the first issue, and the story inside. There was so much riding on it— Blur were a big name and I wasn't sure how easy they would be to work with. Up to that point I had been photographing people who had been building their reputations, so this was a different challenge. But I got the shots that were required and the story was successful.

Blur, *Metro* launch cover
At this stage in my career I hadn't shot anyone as famous as Blur, so I was quite nervous. On top of that, the shoot was for the launch cover of a new magazine supplement in the Saturday *Times*. I resorted to old tricks I knew would work for me. I took Blur onto the roof of the hotel, where we were staying, and asked the guys to position themselves anywhere— and to do whatever they wanted.

CAMERA: Nikon F4
LENS: 18mm
FILM: Fuji Provia 100
APERTURE: f/22
SHUTTER SPEED: 1/60 sec
LIGHT CONDITIONS: Daylight, sunny

Soulla Petrou: Inspired by style

Todd Terry, Defected Records
Todd Terry wasn't photographed at night in a Miami street—he was shot in a studio against a black Colorama background, using a spotlight from above with a smoke machine. The landscape was captured later, using a tripod and long exposure. The two images were then put together using layers and blending in Photoshop.

CAMERA: Canon EOS 5D
LENS: 24mm
ISO: 200
APERTURE: f/5.6
SHUTTER SPEED: 15 sec
LIGHT CONDITIONS: Flash with Fresnel spotlight, smoke machine, and ambient light

AS: Do you shoot what you want or do others generally define what's required of you?

SP: With record companies I'm commissioned for my style and there's relative freedom. Fashion and beauty magazines are different, with stylists and make-up artists often taking the lead. I like guidance, as it reduces the pressure if I'm told what's required. But I also like being creative and doing my own thing.

AS: Where are you mostly based, and where are your most popular locations?

SP: I love London and the majority of my commissions are based there, however, I also shoot in Los Angeles, Miami, and New York. Many commissions early in my career were in Germany and France, because of their ties with electronic music.

AS: Which types of places do you like to photograph in the most, and why?

SP: I like big skies and open spaces. I like mountains and dark, moody skies. I'm attracted to drama. I also love old buildings that have character, although I admire modern architecture as well.

AS: What things do you enjoy most about your job?

SP: Variety: the people, the places, the travel. I get to meet loads of different characters and I'm always learning from them. The freedom and challenges keep me going. I seldom know what I'm going to do from one day to the next.

AS: From a technical aspect, what are the most difficult things about your photography?

SP: Some jobs are more complicated than others. The Todd Terry picture, for example, was shot in a studio and the background of Miami was photographed separately, and added later. These things are difficult because the lighting and angles of both studio and outside had to match perfectly. These types of pictures are challenging, but they can work.

AS: How would you describe your personal style or technique?

SP: I love the quirky angles Bill Brandt and Guy Bourdin found with their photography, and I like to echo their styles. The look of 1970s color is fantastic—bright and rich—and this has influenced my work. I always think about what people say to me when I'm commissioned and, when people see my portfolio, I like to think they're inspired by my style.

AS: What's in your kit bag? Which camera system do you use and why?

SP: I've got two Canon EOS cameras: a 1D MKII and a 5D. I use the 5D more nowadays because it's lighter. I mainly use 14mm and 100mm lenses, and from time to time 24–35mm and 80mm. I also have a 200mm unit, but I rarely use it as macro lenses are my favorites. I view images direct from camera to laptop so clients can see my work immediately. With film, I always shoot on ISO 100—it gives clarity and quality.

Left: **Irusha, *CosmoGIRL!***
I was in South Africa for two weeks with *CosmoGIRL!*, shooting several beauty and hair features. The quality of the light for this shot was incredible, as was the landscape. Shots were taken on a windy day in Cape Town, near a cliff-edge. The sun was so bright it made the shadows incredibly harsh, so I used a canopy to keep the model in the shade. Irusha was then flash-lit so she would be as bright as the background. Shooting this way gave me a lot more control over the light.

CAMERA: Mamiya 645
LENS: 80mm
FILM: Fuji Reala 100
APERTURE: f/22
SHUTTER SPEED: 1/60 sec
LIGHT CONDITIONS: Flash with beauty dish in daylight

Right: **Sophie Ellis-Bextor, *Ministry***
This shot is part of a series of Sophie taken in my flat using one of my many glitter-plastic backdrops, which I loved at the time because they reminded me of 1970s' fashion photography. With this in mind I wanted the image to be really colorful and punchy, which was achieved through clothing and Natalie Dean's amazing make-up. I also added a little sparkle by using a starburst filter. The image was then scanned and altered in Photoshop to boost contrast and saturation.

CAMERA: Mamiya 645
LENS: 80mm macro
FILM: Fuji Reala 100
APERTURE: f/16
SHUTTER SPEED: 1/60 sec
LIGHT CONDITIONS: Bowens flash

AS: Do you try to make sure your work appeals to the widest possible audience?

SP: Not deliberately. But some faces I photograph are very well known and have been widely published.

AS: When are the busiest times of the year for you?

SP: There's no pattern because commissions are very random and, on the whole, my job is not seasonal. I never know when to book a holiday.

AS: Which places or things do you dislike photographing the most?

SP: Clubs. It's gone midnight and people are pushing you, there's dry ice everywhere, and the lighting is very difficult to work with. But that was early in my career. Recently I had to photograph a pair of hands with 20 rings on them—two on each finger. I took frame after frame—an eight-hour shoot in all—and ended up choosing the first photo I took!

AS: What types of pictures do you find the most difficult to take?

SP: Some shots are quite intense. For example, if I'm doing a beauty shoot and I'm working with just a small area, such as an eye or lip, it can become extremely intricate. Other stuff I do is a bit more loose; this freedom will show in the pictures.

Norman Cook (Fatboy Slim) and Pizzaman, *Mixmag*
I was on Brighton beach lying on the pebbles, shooting up toward the sky. The guys were a bit bemused at the time, but all became clear when I explained I was bored of photographing people standing up and wanted to try something different. It was during this shoot that a journalist discovered that Norman Cook was actually Fatboy Slim—it had been pretty much kept a secret up until that point!

CAMERA: Nikon F3
LENS: 16mm
FILM: Kodak Ektachrome 100
APERTURE: f/8
SHUTTER SPEED: 1/30 sec
LIGHT CONDITIONS: Daylight, slightly cloudy

Katya

This photo is part of a personal project, with the assistance of make-up artist Therese Dombek. The shots were extreme close-ups using a macro lens and dramatic lighting. Taken on a digital camera and adjusted as a RAW file, I worked on the image to create a style using Capture One software, which I then applied to all the other images before processing into TIFF files. I cleaned up the image in Photoshop by removing spots, hairs, and other blemishes. The skin texture was smoothed out deliberately, so that the focus would be on the eye make-up, nails, and lips.

CAMERA: Canon EOS 5D
LENS: 100mm macro
ISO: 100
APERTURE: f/32
SHUTTER SPEED: 1/60 sec
LIGHT CONDITIONS: Bowens flash

Left: **Kylie Minogue, Polydor Records**
I superimposed this shot of Kylie onto the background. I decided to put her into a different environment, one I'd never seen her in before. I remembered a corn field near Luton I'd seen a few years earlier, so I went up there and shot the field, with my assistant standing in Kylie's place, to create a shadow. Matching the light to Kylie's portrait was important to make the image look real. Back at the office the image was scanned and put together in Photoshop.

CAMERA: Mamiya 645
LENS: 45mm
FILM: Fuji Reala 100
APERTURE: f/22
SHUTTER SPEED: 1/60 sec
LIGHT CONDITIONS: Flash and daylight

Right: **Irene, Fujifilm Distinctions awards**
I took a series of shots of Irene as a personal project with the help of make-up artist Natalie Dean. The shoot was classically beautiful, but I felt it needed something more—Irene was a bubbly girl and I wanted her personality to shine through. Chewing gum allowed her to be more expressive, and to have some fun. This picture was awarded a Distinction in the Commercial category of the Fujifilm Distinctions awards, where entrants submit images only using Fuji camera film. It was actually used by Fuji to promote itself at a later stage.

CAMERA: Mamiya 645
LENS: 120mm macro
FILM: Fuji Reala 100
APERTURE: f/5.6
SHUTTER SPEED: 1/60 sec
LIGHT CONDITIONS: Bowens flash

AS: Which do you prefer, digital or film, and why?

SP: Digital—it's an instant Polaroid. The technology enables me to do more in-camera, which means I make concise decisions before I shoot. I love digital because I can see the results quickly, and so can my clients. The software is equally remarkable. I love Capture One and I can play around with contrast and saturation, rather than leaving it in the hands of a film lab.

AS: How much of your work do you manipulate using imaging software?

SP: I tweak images, but ever so slightly. It's important I show clients what might happen with particular changes, and if they like them, I'll use them in the final product. I try to edit on the day, with small JPEGs, and then change bigger RAW files later, once the client has decided.

AS: What do you consider your greatest photographic achievements to date?

SP: Being awarded a Distinction in the Commercial category of the 2002 Fujifilm Distinctions awards. It was lovely to have such a leading organization recognize my work.

AS: What does the future hold for you?

SP: I'll continue to adapt to economic changes that affect my business. In terms of the types of photographs I take, I'd like to expand more into advertising. I'd also love to do a solo exhibition at some point, and a book to go with it.

Ruth Crilly, Fujifilm Fashion Collective
This picture, one of a personal series, involved a long exposure with flash, in a blacked-out studio. Once the flash had fired the shutter remained open, so I could paint with light (my assistant running around the background with my fairy lights), while Ruth stayed as still as she could. I entered the series of pictures into the Fujifilm Fashion Collective awards and won a Merit.

CAMERA: Mamiya 645
LENS: 80mm
FILM: Fuji Reala 100
APERTURE: f/8
SHUTTER SPEED: 10 sec
LIGHT CONDITIONS: Bowens flash and ambient light

Tips for Success

1. Get it right in-camera
Don't rely on Photoshop to correct basic photographic mistakes, such as exposure. This will ultimately save time and increase productivity.

2. Always try to experiment
Try shooting from different angles, such as lying down on the floor; a variety of shots will give your client more choice.

3. Use a variety of lenses
Try out some extreme wide-angle lenses, which allow you to create dramatic and graphic effects, or incorporate more of the background to say something about your subject.

4. Take at least three large umbrellas on any location shoot
One for the subject, one for yourself and camera, and one for the lighting source, if separate. Rain is no reason to stop shooting—within reason—as you may be able to achieve something different with the mood the weather creates.

5. Always prepare some ideas before a shoot
Researching your subject is important. If this isn't possible, at least turn up to the shoot an hour early to make yourself familiar with the location or studio. Most celebrities are busy people who don't have time to wait for you to mull over ideas.

6. Have some varied, portable backdrops
Fabrics can provide an interesting alternative to background paper and give your client another option. They're lightweight and easy to carry; two or three meters is usually enough.

7. Take your lights outdoors on a sunny day to create a vivid, blue sky
By lighting your subject brighter than the sun by using one or two additional exposure stops, you're effectively underexposing the sky, creating a darker and richer shade of blue.

8. Retouch in a natural way
Don't go too far unless the project demands it. Working in Photoshop, make each significant change in a different layer, so you can always go back if you've gone too far. Walk away from your computer for a few moments every 20 minutes to re-evaluate your picture.

9. Keep it real
When shooting images that are going to be used in a composite, ensure you light everything in the same way. In other words, the angle of lights, lens, and camera should all be the same for each image. For example, if you're shooting your subject from above, shoot your background from above too, with the same lens and same light setup.

10. Be patient and persistent, without being annoying
It's important to keep showing your work to as many potential clients as possible. Their feedback is invaluable; ask politely for an honest opinion.

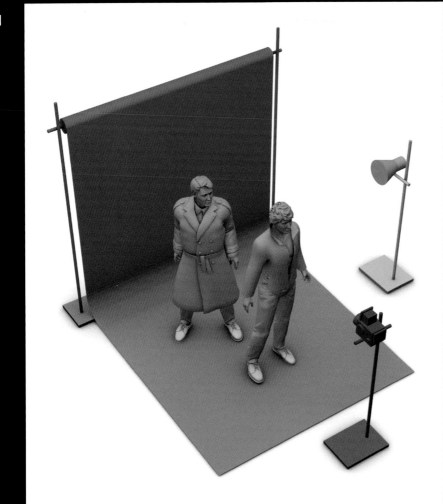

Air, *The Face* magazine

The Face had sent me to France to photograph several other dance music supremos, but on this occasion Air were in London. I knew their music and wanted them to look a bit mysterious. Lighting them from the side with a direct flash meant you would only see half of their faces, making the image a bit spooky. Using black-and-white film, for a change, removed the element of reality.

Essential Equipment

- **Canon EOS-1D MKII camera body**
- **Canon EOS 5D camera body**
- **14mm f/2.8 lens**
- **100mm f/2.8 macro lens**
- **Lens hoods for all lenses**

- **Canon flashgun**
- **Spare lithium-ion batteries**
- **Range of CF media cards**
- **Laptop computer**
- **Capture One imaging software**

Specification

CAMERA: Mamiya 645

LENS: 35mm

FILM: Ilford Delta 100

APERTURE: f/22

SHUTTER SPEED: 1/60 sec

LIGHT CONDITIONS: Bowens 1.5K flash

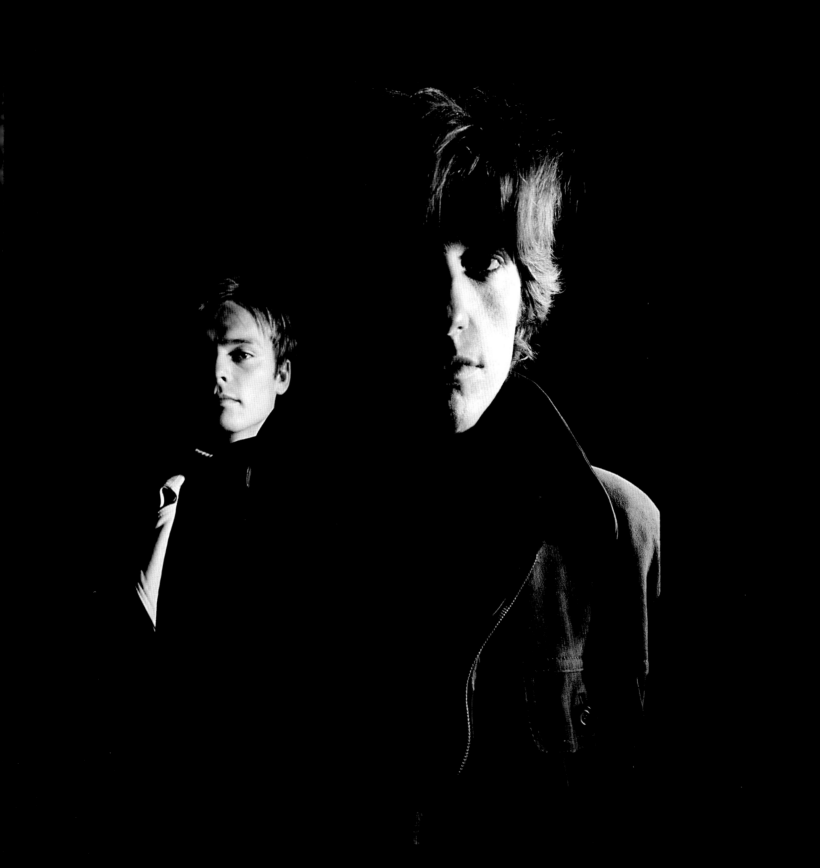

Credits

Polly Borland

© Polly Borland
© Mark Vessey (Polly Borland portrait)

pollyborland@hotmail.com

Russell Clisby

© Russell Clisby

pictures@russellclisby.com

Andy Gotts

© Andy Gotts

www.andygotts.com

Michael Grecco

© Michael Grecco
© Paula Lernes (Michael Grecco portrait)
www.michaelgrecco.com

Karen McBride

© Karen McBride
© Patricia Statham (Karen McBride portrait)
www.karenmcbride.com

Miles Ladin

© Miles Ladin
www.milesladin.com

Soulla Petrou

© Soulla Petrou
www.soullapetrou.com

Index

Acknowledgments

As well as expressing my sincere thanks to the editorial team at RotoVision, I would like to call attention to a few individuals.

Firstly, Liz Farrelly for "introducing" me to this project, and for having faith in my ability to put together another winning title! Secondly to Lindy Dunlop for her professionalism and liaison between author and book publication. And thirdly to Jon Ingoldby, for his immaculate attention to detail and clarification of my grammatical shortcomings.

I offer a sincere thanks to all who have helped make possible the publication of this book, not least of which is contributor Karen McBride, who, in addition to her understanding of meeting deadlines, drove from Manchester on just three hours' sleep to visit me in Essex. Thanks!

And finally, underpinning the whole book project, I most warmly acknowledge the patience and support of the most precious people in my life: Jenny, Karen, and Becky.

Andy Steel